NEVER SAY DIE

FIONA CRAWFORD is a writer, editor, and researcher whose work spans social and environmental issues, the arts, and football. Fiona has written about football for many publications, including *FourFourTwo*, and has managed and produced content for Football Federation Australia's women's football (Matildas, W-League, Girls FC) social media. Her PhD investigated how the Homeless World Cup uses football to tackle, and change perceptions around, homelessness.

LEE MCGOWAN is a researcher and writer at the Queensland University of Technology. He is collaborating with Football Queensland on a digital history of women's football and working on a range of other publications. His football research has featured on SBS World News, *Australian Story*, ABC radio, and in the *Courier-Mail*. He recently completed the academic text *Football in Fiction: A History*.

NEVER SAY DIE

The Hundred-Year Overnight Success
of Australian Women's Football

FIONA CRAWFORD & LEE MCGOWAN

NEWSOUTH

A NewSouth book

Published by
NewSouth Publishing
University of New South Wales Press Ltd
University of New South Wales
Sydney NSW 2052
AUSTRALIA
newsouthpublishing.com

 A catalogue record for this
book is available from the
National Library of Australia

ISBN 9781742236667 (paperback)
 9781742244716 (ebook)
 9781742249216 (ePDF)

Design Josephine Pajor-Markus
Cover design Lisa White
Cover image Sam Kerr of the Matildas celebrates after scoring a goal during the women's international match between the Australian Matildas and China PR at AAMI Park on 22 November 2017 in Melbourne, Australia. Photo by Robert Cianflone/Getty Images.
Printer Griffin Press

All reasonable efforts were taken to obtain permission to use copyright material reproduced in this book, but in some cases copyright could not be traced. The authors welcome information in this regard.

This book is printed on paper using fibre supplied from plantation or sustainably managed forests.

This project is supported by the Australian Academy of the Humanities.

CONTENTS

INTRODUCTION

In monsoonal conditions on the evening of 30 May 2010, 16-year-old winger Sam Kerr put her teammates, the Matildas, one goal ahead. She did so with an uncomplicated confidence and the deftness she's now known for, which was even more impressive given the waterlogged playing surface. It was the 19th minute of the Asian Football Confederation (AFC) Women's Asian Cup final. The Matildas maintained their lead into the second half, but with 17 minutes remaining, buckling under the tide of pressure from their DPR (North) Korean opponents – ranked sixth in the world – the exhausted and soaked-through Australian national team conceded what seemed like an inevitable equaliser. The North Korean goal would see both teams play a nail-biting 30 minutes of extra time.

When the final whistle blew, barely audible in the thunderous rain, the score was still even. There would have to be a penalty shootout to determine the victors. Few footballers or football fans relish a penalty shootout. The Australians'

surrender of a 2–0 lead to lose to China on penalties at the 2006 tournament, and the desire to redeem that result, may have been on the Australian players' minds as each team nominated five penalty takers.

Each player took their penalty: a single shot from a designated spot in front of the goal with only the goalkeeper to beat. Behind the keeper, barely visible through the pouring rain, thousands of fans waited, willing a miskick or a fingertip obstruction from the keeper's glove. No player wanted to be the first to miss their penalty kick.

The Australians had scrapped and battled with everything they had to get to the final of the most prestigious international women's football tournament in Asia. Their ranking (12th in the world) suggested a higher-ranked team such as China or South Korea should have had the spot. Emerging victorious from the semi-final clash with one of the world's powerhouses, the fifth-ranked Japan, was a huge ask. But the Matildas managed it.

The players left standing on the pitch for the final were drawn from a squad decimated through injury. Key striker Lisa De Vanna, for example, was missing after having broken her ankle in the third group game. It was a game for which coach Tom Sermanni had planned to rest her, but she pleaded with him to play. She sustained the injury within five minutes of being on the pitch. Distraught that she couldn't play the final, De Vanna refused to take painkillers so she could remain lucid and feel every emotion of the game. Tightly gripping teammate Thea Slatyer's hand, she cut an anguished figure on the sidelines.

It all came down to one kick. The Australians were at a psychological disadvantage, having lost the lead and the momentum, and both sides had just completed 120 exhausting minutes of ferocious contest in conditions that would see most games called off. One of the North Koreans had scuffed their penalty wide of the post. Taking the final penalty, 18-year-old Kyah Simon showed no sign of nerves as she placed the ball. She sized up the strike, took a couple of settling breaths, and picked her spot. In the few small steps and the shot that followed, Simon embodied the national team's never-say-die motto and captured everything that led to their success. That final penalty in Chengdu, China, marked the realisation of decades of female footballers' dedication, resilience, and sweat, and proved an important milestone for the national team.

With that kick, which gave the team a thrilling win over North Korea, the Matildas, long overshadowed by men's football and largely ignored by both the governing body for the sport and commercial broadcasters, became Australia's most successful football team. This should have been the result that finally brought Australian women's football into the spotlight. But apart from some brief mentions of the Matildas' win, the following day's sports pages were, as per usual, mostly filled with stories about male rugby league players and male Australian rules football (AFL) teams. Readers were offered insight from Socceroos goalkeeper Mark Schwarzer on the new football Adidas had designed especially for the 2010 [Men's] World Cup. The Matildas, who had become a symbol and benchmark for the next generations they

continue to inspire, returned with little fanfare to their W-League clubs and their part-time jobs.

The story of Australian women's football is one of both substantive international achievement and domestic challenges. It starts with grassroots games organised 100 years ago and features a sadly familiar struggle against gender bias. While it would be nice to think that poor attitudes toward female footballers are just a historical curiosity, most of the sentiment that prevailed then remains pervasive today. There are countless illustrative examples – from 50 years ago or yesterday. Stories of men training on the good pitches while the women were relegated to the poorest, least-lit pitches (or even a local high school's oval pockmarked by students' shot put practice). Of women having to change into their playing kit in their cars, or arrive fully dressed because there were no changeroom facilities. Of women lost to the sport because the physical, mental, and financial exhaustion of trying to juggle training, work, study, and poorly supported injury rehabilitation became too wearying. There are stories too of top male football administrators – the ones pulling Australian football's levers of power – telling female football administrators that no one wants to watch women's football. And of men being at first baffled and then incensed when a grassroots club's female footballers asked for the changerooms to stock a single sanitary bin.

At every level, the story of Australian women's football

is one of heartbreak, adversity, and obstacles – so many obstacles – but also of tremendous courage and perseverance.

Australia's elite female footballers have long made do with hand-me-down, comically oversized men's kits. Without a 'liveable' salary for playing professionally, they've worked part- and often full-time jobs, and delayed moving out of home and having children. They have paid for their own medical insurance and gym memberships and have, as a result, had limited access to good medical and rehabilitative care, despite suffering a higher incidence of season-ending knee injuries than their male counterparts. They have played in obscurity both domestically and internationally because no broadcaster was interested in showing their games. Regardless, the players have persevered, quietly improving their technical skills and their playing conditions, ensuring that future generations have it better than they did.

When two-time Olympic gold medallist, Women's World Cup winner, and all-time highest goalscorer for the US Women's National Team (USWNT) Abby Wambach retired in 2015, sponsor Gatorade created a farewell ad for her. Featuring Wambach urging fans to forget her – forget her name, her number, the records she broke – the ad outlined that Wambach wanted to leave a legacy that ensured future generations would surpass her. It was a clever bit of marketing that made a salient point, one that might equally apply to Australia's female footballers and administrators who have unassumingly gone about improving the game. We mightn't know all of their names and they're likely working quietly alongside us. As former elite female footballer Ellen Beaumont recalls,

Matildas great Sue Monteath once coached her in a representative team without once mentioning her own achievements.

To understand women's football is to realise that its humble beginnings and hard graft are inspiring. As a sport, it's easy to fall in love with. The sport is gaining recognition and popularity around the world. Celebrities revealed the 2019 English Women's World Cup squad through a video released on Twitter. Prince William announced captain Stephanie Houghton; former Lioness turned commentator Alex Scott announced Lucy Bronze; David Beckham announced Nikita Parris, whose jersey number would, like his, be seven. It was a significantly improved show of respect displayed for a team that had previously been banned, then kept largely invisible to an English general public obsessed with men's football. The German squad – two-time Women's World Cup and eight-time European champions – announced itself with a provocative, tongue-in-cheek video. In it, the team called out the prejudices it continues to face, such as comments that women should stick to having babies and that they belong in the laundry. One segment of the video shows the team sipping delicately from tea cups – a cheeky reference to the time the team won the 1989 European Championship and received tea sets instead of any kind of monetary reward.

The World Cup team Australia announced via social media five months after the tumultuous sacking of the coach under which it had achieved unrivalled results, featured a largely settled and unsurprising line-up that comprised a mix of youth and experience. It included 16-year-old emerging talent Mary Fowler, who has only known a time of paid football and struc-

tured development, and golden-generation players and four-time Women's World Cup attendees Clare Polkinghorne and Lisa De Vanna, whose careers have spanned the resource-poor 2007 and the much-improved 2019 Women's World Cups. The squad also included 34-year-old Aivi Luik, a talented, respected, modern journeywoman who finally made her first Women's World Cup squad.

The 2019 Women's World Cup Matildas campaign that unfolded – one that fell far short of Australia's ambitious expectations – would see the team and Football Federation Australia (FFA) scrutinised for everything from coaches to injuries to sexuality to investment to pay parity. Although the Matildas didn't do as well as they'd hoped on the field, overall the Women's World Cup would exceed all off-pitch expectations. Former female footballers would lead commentary teams. Skilled all-female referee teams would officiate the matches. The media would relentlessly shine a harsh light on governing bodies' failure to provide female footballers with fair wages. And Sam Kerr's off-the-cuff statement instructing 'haters' to 'suck on that one' raised awareness around the online abuse female footballers cop (particularly those identifying as lesbian and/or queer). The 2019 Women's World Cup was significant for women's football worldwide. At the final, the crowd spontaneously started chanting 'equal pay' when Fédération Internationale de Football Association (FIFA) president Gianni Infantino awarded the USWNT the Women's World Cup trophy. The women's game had jammed a foot in the door of the governing bodies and wasn't going to be overlooked, ignored, or pushed backwards again.

As we worked to put a century of Australian women's football to paper, we realised that, like many of those we interviewed, we were generally terrible at remembering who scored when and what was won. This is not a book of scores and fixtures. The stories we tell focus equally on the heroism of players, administrators, and teams on tours and in tournaments, and the generosity of friends and families to help them realise their football dreams.

Facts and figures are important, but only to note the growing numbers of participants and fans, the increased media coverage, and the stark differences in pay and conditions between female and male footballers. We highlight and celebrate origin stories – first games, clubs, coaches, administrators, and referees – and significant milestones, teams, and people; however, our interest lies most of all in the interwoven, tacit, and overt issues women's football faces and the incredible efforts players and their supporters have made to overcome them. We want to highlight how much they give back to the game, the invisible contributions footballers have made and continue to make covering their own costs to participate, and the fans who have shown unwavering support, even when media and broadcasters haven't. Family, whether biological or club-based, sits at the centre of all of these things; parents and siblings provide transport, food, shelter, and tear-soaked shoulders for support. Also central is the pervasive, contagious sense of community around clubs and players and fans.

Every element we discuss in this book represents a historical and cultural rabbit hole that could – and should – be pursued in a book of its own. By unearthing and piecing together interviews, anecdotes, notes, archival research, and books by everyone from football luminaries to specialist historians, we've attempted to augment the community's collective knowledge, particularly around the domestic game. We couldn't possibly incorporate every aspect of the entire 100-year history of Australian women's football – it's too rich, too deep, too unknown. So we've included stories that illustrate key themes, major events, and significant periods and developments, and tried to embed the history within a wider discussion of the issues and pressures women's football faced and faces.

With much of Australian women's football taking place out of the sight of television cameras and before the time of social media, we're conscious, too, that there are many more stories that warrant telling. Our hope is that this book prompts others to uncover them. Either way, we've tried to do justice to the stories with which we've been entrusted. They're undoubtedly incomplete and our retelling of them imperfect. But this book is a beginning. It's a conversation starter and a contextualised point-in-time look at the history of Australian women's football, with a view to deepening and extending that look in the future. We hope that the next books to be published will be written by the 'forgotten' players and administrators who lived and created this rich history and legacy so that future generations can surpass their contributions and achievements.

Note: In this book we refer to the world game as 'football', in line with the description most commonly used for the world's most popular sport for women and men, girls and boys, and the term international and domestic governing bodies FIFA and FFA themselves use.

Chapter 1

A ROAR IN THE 20s

If you wanted to drive around a 12-metre tall, six-tonne winking mechanical kangaroo mascot named Matilda, in 1982 the arena now known as the Queensland Sports and Athletics Centre (QSAC) was pretty decent. As a contemporary setting to watch football, the host venue for the 1982 Commonwealth Games opening ceremony is a little less ideal: an athletics track circles the football pitch, making it difficult for people to distinguish between players from the distant stands. So when it was selected for a 2014 match between Australia's national women's team, the Matildas, and Brazil – as well as many of the early Brisbane Roar W-League home matches – this highlighted a continuing problem: the less than perfect pitches to which women's football is often relegated. At that stadium, some 10 kilometres from Brisbane's CBD and not well serviced by public transport, approximately 2500 dedicated fans watched the Matildas beat Brazil by two goals to one. The second goal, which Michelle Heyman scored, sealed a closely contested match and tied the two-match series – Brazil had won the first with a single goal a few days before.

Three years later, the same teams attracted the largest crowds ever seen at a women's football match in Australia. International women's football specifically, and women's sport in Australia more widely, experienced incredible levels of attention and success in 2017. The Matildas turned the Brazilians over twice with the world-beating humility and class that has become characteristic of the team's approach. The match at the stadium in Penrith, an outer suburb of Sydney, sold out – some 17 000 tickets. The second match, at the stadium in Newcastle, a couple of hours' drive from Sydney, recorded similar ticket sales. Somewhere in the 1154 days between the final whistle at that dust-dry QSAC track and field and the late-afternoon spring warmth of Penrith Panthers Stadium, Australian audiences switched on to women's football. Not just here, though; it's been happening everywhere.

On a sunny Spanish Sunday afternoon in March 2019, 60 739 fans piled into the Estadio Metropolitano in Madrid to watch their team, Atlético Madrid, play rival team Barcelona. They became the largest crowd in the world to date to watch a domestic, club-level match between two female football teams – an even more impressive effort than the team's January 2019 game, which attracted 48 212 people to watch Atlético Madrid defeat Bilbao. A week later, a domestic women's league fixture between Florence-based team Fiorentina and the Turin-based Juventus sold out the 39 000-seat Allianz stadium in Turin. In London, at Wembley Stadium, the May FA Women's Cup Final drew 43 264 people; 12 months before, 51 211 people attended a Mexican women's Liga MX final.

For Atlético Madrid, the January and March 2019 fixtures were the only two their parental organisation had so far afforded the women's team in the club's new home. They usually play in the less glamorous surrounds of the Cerro del Espino, a 3500-seat stadium used by the Atlético Madrid men's team reserves. Importantly, the attendance figures were the result of intensive, well-orchestrated promotional campaigns for carefully selected fixtures, reflecting the extraordinary, mostly unpaid efforts of players, supporters' groups, and family members who promote the match and, with it, the code as a whole. They drew on the help of friendly mainstream media, clever use of social media, and promotional events including signings, appearances, and ticket and merchandise giveaways in the lead-up to game day. The club also targets fan groups, local teams, and schools with free and cheap tickets.

Cynics will always question the value in counting free tickets, or make unfair comparisons with attendances at elite, affluent matches in the English Premier League, La Liga (Spain), or Serie A (Italy) competitions, which receive almost all of the media's coverage. But when the goal is simply visibility – 'if you can see it, you can be it' – these well-attended fixtures are a sound measure of success and demonstrate a tangible return on cost-effective, energetic, and targeted promotional investment. Taken together, the match attendances and the successful promotional activities clearly indicate the considerable, burgeoning interest around the game: female football doesn't need the hard sell; it only needs attention.

The Atlético–Barcelona match broke an attendance

record for women's football that had stood for 99 years. On 26 December 1920, 53 000 people squeezed into Goodison Park in Liverpool, home of Everton FC, to watch the Dick, Kerr Ladies FC play rival team St Helens FC. Newspaper reports estimate over 14 000 people were turned away from the match because the venue had reached capacity. Historians often cite these figures, then immediately contextualise them as an anomaly – a peak in interest. But, three weeks later the Dick, Kerr Ladies played in the sold-out, 35 000-seat-capacity Old Trafford stadium, the home of Manchester United. These figures are not rare. People have always been interested in women's football.

On Christmas Day 1917 in Preston, the women's team associated with Dick, Kerr & Co, the foundry and ammunitions factory, beat the men's team from Arundel Coulthard Factory by four goals in front of a crowd of 10 000 people. In March 1919, 35 000 people attended a Dick, Kerr Ladies' match in Newcastle. In 1920, a home-and-away series against a French women's team enjoyed crowds of 20 000. The newspapers assumed the stout northern English factory workers would roll over the top of the elegant French shop assistants, but these games were fiercely contested on the basis of technical ability. Serious teams were drawing serious crowds – more than 12 000 people attended a match between Plymouth and Bath in 1921. A report in the New South Wales *Northern Star* in 1921 suggests that in England 'there are sixty clubs and many own their own grounds'.

In the period following the First World War, women's drive for emancipation gathered momentum. Activists argued

that for women to fulfill their potential at home, at work, in society, their needs had to be recognised. In the UK, in her book *Married Love* (1918), birth control pioneer Marie Stopes advocated for gender equality in marriage and the importance of women's sexual desire. The *Sex Disqualification (Removal) Act 1919* (UK) restricted the power of marriage, previously a (legal) barrier to work outside the home, and cleared the way for married women to keep working. The *Representation of the People Act 1918* (UK) and the *Parliament (Qualification of Women) Act 1918* (UK) extended the right to vote and enabled women to sit in parliament. These developments, while still slow and limited in their uptake and impact, were also being reflected in football.

There are contemporary and historic parallels in Australia, too. During the Cup of Nations, a warm-up tournament for the 2019 Women's World Cup, 10 580 people turned up to Brisbane's Suncorp Stadium to witness the Matildas dismantle their South Korean opponents. It was a Sunday evening, a school night, and a 'friendly' fixture. It was also Brisbane's largest ever crowd for a women's football match. (The other matches in the tournament played mid-week, either side of the Brisbane match, each attracted around 7000.) The last time Brisbane recorded 10 000 people turning up to watch women's football had been on 24 September 1921.

The first public Australian women's football match took place at the Brisbane Cricket Ground, in the city's Woolloongabba suburb. 'The Gabba' is now better known for hosting Ashes cricket tests and for being home to the Brisbane Lions AFL team. In 1921, the ground was under the lease of

the Queensland FA, an organisation that wasn't completely convinced a game between two women's teams should feature on its match-day program. The women's match, wedged between two men's games, has until recently been portrayed as a one-off exhibition. But it was only the most spectacular of a short series of representative matches. The two competing teams drew their footballers from three separate teams training and playing in the city at the time. We believe three more existed in Brisbane. In the same year, matches were played in Ipswich, Toowoomba, Sydney, and the Hunter Valley. Alongside the emergence of women's teams playing AFL and rugby league, there were over a dozen women's football teams training for and playing matches in Queensland and New South Wales. While the players involved in the Gabba match were selected from teams that competed locally, it arguably qualifies as Australia's first representative female football match.

In the early days of the women's game, in Australia and elsewhere, especially England, the key obstacles were men. Unconscious bias and a tacit fear that the women's game would detract attention and income from the men's game factored into their rationalisation. For these and other reasons, the women's game disappears from the historical record at certain points. The sparse details captured don't always tell as much of the story as we know, or would like to.

The world's oldest surviving football (dated to the late 1540s) was discovered in the former chambers of Mary Queen of Scots in Stirling Castle, Central Scotland. Organised football games occurred in castle courtyards across Scotland at the

time. The ball found in Stirling, constructed of a pig's bladder, was evidently kicked high into the rafters and later hidden during renovations. After her flight from the Battle of Langside in 1568, during a stop at Carlisle Castle, members of Mary's retinue played a form of football for two hours simply for her amusement. It was a rough game in the 16th century: bones were broken, ligaments torn. If she was fond of a kickabout with or watching her courtiers, it says something about the game's attraction, and about the young queen. Certainly it indicates that female interest in the game is nothing new.

The first recorded 'competitive' or exhibition games of women's football are believed to have taken place in northern Scotland, contested between teams of wives against teams of single women from Highland villages. Researcher Jean Williams notes a game recorded in Inverness in 1888 consisted of a lot more players than the 11-a-side matches we watch now. These early games were played on holidays such as Shrove Tuesdays, with fixed goals, even numbers, and players wearing colours to designate teams. It's likely the games informed the local farmers' determination of a worthy spouse.

It seems funny and not a little misogynistic now, but the practice of using a football match to determine how well a prospective partner is equipped to round up sheep and cattle contradicts many popular beliefs about women and physical activity. It's certainly a strong contrast to the 1920s, when leading British medical journal *The Lancet* condemned football as a sport for women: 'We can in no way sanction the reckless exposure to violence, of organs which the common experience of women had led them in every way to protect'.

Two doctors, also vocal proponents of the eugenics movement, made claims about football's detrimental impact. Pioneer British physician and gynaecologist Dr Mary Scharlieb of Harley Street declared football a 'most unsuitable game, too much for a woman's physical frame'. Another physician, Dr Elizabeth Sloan Chesser, also of Harley Street, stated: 'There are physical reasons why the game is harmful to women. It is a rough game at any time, but it is much more harmful to women than men. They may receive injuries from which they may never recover.' The dusty grey men of the English FA seized on these paternalistic expressions of medical fear. The other matter of consternation that Williams highlights was players' physical appearance. Playing in a dress, with the ball getting lost in material or underfoot or, for the factory girl, in a set of baggy breeches, would not have been comfortable or practical. Where necessary adjustments to uniform threatened to compromise the status quo, women's football would, it seemed, always be susceptible to public reaction.

Amid the game's growing popularity in the 1880s, the earliest organised women's matches emerged in Scotland too. A series that took place in 1881 in Edinburgh and Glasgow included seven 'international' matches featuring a Scottish side and an English side. Reports note the first match in Edinburgh attracted 5000 people to the Hibernian FC stadium. Team selections for the matches highlight that players changed teams throughout the series, which is unusual for a national side, but suggests that stronger players were distributed evenly to provide a more sporting contest for the audience's benefit. There was also a commercial imperative for

putting the matches on: cashing in on the long-established rivalry between Scotland and England.

The first ever women's association formed in Glasgow in 1894 and completed an exhibition tour of Britain in 1895. The openly activist tour foregrounded the fight for women's rights, and the matches, contested by sides nominally known as England North and England South, were positioned within the 19th-century feminist movement and its drive for political, social, economic, and recreational emancipation. The Australian press carried reports of the tour, including a column by sponsor Lady Florence Dixie arguing for reasonable dress codes that would allow women to wear clothes permitting an appropriate range of movement for football and other sports. She also emphasised that women should have the right to choose their own attire.

The popularity of the teams, the matches, and the players in England led to resentment, both privately harboured and openly expressed, and the game's all-male authorities regarded the women as a nuisance. Women were expected to return to domesticity after the war; there was also the small matter of their support for striking miners. Chairmen and club managers and the aging men of the English FA, despite the incredible success of women's football, would begin to paint the game as unfitting and improper for women and girls. In his discussion of the language used to describe women's football, football writer and historian Peter Seddon notes the 1920s Arsenal FC manager Leslie Knighton's assertion that 'anyone acquainted with the nature of the injuries received by men footballers could not help but think – looking at the girls

playing – that should they get similar knocks and buffetings their future duties as mothers would be seriously impaired'. Gender fast became a divisive factor across the world's most popular sport – as it has continued to be.

Women's football took a significant step forward with the changes to the workforce brought about by the outbreak of the First World War. There were three key influences on their game's development. First, a longstanding debate around retaining the amateur status of men's football crumbled. The upper classes had been arguing that the game should not be professionalised. Sports historian Allen Guttmann highlights that the rules of amateurism established and perpetuated by the Victorian upper classes excluded 'the "lower orders" from the play of the leisure class'. If they'd had their way football would remain the game of gentlemen to this day. But affluent factory owners knew there was money to be made from football and the best players sold the most tickets. They were soon paying footballers, over or under the table, to win matches. Demand to see these players and teams, fed by media who sought to increase their own circulation, exponentially grew the game. Second, the prominence of men's football, increasingly popular and professional by 1914, was abruptly halted as most players were shipped off to the trenches. The working public had gotten used to and demanded the relief Saturday afternoon football brought from a long week of longer shifts. Third, as women were called on to take on roles in the workplace, they changed public perception around a range of issues, including appropriate clothing. It became more acceptable for women to wear trousers and overalls, for example.

Watching their female workforce play football during their lunch break, obliging entrepreneurial (or exploitative) factory owners, accustomed to the income generated by large attendances at men's matches, were inspired to temporarily replace their men's teams with women's teams until the war was over. And so, by 1920 the women's game became a successful and well-organised enterprise. In addition, significant amounts of match revenue were distributed to local and national charities. By 1921 Dick, Kerr Ladies had raised £60 000 (in a modest estimate related to the Consumer Price Index (CPI) this would be around A$4.2 million today) for returned servicemen, hospitals, and infirmaries.

The rapid growth and popularity of the women's game threatened the establishment. The English FA continued to underline the contentious research that suggested strenuous or athletic sport could permanently affect women's health. While it suited these men to support women's football during the war, their key demographic was returning from Europe and they wanted to re-establish the sport as a masculine activity. On 5 December 1921, the English FA passed a resolution that 'complaints having been made as to football being played by women, the council feel impelled to express their strong opinion that the game of football is quite unsuitable for females and ought not to be encouraged'. They saw fit to include concerns that 'an inadequate percentage of receipts were donated to charitable objects'. To funnel revenue into men's football, it banned women from playing football.

Technically, the English FA did not actually ban women from the game, which would not have been possible. Instead

it banned women from playing on affiliated grounds. Women could still play football, just not anywhere football could readily be played. As Williams notes, the ban fundamentally changed women's football. It became ad hoc and self-regulated. The rationale for the ban spitefully discredited women who had contributed so much to the war effort. Researcher Ali Melling notes another dimension. In 1921, northern English women's teams that raised money for veterans began raising money for striking miners too: 'During the coal lock out valuable assistance was rendered by these girls to the funds for miners' children'. This shift from acceptable social support to perceptibly class-oriented political purpose might have provided further impetus to shut down the women's game.

The emergence of women's football in England and the subsequent counteraction from those in the men's game is documented in Australian newspapers of the period. The same newspapers also note that Australian women played before and after the ban. In 1903, a delegation of women convinced the secretary of the Clyde Engineering Sports Club, Sydney, to support them to form a team. The sports club was a significant organisation, and the starting point for Australia's oldest football club, Granville, which formed in 1885. The secretary took some convincing, emphasising the dangers of the sport and concerns about what the women would wear:

> There were some objections raised as to the advisability
> of such a step being taken, but the fair petitioners
> themselves have suggested ways and means of getting

over these. As to the ball, it was proposed that a much smaller sphere could be used; touching the roughness of the play, it was pointed out that there need be nothing of the sort indulged in; indeed, if anything, it was believed that the girls and young women would be able to give a more delightful and pleasingly scientific exposition of football than the sterner sex. Then touching the costume, this objection was wiped away by the suggestion that a modern ladies' bicycle outfit would be ample dress to give freedom. (From *The Cumberland Argus and Fruitgrowers Advocate*, Parramatta, 30 May 1903.)

The secretary and the Clyde Engineering Sports Club resolved to support the women. Another team is reported to have formed in Candelo, New South Wales, in 1908. While some women were spotted kicking a ball around at Granville FC in 1913, women's teams are also known to have played in 1916 in Wallsend, Newcastle, New South Wales. A little later, in 1918, a small number of matches took place in Newcastle, and in 1920, two women's teams played in Adelaide, South Australia. These examples appear to reflect the migration of working-class people, particularly engineers and miners, from the UK. The growth in popularity of British women's teams, including the Dick, Kerr Ladies, and the size of the crowds being reported incited great interest in Australia.

The most significant year in the game's early development in Australia is 1921. It's the year the game is most clearly and regularly documented and the year in which teams emerged most frequently before the 1960s – even then, similar levels of interest in the public domain have only been realised in the last handful of years.

The first of five teams in the city of Toowoomba, Queensland, formed in late June 1921. The Toowoomba Cities and Toowoomba Rovers teams emerged from a town hall meeting attended by 27 women and official representatives of the Australian British FA and the Referees Association. After an introductory lecture on the game that included blackboard illustrations, the teams' first training session took place at the local showgrounds the same day. Following the example set by women's teams in England, the Toowoomba teams determined that: gate receipts from their public matches would be directed to a local charity; they wanted to train and play in private, out of the public eye; their playing attire or 'costumes' would be green jerseys, navy bloomers, and blue caps for Cities; and cream jerseys, blue bloomers, and white caps for Rovers.

In Sydney, on 30 June 1921, as many as 30 women attended a similar meeting. They formed four teams and began trials and training in early July – for the purpose of trying out, 'the consensus of opinion seemed to be in favour of annexing their brothers' togs, with or without his consent'. The teams that played at the Gabba three months later emerged out of Australia's biggest association, which formed when over 100 women attended its inaugural meeting in

the Brisbane Gymnasium on 8 July 1921. In its 6 July 1921 issue, the *Daily Mail* in Brisbane reported resistance that 'certain old-fashioned, individuals to whom a ride in a smoking compartment is almost an adventure are opposed to the formation of a ladies' Soccer club'. But the meeting was enthusiastic: 'Girls – of all ages – and sizes – to the number of about 100, typistes, shop assistants, and workroom hands, decided at a meeting at the Brisbane Gymnasium last night to form a Queensland Ladies' Soccer Football Association (QLSFA). (From the *Telegraph*, Brisbane, 9 July 1921.)

Interest in a women's team arose a little earlier during a Queensland Football Association (QFA) meeting in mid-June 1921, but it is likely news of the clubs forming in Toowoomba, and the formation of the Newcastle association, prompted action. Brisbane's first side, the Latrobe Ladies Soccer FC, formed on 4 July 1921. An RJ Powell actively encouraged women to train and began teaching them how to play. Following Powell's lead and the model he'd established (one borrowed from Europe), two more teams, South Brisbane and Brisbane Ladies, formed a few days later at the inaugural meeting of the QLSFA.

William Betts, the Brisbane Gymnasium's 'physical culture instructor', provided advice on health and wellbeing, organised training, offered instruction, and painted footballs with aluminium so that they would be bright enough for evening sessions. As the first chair of the newly formed association, Powell presided over voting and decisions on team formation and uniforms:

The objects of the meeting having been outlined,
Mr. Powell invited suggestions. There was a pause.
One girl half rose from her seat. The chairman was
quick to encourage her. 'Come on', he said. 'Don't be
afraid. I am a bit shy myself.' A lady in the front row,
who is identified with a prominent ladies' swimming
club, came to the point in a very business-like way.
'Of course', she said, 'we must first of all form an
association', and when the chairman seemed to hesitate
about adopting such a procedure, she exclaimed,
'Oh! you need not be afraid. You will get the clubs all
right once you have the association'. Her confidence
at once put the chairman at ease. 'Those who are
in favour of forming a Ladies' Soccer Association',
said Mr. Powell, 'put up their hands'. One hundred
hands shot into the air. 'That is carried unanimously',
declared the chairman, amidst applause. All agreed
that the most appropriate name for the new body was
the Queensland Ladies' Soccer Football Association.
(From the *Telegraph*, Brisbane, 9 July 1921.)

The decision that socks would be worn instead of stockings
caused the greatest furore in the gymnasium that evening:

The all-important question 'What shall we wear?' was
then asked.

'I will tell you', replied the chairman, 'what the
Latrobe Ladies' Soccer Club has decided to wear'.

'Break it gently!' interjected a girl.

'They decided on jerseys, navy blue bloomers, football boots, and socks.' 'Socks!' screamed the girls, almost in one voice. Someone started to titter, and a general laugh followed. 'Well, it's like this', explained the chairman, 'If you wear stockings you will want a new pair every week. They play in socks in the old country'. Still, the ladies did not seem to like the idea. Then someone explained that the chairman had hit on the wrong word for three-quarter hose. Everybody had a good laugh. 'What boots shall we wear?' asked a girl, 'Latrobe club', replied the chairman, 'have made arrangements to secure boots with light wallaby tops, and bars instead of studs. Of course', laughingly added Mr. Powell, 'you won't want highheels on your boots'. (From the *Telegraph*, Brisbane, 9 July 1921.)

Powell, it has to be said, was one of the women's game's earliest allies.

In a characteristically weakly reasoned decision, the all-male governing committee (overly concerned with the QFA's thinking on such matters) determined that it was too late in the season for the small number of women's teams to form a competition (the men's structured competition ran March to October); however, they could participate in recreational matches. Regular training soon began in earnest. The first QLSFA executives meeting took place a fortnight later and was run by the 'confident woman' from the previous

excerpt, Jean McGregor-Lowndes – often referred to as Mrs VA McGregor-Lowndes after her husband's name – a fierce supporter of and advocate for a number of women's sports, including swimming, tennis, and women's basketball (or netball as it's been known since 1970). Under her guidance, the executive determined the uniforms for at least one of the women's teams, resolved to continue to pursue affiliation with the QFA, and arranged a match with a team from Toowoomba. Neither affiliation to the QFA or the arrangement of a match would be as straightforward as the uniforms.

The group of men that formed the QFA board were afraid that the women's play would be of such poor quality it would humiliate the entire sport and, of course, much more directly for them as its governing body. So they refused to consider the QLSFA's application for affiliation. Instead, they actively sought to deny the women opportunities to play a public match. When they did eventually vote to accept the QLSFA as an affiliate, the chair, John William Kendal, insisting that football was a man's game, resigned in protest. At that time, he was Brisbane's most powerful man in football. Unperturbed, or at least caring little for Kendal's position, McGregor-Lowndes and her players, who had been training regularly, continued to lobby for high-profile match time. Under Kendal's now out-of-joint nose, they successfully negotiated to move their planned 13 August fixture against Toowoomba to 10 September where it would be the curtainraiser for an interstate AFL match at the Brisbane Showgrounds. Trying to renew fan interest in their code (it had all but disappeared in Queensland where rugby league became more

strongly favoured), the AFL's organisers were keenly aware of growing public interest in women's football and sought to exploit it. They offered the QLSFA £50 (the 2019 CPI equivalent would be around A$3500) to play an exhibition. When the QFA executives caught wind of the arrangement, they changed their own position and offered the QLSFA a percentage of the gate at a potentially lucrative replacement fixture. Kendal was persuaded to return as chair (six other board members threatened to resign if he did not) and the Gabba match became Australian women's football's official public debut. In a tidy bit of business, it also netted the organisation in excess of £90 (a CPI around A$6300 in 2019).

Kendal's views were typical of attitudes toward women playing association football in Australia. The QLSFA could have chosen to remain independent, but public matches raised revenue for their game, and access to public matches was only possible through affiliation. In addition to the revenue, the women simply wanted the recognition they deserved and the opportunity to play. When the QFA exercised its control of resources like this, it showed how willing organisers were to impose their rule. Football writers at the time underlined how enthusiastic the support and advocacy for the women's game was, including in one article that notes the Referees Association's support for the women's game and another that details Kendal's protest resignation and expresses disdainful regard for the QFA's handling of any attempts by the QLSFA:

> after three hours the meeting proved abortive. Do
> the ladies think of the storm in a tea cup which

Mr. Kendal has caused merely through the trifling matter of accepting the affiliation of the QLSFA? Is all this bother 'really about nothing' worth while? What is it that Mr. Kendal fears? Surely, it can do no harm to give a helping hand to the ladies so keen as they are on the soccer form of outdoor exercise – by accepting their affiliation with the QFA. I cannot for the life of me see the need for opposition to the ladies' affiliation. The argument that the affiliation is unconstitutional is suspiciously like a pretext. It really does seem a pity that such a trivial thing should have been the cause of the delegates of the QFA squabbling amongst themselves like a lot of school children; And all because three men refused to bow to the will of the majority. (From Right Half, the *Telegraph*, Brisbane, 4 August 1921.)

Practice matches took place in Bowman Park, Brisbane's most popular venue for football. A report in the *Darling Downs Gazette* of two matches in Brisbane noted that '"when the girls first appeared in shorts", remarked one of the officials, "they were timid and shy. But now they have become quite hardened to the idea"' (10 September 1921). The women undertook a significant amount of training before they played any public games. Unlike the exhibition match, these practice games were never advertised and only ever discussed retrospectively. 'All played utterly indifferent to the two score or more men who, having got wind of the projected games, had gone out to Paddington post haste to admire "the new

Eve". The fixtures had been secretly arranged, that is so far as was possible' (*Darling Downs Gazette*, 10 September 1921). Reports also highlight that the Brisbane Gymnasium offered the relative privacy the women preferred for their training. The team selections for the Gabba match were made during additional practice games at Toowong Sports Ground, Brisbane, the week before: 16-year-old Jean Campbell of Brisbane City would captain North Brisbane (the Reds) and Miss G 'Fatty' Wenlock, a former member of the English Women's Battalion Soccer XI, then of Brisbane Ladies, would captain South Brisbane (the Blues). The players selected all came from Brisbane City, Brisbane Ladies, or Latrobe Ladies teams.

The match, two 30-minute halves refereed by a CW Searle, whose wife would later become the first QLSFA president, was scheduled to follow a local second-grade men's match and be before a highly anticipated top-of-the-bill match, Home (expatriates from the UK) versus Queensland (those born in the state). To add to the spectacle, Amy Rochelle, a singer and national celebrity, kicked the match off. A woman named H Breeze scored the first goal in the first half and the eventual player of the match, Jean Campbell, tucked away a penalty in the second half, leading the Reds to a two-goal victory. Both team captains were reported to have had excellent games; the crowd even cheered Campbell's name. The action is reported with unprecedented gusto and detail, and the press privileged the story over the men's games either side. One report in the *Queensland Times* notes women's skilful treatment of the game, the players' remarkable stamina, and that their training and preparation were clearly evident.

Historians argue that the estimated attendance figure, approximately 10 000, is a reflection of the Home versus Queensland match that followed; however, in Ipswich on 15 October 1921, two teams with similar team selections topped the bill, with a first-grade men's game providing the curtainraiser. The initial plan was to have a representative Brisbane women's team play a representative Ipswich team. The Ipswich team withdrew very late in the process and was replaced with the second Brisbane team. The final result split the honours (2–2), but the match drew a crowd of around 3000. Considering the levels of interest in other countries, the novelty of women's football in Australia, and the comparative populations of the cities, genuine interest would have contributed to the significant attendance at both these matches. The intimidating size of the crowd may also have been the cause for the Ipswich team's withdrawal.

In early February 1922, the British Association Interstate Conference unanimously decided 'not to recognise ladies' football in any shape or form and to forbid the use of any association or club grounds for such matches'. Australian newspapers had widely reported the English FA ban on women from playing on English FA-affiliated pitches the previous December. The New South Wales Rugby League (NSWRL) organisation also banned women from playing rugby league, a sport that attracted similarly large crowds for women's matches – a week before the Gabba match in Brisbane, two women's rugby league teams played in Sydney before an estimated crowd of 30 000 people. Echoing the questions that had been raised in England around the

appropriation of revenue and preposterous medical argu-
ments about the game's unsuitability for female players, the
reasons given for the rugby league ban were related to the
'private' nature of its sponsorship model and fear that wom-
en's participation would open the way for a rival league.

Advocates in the Australian press, such as the reporter
writing under the pseudonym 'Right Half', which also
describes a traditional player's position, made positive argu-
ments for women's participation in football. A fragmented
state-based structure and the organisations' failure to commu-
nicate their agenda cohesively meant the ban was not directly
or effectively put in place at a national, state, or local level;
however, it had the intended effect where it was accompanied
by newspaper arguments excluding women from Australian
football codes.

Determined to continue, the QLSFA met in the Brisbane
Gymnasium for a second annual general meeting on 22 Feb-
ruary 1922. The committee announced substantial member
numbers: six teams (though not necessarily the same six that
were around in late 1921) and healthy finances (a balance of
£64 – around A$4500 today). They declared their enthusiasm
for building on the previous season by scheduling matches.
The press also celebrated the return of Brisbane City and Bris-
bane Ladies for their second season and the fact that clubs
were forming in Ipswich. The 1922 Brisbane City Ladies FC
team sheet illustrates that many of the players who partici-
pated in the previous season had returned.

The first reported trials and matches took place in June.
The teams undertook several weeks of training in preparation,

so pre-season likely began in May. Members of the press were invited to matches, but were asked not to report until afterwards. As a result, newspaper stories portrayed the women as being shy of public attention. An interview with one player underlined that they were reluctant to give away details:

> The Press was invited, but was asked to refrain from referring to the fixture until after the match had been played. Indeed, it was the intention of the players to forego the game if there was likely to be anything in the nature of inordinate public curiosity or innuendo. Happily there was nothing unseemly on the part of the handful of spectators who were privileged to watch the contest, and the fair players conducted themselves in keeping with their sex. (From the *Telegraph*, Brisbane, 19 June 1922.)

The women clearly wanted to be away from the spotlight, an understandable response given the nature of some 1921 match reports, which would, at times, be presented with disdain and more than a little objectification. Right Half's report suggests the English journalist was hypnotised by the 'bare knees adorned with the most fascinating of dimples' and highlights descriptions of a French player as 'the prettiest little thing', 'a living breathing Venus De Medici'.

Some press reports presented Kendal's resignation and stance on the QLSFA as positives. One writer noted he would rather a woman carried a violin case than a football under her arm, and, in possibly the worst example, the Charters Towers

Evening Telegraph (24 June 1921) printed a misogynistic parody depicting female players ripping each other's clothes, name-calling, and pulling each other's hair. The game ends when the supply of hairpins runs out. Such coverage skewed debates on the acceptability of women playing football. Other reports reinforced arguments of the patriarchal football establishment, dressing their obstructive, self-interested perspectives in paternalistic rhetoric, suggesting the women should be saved from themselves. The editor of *Sporting Life* magazine suggested that football 'is not a woman's game', because, he added, 'it takes away their womanliness'. As a result of these attitudes in the newspaper and some of their approaches to reporting women's football, as noted in the *Telegraph* (Brisbane, 13 April 1922), 'after their debut last year, and the disturbance they then caused amongst the ranks of the QFA [Queensland Football Association], members of which body hold varying opinions on women as footballers, would not reappear on the football field this season'. But at least 'two of last year's clubs, Brisbane City and Brisbane Ladies, will take the field again this season, and new clubs are said to be in the making'. Miss Nell (no first name is provided), the player being interviewed states that 'A great difficulty we have to contend with is that the girls are scared of public opinion'. The 1922 season results are not well recorded, and the lack of evidence has been construed as the end of women's football, but anecdotal evidence suggests there were games through June and possibly up until September.

It's possible the QLSFA may have continued into 1923. McGregor-Lowndes was commended for her efforts across

the period, but no football is reported. Emphasis on hockey, netball, and vigoro grew their recruitment and participation in Queensland alone between 1923 and 1929. A commonality across these sports is that they require a sports skirt for play, so it's possible that a more acceptably 'feminine' dress code contributed to their immense popularity.

In the latter half of 1926, newspaper reports highlight regular weekly matches of women's football organised through the Brisbane City Ladies Soccer Football team. In July 1926, the QLSFA re-formed and took offices in Brisbane's CBD. Local newspapers featured a recruitment drive with images of players in football boots, shorts, jerseys, and caps. Reports of teams playing against each other on a weekly basis began in June, noted training had started some weeks before, and continued throughout the latter half of 1926 and into the early months of 1927.

Football also gained momentum in New South Wales. In the years between 1928 and 1933, a number of teams, including Kurri North End, Weston, Abermain, and Speers Point, would compete in and around Newcastle and Sydney. Another collection of teams formed west of Sydney in the early 1930s, including Zig-Zags, State Mine, Blue Birds, and Vale of Clwydd. The team names of the latter group echo the formation of workplace-based teams in England between 1917 and 1921. Matches raised funds for a soup kitchen, a local school, and the northern miners' relief fund. The teams practised for weeks in the lead-up to any advertised public match, including those that took place at the Sydney Sports Ground. In 1929, under floodlights, a paying crowd of over

7000 watched Speers Point beat Weston Ladies 1–0 for the New South Wales state title. Within 12 months, the Women's Soccer FA emerged in Lithgow, with 50 women forming two teams to play against those already playing in Sydney and the northern coalfields.

Weekly 'ladies' soccer' meetings were advertised in local newspapers in 1933 in Ipswich. A women's team formed in Booval, Ipswich, and held weekly meetings beginning in March. Swifts Ladies Soccer Club, formed in Bundamba, Ipswich, announced its own regular meetings soon afterwards. A number of public calls were made encouraging the establishment of an intercity soccer competition solely for women's teams. The all-male committee of the West Moreton British FA even went as far as suggesting women's games would provide excellent curtainraisers for their already-popular men's competition.

Following the run of years where women played football between 1926 and 1933, women's football and any records of it becomes even more fragmented. There is anecdotal evidence of women's matches in Bankstown and in Newcastle in 1938 and 1939. We know, for example, the changing factory workforce during the Second World War led to football matches being recorded across 1942. Team names followed the historic pattern and were based on employers' names. Teams called MM and Lysaght's Works, Richard Hughes Co. Ladies, Five Docks, Granville, Central, and others played competitively. In 1943 matches are recorded, including photographs, of Wollongong beating the Guildford Black Cats at the Sydney Sports Ground. Two women's teams played an exhibition

match at the Margaret River Carnival, 1946, in Western Australia (Rosabrook beat Margaret 3–1) and three teams played a series of matches in Collie, also in Western Australia, in the same year. In 1950, two women's teams played a match in Cairns. In September 1953 players in Ipswich initiated a 'novelty' match featuring Blackstone Rovers and Bundamba Rangers teams. A further report in November the same year suggests a pattern of exhibition matches took place in order to support charitable causes.

A sift through the newspapers indicates individual games and plans for related activities, the odd nod toward a football organisation, and the occasional result. As historians Elaine Watson, Roy Hay, and Bill Murray have noted, we are never allowed to see the full picture of the activities. Regular games and routine performances appear to have been too mundane for the press. Forensic investigation of the archives does reveal enough evidence, even if it is fragmented, to argue that a great deal more women's football took place than we know about.

Chapter 2

NOT QUITE A GOLDEN HALF-CENTURY

Women who play (and have played) football, and those involved as coaches and administrators, continue to face obstacles and barriers to entry that male players and participants never will. The tone for the treatment of the women's game set in the 1920s rippled through the 1960s all the way to the turn of the 21st century. In 1976, Lyn Ketter gained a Level 2 Australian Soccer Federation (ASF) coaching qualification. 'I loved it. I wanted to get involved. There was a lot more to it than I could ever have imagined. There was a lack of coaches – it was always someone's husband or dad. And I wanted to know everything about it: how to play better, how to coach. I didn't really want to be an administrator', Ketter says. Which is amusing as she held the office of president of Women's Soccer Queensland from 1990 until 2004. In 1977, the Queensland Soccer Federation (QSF) invited her to undertake the Level 3 qualification program at the National Training Centre (NTC) at Tallebudgera. Halfway through the five-day live-in coaching course, national training director Eric Worthington directed her to leave. 'He

arrived at the training and he pulled me aside. He said, "I just want to tell you you can no longer participate". When I asked him why, he said, "It's a FIFA rule. Women cannot participate with men on the field. Women are not allowed to be coaches. You have to go".'

The ruling wasn't entirely accurate. Technically it only applied to players and only to competitive fixtures. In 1984, the Australian Women's Soccer Association (AWSA) president Elaine Watson received clarification from FIFA on the matter – she sought an explanation because she wanted the playing experience of older players to be of use to young and new players. She informed Ketter at the National Championships in Newcastle that whether women could participate in coaching courses with men was, it turns out, a matter for the AWSA and the ASF to resolve. FIFA could not, and would not, intervene.

Ketter thinks Connie Selby (née Byrnes), whose husband Jim Selby coached the first Australian national women's team, might have qualified for her Level 2 certificate before she did, meaning Selby is likely to be the first Australian woman to obtain a football coaching certificate. Still, Ketter was one of, if not the, first. On the 1976 Level 2 course, she was the only woman in a group of 48 trainees. On the Level 3 course in 1977, she was the only woman in a group of 18. Most of the male trainees on both courses were confused by her presence. They didn't understand why a woman would want to be a coach or why women would want to play football at all. The exercises required partnering up with someone. Fortunately, Ketter says, 'a group of younger fellas from the

Glasshouse Mountains accepted me. We'd go to the pub at night after the sessions.'

On the day, the purported FIFA rule was what Worthington told Ketter to ensure she didn't complete the course. The former England women's team coach (he managed a single defeat to Scotland in 1972) travelled from Melbourne to the Gold Coast to enforce his view. As Ketter noted, 'He'd had plenty of time to think about what he was going to say. After that I wrote to the newspapers, the association, and the coaches federation. Everybody. I'm still mad at myself for not writing to FIFA. You have to understand, he *was* FIFA as far as I was concerned.' Ketter regrets taking Worthington at his word. The national coaching scheme was sponsored by tobacco company Rothmans, so from the ASF's perspective it was subsidised. But even though she'd paid full fees for the course, she did not receive a refund.

While some people were being kept out, the Australian media's tendency to present football as a non-Anglo, ethnic game meant Indigenous players were more likely to be included. First Nations players and coaches were still subjected to overt racism at worst and unconscious bias in even the best circumstances, but were generally welcomed to, and embraced by, a game also being marginalised by the mainstream. Between 1976 and 1978, Goreng Goreng woman Leonie Young (née Yow-Yeh) played alongside the likes of Doris Haddock and other celebrated national team-level players at the West Mitchelton club in Brisbane. She then played with Kaye Sullivan and others at the Grange Thistle Football Club, also in Brisbane. She was 13 or 14

when she played her first match. Even now, she still has a run sometimes.

Young credits Bert Fry, her coach during the 1970s at West Mitchelton, for her ball control, movement, and reading of the game. The speed was all her own. The first Aboriginal woman to play for Queensland, from 1980 to 1983, she's one of two candidates for Australia's first Indigenous female player. In Worimi historian John Maynard's book *The Aboriginal Soccer Tribe*, his interview with Karen Menzies establishes that she played in 1976 in New South Wales, around the same time Young took up football. Both women started playing football in their early teens. Both would quickly go on to represent their state. Both would be subjected to race- and gender-related discrimination. Menzies would go on to play for, but then actively quit, the Matildas because a male coach challenged her openness about her sexuality, asking her repeatedly if she thought it was an issue. The questioning unsettled her enough that she withdrew from the 2000 Olympic Games selection process.

Young played an instrumental role in forming Australia's first all-Indigenous women's football team. Young's mum, Iris Yow-Yeh, watched her daughters play for over a decade before she determined they should play their own brand of football for their own team. Iris suggested that Young, her sisters, and her cousins form a team. The team, Tiwiwarrin, quickly gathered First Nations players from teams across Brisbane. Iris managed the club, the strips, and the administration. Young's father, 'Pop' or 'Mr Yowie' to the players, drove the team bus, which doubled as the supporters' transport. The

family and friends played as Tiwiwarrin for the best part of the next two decades. They still put a team together for the odd Masters (over-30s) tournament today.

Geraldine Harris, who is in her early 70s, and Lynette Boorman (née Kopp), who is fast approaching them, are funny, fierce, and robustly fit. Football brought the women together, twice, and both seem happier for it. They played together in Brisbane between 1963 and 1967. In October 2018 they met and chatted at a presentation on Brisbane's women's football history after having drifted apart in the late 60s. Boorman had struggled a little with what both women refer to as Harris' 'lifestyle choices'.

The club they played for in the 60s, Wynnum, had so many players it entered an 'A' team and a 'B' team into the local league. Five other teams made up the competition in their first season. It's likely a number of those teams played in previous seasons. The fact that so many teams existed underlines Harris' assertion that 'it wasn't hard to find players'. They just needed structure, guidance, and a basic skill level. As novices, their game had a kick-and-rush nature like that of schoolyard games, with players swarming the ball and 'barrelling' into one another. 'It was poor and a bit rough', Harris says, 'but it was what we had'. For the players, Wynnum's greatest asset was their coach Bob Joy. 'He was brilliant, and he had the skills', Harris says. 'He wanted a job with the men's team, but they told him to coach the women.' A recent arrival from England, Joy and his wife Sylvia (and their baby) were big fans of the game and keen to get involved in a local club. Joy, a willing and knowledgeable coach, is still revered

by the players for his patience, his ability to teach basic skills and ball control, and for his generosity in helping players understand the game. During matches, 'while Sylvia played, he would stand at the side of the pitch holding their baby and shout instructions'. Boorman and Harris say that Wynnum were the teams to beat in those days, that the competition between the A and the B teams honed quality. Boorman thinks the A team (her team) won the league in their first season. Harris sardonically suggests she 'may be remembering it wrong'. They laugh. It matters little to either woman. 'More than anything else, it was about being with your mates and having fun', Harris says. With a tinge of regret, Boorman says she only played three or four seasons. Harris, whom Boorman introduced to football, would dedicate 40 years of her life to the game.

Players, coaches, and presidents continue to face hurdles; each obstacle seems to have merely increased their determination to participate in the sport they loved. The efforts to keep Ketter away only made her more determined to find alternative avenues for women to qualify to coach football. Although she was denied the opportunity to gain her Level 3 coaching certificate, in the months after the 1977 decision Ketter coached a boys' team all the way to the 1978 State Championships while also managing her duties as assistant coach to the women's state team. Young and her family found their greatest strength in their community, and they 'had more fun' playing football together. Harris and Boorman's recent reconnection belies the time that's passed but it does speak to a change in attitudes toward sexuality since their football

days together. The stories are very much of their time, but the themes, which remain at the forefront of women's football, are clear and echo across decades.

In August 1974, under a tin roof peppered with winter rain, a group of people, most of them women, gathered in a Sydney shed. Amid plumes of breath and steam rising from wet coats and hair, with people rubbing their gloved hands together trying to stay warm, the most important organisation in the development of Australian women's football came into being. Teams from Victoria, New South Wales, Macquarie and Districts (later to become Northern New South Wales), Queensland, and Western Australia had played out Australia's first women's football National Championships at Granville (Australia's oldest club), Bankstown, and Centennial Park. That night, the inaugural meeting of the AWSA distributed awards and determined the immediate future of women's football. The championship winners, the player of the tournament, top scorer, and others received deserved accolades. The less than salubrious surroundings reflected the status of a sporting code that would spend much of the next four decades getting by on minimal budgets with little support. Those humble beginnings would provide the foundation for the present-day Matildas to play in technicoloured stadiums, broadcast to an eagerly watching world on giant flat-screen TVs. At that meeting, though, the participants were thinking less of the auspiciousness of the moment and more

about maintaining circulation, as well as enjoying the relief of finding like-minded company and pleasure in making collective progress. As they celebrated the success of their first national competition, they tacitly acknowledged both the future to come and the history on which they built. The sense of community pervasive in the individual associations had coalesced into a national forum, a heady reward for months of networking and organisation.

Awarded the Order of Australia Medal in 1993 for her services to women's football, Elaine Watson's inimitable drive, ability to take others along with her, and her own football story are woven into the fabric of the game at local, state, national, and international levels. Harris, who at one time saw Watson as her nemesis, is certainly not alone in noting that 'Elaine was such a great support, she really helped me and the game. She was so committed.' Fred Robins, who coached Queensland and the Matildas, affirms how Watson was viewed. 'Not many men in football liked Elaine Watson. She was a clever woman and worst of all for the men, she was right on the nail with every cent that was spent.' Watson is Australia's first female referee, its first female coach, and first female AWSA president, and is correctly credited for tearing down barriers around the women's game. 'We were the last to get fixtures, never had linesmen, hardly any equipment', Harris says. 'It was the men, the boys, and then the women in those days, but when Elaine and the national association [AWSA] and the Queensland federation [SQWSF] took over, we started to get referees and linesmen and fixtures.' Watson was responsible for driving these organisations and

the changes they wrought on the sport's landscape. Her unflagging contribution to the development of the national women's game lasted for more than 20 years.

Watson campaigned for whatever funding they could pick up from sources like the Australian Sports Commission (ASC), such as a A$25 000 grant awarded in 1985, and established Australia's earliest links to, and collaboration with, the Asian Football Confederation (AFC). In 1978 she managed the team, made up of players from New South Wales and Western Australia and coached by Jim Selby, that played in the first Women's World Invitational Tournament in Taipei, Taiwan – to promote and develop their women's football. The Chinese Taipei Football Association established the tri-annual tournament and invited a small number of prominent club and national teams, including Germany, Finland, France, New Zealand, and the United States. It's worth noting the players, despite the funding support, still had to pay A$100 each to make the trip possible. As the Oceania Women's Soccer Federation president from 1984, Watson drove the AWSA's move to Canberra in 1986 to facilitate closer relationships with funding organisations such as the ASC and the Australian Institute of Sport (AIS). Her significant influence was critical to Australia's participation in, and the organisation of, a FIFA-endorsed trial run for a 'World Cup' tournament in 1988 in China. She did not do it all on her own, of course, and was not always liked for her assertive and at times unwavering and determined approach; however, she is and will remain the most fiercely respected administrator and advocate. Alongside football administrator and

FFA executive member Heather Reid, former Matilda and the first Australian woman on a FIFA executive committee, Moya Dodd, former AWSA vice president Maria Berry, inaugural FFA Hall of Famer Betty Hoar, and a handful of others, very few have given more to, or so substantively progressed, Australian women's football.

Watson's first contact with the game involved taking her sons to play football in 1963, while her husband Arthur joined the executive of the Brisbane Junior Soccer Association (BJSA). Before too long, Elaine found herself immersed in the women's game, but not before making her own mark on the Brisbane men's football scene. With a notoriously quarrelsome men's fixture approaching, Arthur volunteered Elaine to take charge. At the time, Elaine was Australia's only qualified female referee – thanks to the forward thinking of the Mackay and Brisbane Referees Associations, which made the exception for a woman to participate in their training courses. Her presence would, Arthur noted confidently, instigate a calmer, more civil level of behaviour on the field. In the end it made no difference to the match outcome. The male players earned the anticipated number of cards (several yellows and one red) they probably would have with a male referee. Elaine, though, had proven herself more than capable of managing even the most volatile football match.

The Brisbane women's football competition and its organisation, likely to have formed prior to 1961 (making it the earliest in the re-emergence of women's football in Australia), fell under BJSA's patronage. Widely credited with enabling female players to organise their own competition, BJSA

secretary Frank Clarke helped set up the seven teams competing in a home-and-away fixture run on Sunday afternoons. Between them Boorman and Harris recollect that the following teams played: Wynnum As and Bs (in white and blue vertical stripes); Mitchelton (in light blue); Aston Villa (in red, now known as Eastern Suburbs FC at Heath Park, Brisbane); Merton Rovers (black and white stripes); North Star (white shirts, blue shorts); and Annerley (dark blue). They would soon be joined by Budapest Grovely (red and white shirts, known as Westside today) and another Brisbane side, Riverside United; a team called Toowoomba from Toowoomba; and Coal Stars from Ipswich.

The Brisbane competition was only the first, and women's football was going strong in other states across Australia. Historical records, local newspapers, and books by Bill Murray, Roy Hay, and Watson provide disparate evidence of matches being played in South Australia in the late 1950s and 1960s and a small and short-lived competition in the early 1970s. The state's first competitive league really began with footballer, coach, and born leader Ann Gibbons, who established the first serious senior women's team at Salisbury United Football Club in Burton. With the support of her father, Bob Bush – the club's main stand is now dedicated to him – the expat family expanded their involvement in women's football to form the South Australia Women's Soccer Association (SWSA), which quickly affiliated with the AWSA, in 1978. Through interstate collegiality, including hosting the National Championships, South Australian state participation grew to support 19 teams. In their book *A History of*

Football in Australia, Murray and Hay note a 1959 charity match in Tasmania as the state's first, but it would be the 1980s before a league was established there.

The Wynnum matches Harris and Boorman played were often attended by as many as 200 people. The club loved the crowds. Whether people came for the novelty of seeing women play or because they genuinely supported women's football, the crowd always finished in the club bar. As a result, the Wynnum club supported its women's teams, but it only went as far as providing the same equipment it offered the junior teams: a ball and access to a rough bit of turf in Memorial Park for training two nights a week and match days. There were no floodlights, which made training difficult. Players had to purchase their own playing strips, shorts, and socks. On game day, the kit needed to be matching, clean, neat, and tucked in. A loose shirt warranted a caution from a referee; mismatched kit was considered reprehensible.

Detractors focused on criticising their appearance too. Quick to point to any flaws in women playing, the newspapers demeaned their early efforts by describing the football as 'kick and giggle'; made sexist and belittling remarks about the players, the poor quality of their play, and their hair, make-up, and uniforms just as the newspapers of the 1920s had. It's a situation that continues today. When the media labelled the openly gay Michelle Heyman, she owned it, negating the power of the insinuation. Sam Kerr bravely called out homophobic trolls on Twitter immediately after a 2019 Women's World Cup match against Brazil in June. In between, the misogyny aimed at Heather Reid after she took

up her post on the FFA board peaked in the wake of the Alen Stajcic sacking. All highlight the additional pressure female players, coaches, and administrators face.

Unreasonable comparisons with men's football, where gender is never the basis for criticism, made (and make) it even easier to dismiss the women's game. Commentators and newspaper reporters neglected the players' growing knowledge and skill, their courage and camaraderie, their willingness to learn and play better, and their indomitable enthusiasm. Men who loved the game found it difficult to understand that women could feel the same way about it. It was a rare man who would reciprocate female players' respect for the game. The players' reverence for Bob Joy's coaching is testament to his understanding approach. The women knew they needed training; Joy simply taught them what they needed to learn.

In the conservative late 1960s of Australia, women's competitions burgeoned in Victoria, New South Wales, and Queensland, even though the English FA's ban on women playing would not officially be lifted until 1971. Women who wanted to play football were viewed as aberrant or transgressive. Harris would not tell her parents she played football, although Boorman's brother knew because he played for the first team at the Wynnum club. 'He thought it was great having a women's team. He loved it. He used to come and watch', Boorman says, laughing. Only a small number of male referees and administrators would be so positive.

Harris was 13 when she started with the Manly 'B' team in 1963. She played for several local Brisbane clubs before

being banned in 1973. A verbal disagreement with a referee saw her red-carded. She wasn't involved in the initial incident that led to the referee stopping the game, but she 'questioned him and he wouldn't give me an answer as to why he'd made the decision and he turned to walk away and I said "excuse me" and put my hand on his arm, and because I touched him that was it. Elaine Watson banned me for 10 years.' The offence, which took place at the height of her footballing career, was overturned when she received a pardon in 1977 as part of the Queen's Jubilee celebrations. Before her playing credentials were restored, Harris began coaching junior teams and became increasingly engaged in running the women's game. She would go on to provide the first significant challenge to Watson's authority in Queensland, be president of the South Queensland Women's Soccer Association (SQWSA), and oversee the development of Atlanta Field at Geebung, Brisbane, the first purpose-built headquarters for women's football in Queensland.

The story of persistence despite widespread discouragement is echoed across the country; in 1960 the Victorian Amateur Soccer Football Association banned girls from playing alongside boys, making it difficult for the next generation of female players to even get started. However, Murray and Hay highlight a match between the women's teams Slavia and Cobram at Olympic Park in Melbourne in 1963, and record that numerous other teams were forming within clubs and on their own. In Sydney in the same year, St George Budapest player and junior team coach Pat O'Connor was instrumental in administrating and developing the New South Wales

Metropolitan Ladies Soccer Association (MSLA). Through her efforts, and seemingly endless energy, the MSLA competition would consist of 12 regular teams by 1973. O'Connor captained an undefeated St George Budapest Ladies team for seven years, represented New South Wales at the first National Championships, and managed the national team on its first internationals tour to the 1978 Taiwan tournament.

Also in New South Wales, around the same time O'Connor was working her magic, player–administrator Leonie Parker formed the Killarney Heights team for her daughter and friends, which soon led to Parker developing the Manly Warringah Women's Soccer Association. As women's football researcher Jean Williams notes, their main opponents came from the neighbouring Ku-ring-gai District Association on Sydney's North Shore. These three (including the MSLA), and possibly a small number of other associations, combined to form the New South Wales Women's Federation. Parker would be vice president to O'Connor as president. As well as a playing career and top-level administrative roles, Parker became one of Australia's earliest qualified referees, coached local sides, and was assistant coach to the New South Wales U15s.

Dutch-born Trixie Tagg (née Barry) also deserves an honourable mention for her significance as a player–administrator and for being the first female Matildas coach. Her brief spell in 1981 lasted for four matches and included a tour to New Zealand. In the late 1960s and 1970s, she played for three teams (St George Budapest, Sydney Prague, and Marconi). Between 1970 and 1974, she represented New South Wales and Australia. Appointed head coach of the New South Wales

juniors and youth teams that toured the USA, she would also coach Australia through a very successful 1981 New Zealand tour. Australia won all four matches in the series. In 1985, she coached New South Wales to the National Championships. She also held administrative positions in the AWSA and refereed men's and youths' premier league and New South Wales state women's finals.

In 1973, the Brisbane Junior Soccer Association became too geographically large to run efficiently as a single organisation and split into northern and southern districts. With too few female teams to sustain a women's league in each district, it seemed inevitable that the women's game would collapse. Elaine and Arthur Watson and a handful of others – including Keith Barclay, who coached the Coal Stars, and Bob Geoghegan, who drove the women's game at Annerley – met in the Watsons' living room and resolved to create an entity that could support women's football and the existing teams. Elaine would take the lead, Arthur would assist, and those others at the meeting would form the first executive committee of the SQWSA. With just six weeks to prepare, select players, and organise playing kit, Elaine took a team to the inaugural 1974 National Championships in Sydney. The selected Queensland players were billeted with Sydney football families and were urged to 'take a small thank-you gift of chocolates or toiletries' for their hosts. The players each paid for a formal, light blue slack-suit and red blouse and a $25 subscription toward their airfare. Players had to return the kit at the end of the tournament, although they got to keep the embroidered pocket.

Along with Dr Oscar Mate from the Western Australia

Women's Soccer Association (WAWSA), O'Connor had been instrumental in sounding out and recruiting state associations for that first National Championships. A national organisation could not have been far from her mind. O'Connor's role at the MSLA would lead to her becoming the secretary of the AWSA at that damp, chilly 1974 meeting. Mate was elected as the first president. Frank Clarke offered the BJSA's support in hosting the 1975 National Championships. He was invited to take the vice presidency, which he declined, nominating Elaine Watson in his stead. Once Watson's appointment was confirmed and the officers elected, the meeting determined that an all-star team would be named at the 1975 tournament. They would make a representation to, and seek affiliation with, the Asian Ladies Football Confederation, where O'Connor would be appointed to a vice-presidency role; and New South Wales, the largest and strongest state association, was permitted to enter a team in the first AFC Women's Championship in Hong Kong in 1975. This would be the first international foray for representative Australian players, predominantly one team, St George Budapest, reinforced with players from the championship-winning New South Wales team. The team would feature a 14-year-old Julie Dolan, whose name would eventually grace the medal awarded to Australia's best female footballers. 'Being selected in the national team at 14 at my first national titles was something that didn't really sink in for a long time', Dolan says. The former player puts it down to being at a strong club. 'St George Budapest club had a major influence on my

career, with the team being made up of many experienced football players from abroad who had played in their countries prior to moving to and settling in Australia', Dolan says. 'So, as a 14-year-old I learnt from some great players. The team played in a "local" competition, which essentially meant it was Sydney-wide. We travelled long distances to play. For example, to Ingleburn, Campbelltown, Northern Beaches, Ku-ring-gai etc.' The team's match against eventual tournament winners New Zealand reportedly attracted 12 000 people. The other teams in the tournament included Hong Kong (as hosts), Malaysia, Singapore, and Thailand. The New South Wales team finished a reputable third place.

Dolan, directing traffic from the midfield, would captain Australia while still a teenager in the first Trans-Tasman series in 1979. 'It was a game I loved and played to the best of my ability and the representative honours were what came about through this great love of playing. The national-team captaincy at 18 was an extraordinary honour and one that still humbles me.' In 1988, following her run out at the 'pilot' Women's World Cup, the AWSA created the Julie Dolan Medal, to be awarded annually to the best player. 'The Julie Dolan Medal is awarded to the best player in the W-League (or Australia's #1 league) each year', Dolan explains. 'It came about as other similar awards do, from performances that are considered outstanding, setting a standard and worthy of recognition ... Again, these awards are extremely humbling.'

In 2016 the FFA would honour Dolan further by adding her name to their prestigious annual celebration of achieve-

ments. The Dolan Warren Medal Awards would highlight the best female and male players at the same event. After she retired from her international playing career, during which she played 34 matches for the Matildas, including 18 capped internationals, Dolan would get involved in coaching and teaching.

In 1979, Western Australia would enter a team in the same tournament, this time hosted in India. That team also placed third. Within two years of their inauguration, Mate presided over a league featuring 14 teams, more than double the number in 1972. Two years before the 1979 international tour and a small number of years before a men's team of any kind represented the state at the national level, the Western Australian Women's Soccer Association hosted the National Championships. The AWSA executive members and the executive members of their affiliated state member organisations would be responsible for managing their daily organisation on a voluntary basis. Watson estimates 252 teams and some 19 000 registered female players participated in competitions across the country in 1976. It would be 1985 before funding became available for administrative assistance at a national level.

On the subject of honourable mentions, we must give a nod to The Flying Bats. From the humblest of beginnings, the Sydney club, which started in 1985, is thought to be one of, if not the largest gay women's football club in the world. One of the club's pioneers, Alison Todd, has said, 'the Bats are extremely inclusive and a lot more than just a football team; rather it's a vibrant and supportive community'. The

club, the brainchild of Linda Paterson, with help from her partner and friends Tracey Atkinson and Todd, estimate that more than a thousand women have either been Flying Bats players, coaches, or supporters.

In Victoria, Betty Hoar played, coached, administrated, and supported the game from the mid-1970s. Her duties and voluntary efforts included a seven-year stint as AWSA secretary and managing several international tours. Janet Melvin, Anne McPhee, and Theresa Dees (née Jones) were also instrumental. Melvin played and coached junior and senior football at local and state levels. She would be named in two all-star teams following the 1975 and 1976 National Championships. Dees is what Williams describes as 'a model of continuing participation'. Like many women in football, she began playing in her early teens, then throughout and after her playing career, she contributed to growing and developing the game by investing her knowledge for the benefit of others. After honing her goalkeeping craft at junior football level, she kept goal for her state team Victoria for 18 years. During this time, Dees also provided the last line of defence for the national team for a decade, earning 18 international caps. Following her playing career, she managed tours for the national team and worked as a development officer in state-level football. Awarded the 2000 Australian Sports Medal, she was inducted into the Hall of Fame in 2003 at the same time as Betty Hoar.

From the heat of Darwin to the cold of Melbourne, from the dark of Hobart to the roaring gales of Canberra, from the red, rock-hard ground of Alice Springs to waterlogged pitches in southern Australia, the National Championships took place annually until 1997. The fields were rough and unforgiving, and often small and serviced only by low-quality facilities. In 1975, the final was cut short by severe storms and con- troversially awarded to Western Australia – the committee penalised the Queensland hosts for not planning the kick-off time more prudently. In 1977, Sue Raeburn wore a padded bike helmet back to front to protect the cheek she'd fractured during a training match the week before. The tournament in Darwin in 1979 featured a corroboree and is highlighted as the first tournament in which the Northern Territory players did not complain about the cold. In 1980, Medibank pro- vided a 'Rose Bowl' trophy that would become the annual tournament prize.

By 1984, there were national champions at senior level (registered players stood at around 7500), U17s, and U15s, and nine associations were competing. The Tasmanian cap- tain for seven years, Carolyn Jones, jokes that her goalkeeping position meant she was in danger of getting leather poison- ing when it came to the National Championships. She was the state team's busiest player, and often found herself one- on-one with strikers. 'As a goalkeeper, I was always going to be noticed … we did not have an extensive player base to choose from.' Her excellent 1986 season with the Davenport Women's team at age 16 resulted in her becoming 'the first female ever selected in a men's team at 17'. Jones also recalls

the 1989 National Championships that took place just two years later. The tournament was scheduled to take place in her home state but was moved to Canberra as a result of the pilots' dispute. 'The Tasmanian team', she says, 'had to catch the Abel Tasman Bass Strait ferry, the predecessor of the *Spirit of Tasmania*, to Melbourne, then a VICRail train to Albury, then a bus to Canberra to make the start of the Nationals. We had to do it all in reverse to get home.'

Across all the National Championships, New South Wales won 12 of the senior competitions and almost all the junior and youth competitions. It was also, not uncoincidentally, the largest and therefore best-resourced state association. Ketter remembers with some fondness the resentment she felt when she first saw her opposition. 'The New South players had all the best gear', she says, before pausing then adding, 'And. They got to keep it.' The contrast in resources daunted Ketter and the rest of the Queensland representatives, and arguably worked to the advantage of the New South Wales team. But the association only looked resource-rich from the outside. Money was scarce for everyone, and they all constantly engaged in fundraising. Lamington drives, dances, raffles, and race nights generated funds, and organisations saved money by asking players to re-use and return their kit. Bra manufacturer Hestia donated a one-off set of sports bras to the Queensland squad in the early 1980s, but apart from that, sponsorship would be limited until the late 1990s. 'Most tours/trips away for nationals required fundraising, with each player left to their own creativity in terms of raising dollars', Dolan says. 'There were countless lamington drives

over the years and going door to door to local businesses in an effort to raise funds. While we did get to keep some of our jerseys, most were required to be returned after international tournaments.'

Despite these struggles, women's football was relatively flourishing by the 1980s. The National Championships grew to incorporate nine districts, states, and territories. The national side, regarded as crucial, as well as regular tours and international fixtures, provided an incentive for players and administrators to improve their skills. The number of female coaches increased. Membership numbers increased exponentially across the country, and interest in the game grew accordingly.

Sports journalist Don Bailman, who was elected AWSA vice president, began regularly covering women's football for *Australian Soccer Weekly*. John Economos, writing for the same publication, was one of the first and few male sports writers to shine any light on the plight of female footballers. His work highlighted the sacrifices the players had to make. Even at the national level female footballers bore the burden of much of the travel and accommodation costs and the loss of wages for time taken off work to play matches and attend training camps. He highlighted the use of second-hand gear during the same camps and the overarching hand-me-down nature of the women's game, where funding and respect were in short supply. The contrast in circumstances for male players and coaches made the

players' sense that they were being given short shrift all too real. Some teams didn't make it. This was not unusual in itself. Whole teams were known to shift from one club to another depending on how they were treated, or even simply based on the facilities available; however, the Victorian women's league system, which split in 1974 into two divisions, completely collapsed in 1984. The circumstances are not well known, but we do know football was being played. While it would take until 1992 for a new league structure to emerge, a Victorian team participated in the annual National Championships throughout the period – they won the tournament in 1987, 1989, and 1992.

Women's football did begin to make some headway on the issue of coaching qualifications in the early 1980s. On the condition that enough interested participants could be found, the ASF allowed Selby, the Australian women's national team coach at the time, to conduct training courses designed for aspiring female coaches. Alongside Lyn Smith, who turned up to her training after having given birth only two days before, Ketter and former Matilda stars Michelle Sawyer (also one of Ipswich's most successful players), and Joanne Millman were among those who would be earliest to qualify and go on to coach local boys' teams. Aunties to current Australian tennis player John, Joanne and her sister Kerry Millman were not only both Matildas, they often toured together, playing on the same side. Joanne played for Easts in Brisbane her entire footballing career. She represented her state and the Matildas and was still playing club matches (with a career total exceeding 800) when she started coaching.

In 1986, the Australian Capital Territory became a bustling centre of women's football. The AWSA moved there to build on its connections with the AIS, which in turn became a strong supporter of the national game and the national team. The close proximity of the organisations was conducive to more professional administration and organisational practice, which facilitated the AWSA's success in gaining funding. ASC funding made it possible for the AWSA to employ Keith Gilmour as its first national executive director. Within the six months of his short tenure, he repaid the favour by establishing a stream of funding that enabled employment of a full-time administrative assistant. Heather Reid, the first funded AWSA administrative assistant, eventually succeeded Gilmour as director. She was well qualified to do so. Canberra's women's competition arose in 1978, with no small thanks to Reid's co-ordination. Volunteering her weekends and evenings, she scheduled fixtures, booked pitches, and organised referees. Reid's influence on the women's game cannot be underestimated. In her roles at the AWSA, she facilitated sponsorship and travel concessions with Australian Airlines, drafted the first National Development Plan, and attained government grants in the region of A$70 000, which relieved players of at least some of the cost burden of playing for their national team. She developed a coaching qualification manual certified by the ASF and the state education authorities, and would later become the CEO of Capital Football – the only female CEO of any football code in Australia. Under her guidance, Canberra United became the first profitable franchise in the W-League.

The paid staff and those who gave their time freely grew the AWSA into a formidable organisation. In recognition of their work, the ASF kindly provided office space. But, just when everything was looking promising, the plans snagged on a dispute. The cause remains unclear. Member numbers for the New South Wales association were low, as regional member organisations had begun affiliating with the men's organisation. The New South Wales contingent, traditionally the largest, might have been unhappy with decisions the AWSA made regarding the National Championships' structure and other AWSA matters. They withdrew from the national squad two weeks prior to the second Oceania Cup. Replacement players went to great lengths to meet up with the squad before the tournament in New Zealand. Moya Dodd and Marianna Milanovic hired a car to drive from Adelaide, and Sharon Mateljan spent 24 hours in transit flying from Perth to Canberra as a result of a flight re-fueller strike. After a great deal of consternation and argument, future players would be (unfairly) punished when the AWSA board deemed the New South Wales association culpable and declared its players ineligible for selection in 1987. The New South Wales association did not compete in the 1987 National Championships and threatened to withdraw its affiliation altogether.

Voted Matildas Coach of the Decade, 1979–1989, Fred Robins got involved in women's football in 1980. Soon after he was hired as Matildas coach Jim Selby's assistant. Robins recalls the first training sessions: 'We had a camp at the AIS prior to going to New Zealand. We met in Sydney on the Saturday. And on the Sunday, we go for training in the local

park. I said to Jim [Selby], "Where's the posts?" He said, "We'll use our jackets". There were people flying kites, walking their dogs between the girls doing the exercises. The park was full of people who had no idea what we were doing.'

Robins' recruitment to women's football illustrates Elaine Watson's tenacity. Responding to an advert in an English newspaper in 1963, Robins arrived in Brisbane to coach a men's team. The gentle and talkative coach will tell you himself he wasn't the best player, but he can read the game. His innate ability to understand and articulate the game in terms footballers understood strengthened the men's teams he coached. These same traits made him an excellent women's football coach. Not straight away, however, but his success in men's football marked him in Watson's book. At football functions, she bailed him up about coaching 'her' state team. As much as he could, and not knowing anything about women's football, Robins dodged the issue. But Watson set her trap. She called and asked 'one last time'. Robins was in line for the head coaching job at 'the Azzurri', Brisbane City, one of the city's biggest teams, at the time. Confident he'd get it, he dismissed her. 'To get her off my back, I said, "Okay Elaine, I'll do it". I told her, "If I don't get the City job, I'll take yours". More fool me', he says, and chuckles. He recalls that it was as if Watson knew he wouldn't get the job before he did. No sooner had Robins received the rejection than Watson was on the phone. 'I couldn't go back on my word, could I?'

Robins initially came to women's football with all the classic male football-coaching stereotypes, and openly acknowledges many mistakes he made. The most significant

was treating the footballers like the male players he'd been coaching. 'Coaching women is different', he says and then asks, 'Can men have a baby?' Without waiting for an answer he says, 'No. They can't. Women are better, but they don't have the same power or physical strength as men do. So training regimes need to be different. The way the game is played is different. The way you talk to the players is different, especially if you wanted to get the best out of them on the pitch.' The SQWSA sent Robins to Canberra to undertake a coaching diploma at the AIS. What Robins learnt there transformed his approach. As the current Junior Matildas coach Rae Dower notes, 'Fred was one of the first coaches to bring science to the training. He was ahead of the curve.' Realising the impact that menstruation can have on elite athletes' ability to train, their susceptibility to injury, the speed of their recovery, the effect it can have on their strength and fitness, and their contribution in a match, Robins began drafting charts of his players' cycles. Rather than being intrusive, this enabled better planning for training and for team selection. Dower, who played for Robins in the state team, says, 'Today, the first thing a physio or a doctor will ask a player is where they are in their cycle'. This approach – one that world champions the USWNT uses – and his insight at National Championships, led to the national-team head coaching role.

Robins' second stint with the national team, in which he really came into his own, began in 1985. He led the squad through the preliminary group stage at the 1987 Taiwan International Invitational with two wins but only managed a single point in the next round – a draw with Canada. Australia

lost to Chinese Taipei, West Germany, New Zealand, and the US. But otherwise, they came out of difficult games, playing against some of the best teams in the world, with their heads held high. Robins coached in Queensland between 1980 and 1991. In that period, he led his teams to win three National Championships, travelled throughout Queensland training female footballers, and was instrumental in the efforts to form Women's Soccer Queensland, the state's first statewide organisation. He received an Australian Sports Medal in 2000 for his contribution to the game.

In 1989, Elaine Watson stepped away from the AWSA after 14 years of service (including 11 as president). In the same year, Australia hosted its first international tournament, the third Oceania Cup, in Brisbane. New Zealand, Papua New Guinea, Chinese Taipei, and two Australian teams – Australia 'Green' and Australia 'Gold' – competed. Hong Kong, Polynesia, and India all entered, but withdrew before the tournament started. The Australian teams did not fare well – they drew with each other, lost to New Zealand and Chinese Taipei, and defeated only Papua New Guinea. Chinese Taipei would snatch the tournament from New Zealand during a sub-tropical Brisbane storm. It was a dramatic moment as, amid the rain and noise, Reid received an award for organising the tournament.

The National Championships, the catalyst for the management and organisation of Australian women's football, the platform for our best and burgeoning football, and a vibrant national community fed by and feeding into international, national, state, and local football, is fondly remembered for

its role in nurturing talented players, coaches, and administrators until 1997, when state-level institutes and academies for sport were introduced.

The 1990s would begin with a changing AWSA board and, through Steve Darby, a coaching course for the national playing squad. The National Championships format was overhauled and plans for a national club competition were drafted. A training video of football basics – an in-house production featuring stars of the game – was widely distributed and well received. The funding capacity had grown too, with AWSA officials no longer paying all of their own expenses. Denis O'Brien became president and delegate to the newly formed Women's Committee when the men's football governing organisation, the ASF, was reorganised. The relationship between the ASF and the AWSA was positive. When FIFA confirmed the first formal Women's World Cup, staged in Guangdong, China, in 1991, it replaced the engine driving the Australian women's game. Reid's presence at the 1991 Women's World Cup and contribution to the subsequent FIFA symposium in Switzerland in 1992 was instrumental in alerting those involved in the code to the game's potential and the scope and scale of football's global network. The information-gathering exercise also informed the dynamic campaigns around gender equity and building participation.

Australian Indigenous female footballers continued to make a significant mark on the world game in the 1990s. These

players include Felicity Huntington, a Torres Strait Islander woman who played between 1985 and 2000. Huntington excelled at outdoor 11-a-side football, but arguably achieved her greater heights representing Australia at international level in futsal in the early 1990s. Bridgette Starr from Tamworth played her early football in Newcastle, including playing for boys' teams. She made her Matildas debut at 16 and gained 55 caps between 1994 and 2002 – number 50 was against Brazil at the 2000 Olympics. Kayleen Janssen achieved simultaneous indoor and outdoor football careers at international level, including playing at the 1995 Women's World Cup.

In September 1993, the International Olympic Committee (IOC) announced that women's football would feature as a full medal event in the 1996 Olympic Games. Four days later, the city of Sydney won the host nation role for the 2000 Olympic Games. The Matildas wouldn't qualify for the 1996 Olympics, but they would qualify automatically for the 2000 Olympic Games as members of the host nation. O'Brien points out, 'the Australian Sports Commission wanted a team competing in the Sydney Games. And they wanted them to do well. [In 1999] they announced provision of significant funding (around A$1 million a year) to ensure the team were well prepared. This gave us the opportunity to provide better coaching. Tom Sermanni was a great coach of women players, with a great understanding of the game and exceptional empathy with the girls. He was very important.' This preparation would not have been possible without the funding. The AWSA toiled to attract as much ASC or other government funding as possible, although the players themselves still

bore the brunt of the costs, including travel, kit, and medical insurance. Following the funding announcement, Soccer Australia unsuccessfully sought to bring the women's game into its fold.

The network of sports institutes and academies, under the guidance of the AIS, led to the establishment of elite football programs, which naturally led to the national competition. After 23 years, the week-long annual tournament that pitched state and territory association teams against each other and that served as the selection process for proto-Matildas squads from 1979 to 1995 grudgingly made way for the 'glamour' of the 1996–1997 Women's National Soccer League (WNSL) Ansett Australia Summer Series.

Most WNSL seasons consisted of six teams aligned to a state sports institution or academy, which were themselves affiliated to the AIS. Some believe that implementing a competition built around concentrated pools of talent effectively suffocated grassroots football. The National Championships, grassroots football organiser Faye Dower says, 'were really important and really valuable because they connected with regional teams in ways the institutes couldn't. They helped us see players the institutes wouldn't: late developers and emerging players.' Before the WNSL existed, State Championships determined the squad that would compete in the National Championships, the national-team selection platform. The WNSL arguably removed the best talent from state competitions and denied high-quality rural and regional talent access to sustained opportunities to audition for the national squad. In this system, players outside the preferred age range

as well as late bloomers such as current Matildas assistant coach Mel Andreatta, who only started playing at 18, might have been missed. The new system also challenged the scope and size of the areas that had to be covered, whereas the State Championships run by the state associations benefitted from the success of concerted efforts to establish their state-wide networks. But the AIS system, in partnership with the AWSA, provided invaluable national oversight and infra-structure, reasonably well-resourced facilities, and consist-ent and frequent levels of training and contact with leading coaches, which led to improvements in players' skills and the quality of women's football in Australia overall.

In hallmarks of what would eventually become the W-League approach, WNSL fixtures in the first three seasons began in early December and ran through the southern hemi-sphere's summer months. They finished with a championship play-off, or grand final. In March 1997, Northern Confer-ence winners Queensland Academy of Sport (QAS) defeated Southern Conference winners the South Australia Sports Institute (SASI) to claim the inaugural WNSL championship. Kristy Moore (South Australia), Sharon Black (South Aus-tralia), Lisa Dunne (Queensland), Kim Revell (Queensland), Julie Murray (New South Wales), and Traci Bartlett (New South Wales) were, in that order, the competition's leading scorers. Each player would be familiar to Matildas fans.

Katrina Boyd (New South Wales) would be top scorer in the 1997–1998 competition, with Sharon Black in second place again. The conferences, two divisions of three teams each, were renamed as pools. They featured the same six

teams, which were redistributed in spite of geographical relationships. This meant significantly more travel for away games – South Australia, Victoria, and Queensland were in Pool 1. Cynics noted the new set-up would make it easier for the competition's largest footballing region, New South Wales, to gain a finals place. The determination of order from the first season, a straightforward play-off for places, was replaced with a preliminary and grand final set-up similar to the system used in male sports codes. The top two teams from each pool contested a place in the grand final. A Julie Murray hat-trick for the New South Wales Institute of Sport (NSWIS) meant the team became the inaugural champions.

With five teams competing, the third iteration of the competition, 1998–1999, adopted a traditional league structure. Colourful team names were introduced. The Queensland Academy of Sport team dropped the Academy of Sport from their title and replaced it with Sting, NSWIS added Sapphires, Northern New South Wales added Horizon, and the Australian Capital Territory Academy of Sport (ACTAS) team became Canberra Eclipse, which would later become the foundation of W-League club Canberra United. The 1999 grand final drew an attendance of 852 and was won by the newly named South Australia Sports Institute (SASI) Buffalo Pirates. Julie Dolan Medal winner and the competition's leading goalscorer Sharon Black proved decisive with two unanswered goals in the first half.

Season 4 followed the same structure and marked the appearance of future Matildas such as Taryn Rockall, Sally Shipard, Heather Garriock, Kelly Golebiowski, Bridgette

Starr, and Joey Peters. The fifth WNSL competition, 2000–2001, saw the emergence of the side that would dominate the remaining years of competition. From season kick-off to the final whistle, the Queensland Sting won every match. The invincible team featured Traci Bartlett, Kate McShea, Lisa Dunne, Kim Revell, and Lana Harch. The grand final, played in Brisbane immediately after a men's National Soccer League (NSL) match, attracted a record crowd of 2665. In Season 6, 2002–2003, the Sting won eight of 10 matches as well as the grand final, which was played in late December 2002, with Bryony Duus, Pam Grant, and Sarah Walsh making appearances for the champions. Lisa De Vanna and Heather Garriock shared the honours for the Julie Dolan Medal. In Season 7, 2003–2004, the Sting topped the table, having only lost two matches, but archrivals the second-placed New South Wales Sapphires, coached by an up-and-coming Alen Stajcic, won the competition decider and the team's third WNSL trophy.

In Season 8 in 2004, the Queensland Sting won nine of its 11 matches including the grand final. As well as several national-team regulars, new and future Matildas including Alicia Ferguson-Cook (née Ferguson), Clare Polkinghorne, Pam Grant, and Ellen Beaumont all featured for the champions. The season was also notable for the introduction of a team from Western Australia. Affiliated with the state football organisation led by Mate, and not a sports institute or academy, the team was called Western Wave. It brought hype and branding, inspired by the healthy outdoor lifestyle, and a team sponsor. The brick and paving stone manufacturer Midland Brick paid to have its name on the players' jerseys,

a first for the WNSL, which had not seen individual teams attracting commercial sponsorship. And by choosing to support the women's team, the brand challenged stereotypes about its own blokiness. The WNSL worked hard to accommodate the club, but the Western Wave only played a short, six-game season as it could not resource home-and-away fixtures against prohibitively geographically distant clubs that included the Adelaide Sensation (formerly SASI Buffalo Pirates), Canberra Eclipse, New South Wales Sapphires, a renamed Northern New South Wales Pride (formerly Horizon), and Victoria Vision.

Unfortunately, the WNSL only lasted nine years. Its only sponsor, Ansett, did not survive the post-9/11 airline industry collapse, but the competition carried (struggled) on for several years. Pitched as an opportunity for Australia's best to remain at home and play in a top-tier competition, it established the foundation for the development of quality players such as Julie Murray, Di Alagich, Joey Peters, Sarah Walsh, Heather Garriock, Clare Polkinghorne, and Lisa De Vanna to break into the national side. As the first national league competition and precursor to the W-League, it featured meagre sponsorship and even less media attention, but provided the players with some much-needed experience as they headed into a range of international competitions and tours, including the 1999, 2003, and 2007 Women's World Cups. It was essential in developing clearer pathways for players to develop something of a career.

The AWSA would not immediately conform with the national, and scathing, review of men's football governance in

the *Independent Sport Panel Report* (also known as the Crawford Report) in 2003. The report recommended the consolidation of women's and men's football under the umbrella of the single entity, Soccer Australia (Soccer Australia would be relaunched as Football Federation Australia in 2005) and the suspension of the WNSL competition in 2004, along with all other professional football competitions. Instead, the AWSA independently hosted an eight-team National Championship at the AIS in October 2005. The NSWIS would enter two Sapphires teams: White and Blue. Both teams won their groups, but it was the Queensland Sting, coached by Mike Mulvey, that would win the respective play-off and defeat New South Wales Sapphires Blue in the final. (Mulvey would later successfully steer the Brisbane Roar A-League side to premier and championship glory in the 2013/14 season.) That WNSL grand final was refereed by Tammy Ogston, who would later become Australia's first female FIFA referee. Australian women's football had come a long way in half a century.

Recent years have seen Indigenous players in particular make an outstanding contribution to the sport. Kyah Simon, who just missed out on selection for the 2019 Women's World Cup squad due to a hamstring injury, was the first Aboriginal player to score in a World Cup when she scored a brace in the 2011 Women's World Cup in Germany. She also scored that crucial, trophy-winning penalty for the Matildas' 2010 Women's Asian Cup win. Lydia Williams, an AFL convert and the most capped Indigenous Australian international player with more than 80 caps and counting was, when she

started out, offered a choice between a midfield position for a Division Four team or goalkeeper for a Division One team. She took the Division One goalkeeper's jersey, thinking at some stage she'd switch out. She never did.

At just 17 years of age, Shadeene 'Shay' Evans made her debut in the 2018/19 W-League season. The Northern Territorian discovered football when she was nine through the JMF program run by John Kundereri Moriarty, the first Aboriginal footballer to be selected for Australia, who has been paying it forward with his football academy. The inaugural recipient of a school sports scholarship, Evans moved to Sydney to study at Westfield Sports High in 2015 and has since been selected to play for the Young Matildas and Sydney FC W-League teams. New A-League franchise Macarthur FC will work with Campbelltown Council, the Walker Corporation, and Western Sydney University to launch an Indigenous football academy, so we will see even more talent emerging through the club's programs in the near future.

Female footballers have struggled with a lack of visible sporting role models they could emulate, and that's been even more true for Indigenous players. But recent years have seen some improvement as more efforts are made to tackle gender and race discrimination. Williams has branched out to writing a children's book about growing up in Australia's outback and discovering her talents for football. There is still a long way to go, but the next generation of footballers will likely – hopefully – face fewer visibility, role model, and career path issues.

Chapter 3

MAKING THEIR OWN WAY

The adage 'What goes on tour stays on tour' is true for most of the past decades of women's football, simply because, without media coverage or the ready availability of smartphones and social media, most of what happened on those tours is known only to the core group of players and staff who witnessed the history firsthand. For those players, dates may now be hazy and some tours may have merged together, but plenty of significant moments stand out in their memories.

During one tour of North Korea, a then two-time Asian Cup–winning country whose team would prove a formidable opponent, the Matildas stayed in a marble-finished, Soviet-style hotel straight out of the Cold War era. The hotel was about 22 floors high and, with the exception of a North Korean boys' team, the Matildas were its only guests. They were put up on the 17th floor. 'The electricity would go off three or four times a day, at least', coach Tom Sermanni says. 'Usually only for a few minutes, maybe. But players wouldn't want to risk getting stuck in the elevators, so we were often walking up and down 17 floors.'

During the 1998 North Korea tour, Matildas coach at the time Greg Brown asked for the match ground pitch grass to be trimmed because it was too long. 'We turned up in the afternoon to do the little recce, the familiarisation session before the game', former Matilda Alicia Ferguson-Cook says, 'and there were three blokes out on the pitch with scissors trimming it. Another pitch we were training on, basically the way to keep the grass down was there were two goats tied together that would just chew all the grass.'

Ferguson-Cook estimates she's been to China at least 20 times; it's where she spent her 18th birthday. But North Korea remains for her, and most Matildas and staff you talk to, a standout. 'I was quite young at the time, so I basically thought North Korea was north of South Korea', Ferguson-Cook says. She hadn't yet learnt about the vast difference between the two sovereign states, and found that trip and subsequent trips eye-opening.

'So these are friendly matches', Ferguson-Cook prefaces her statement, 'but we were getting pinched, we were getting spat on, we were getting kicked. It was a pretty filthy game. In one of the games – I believe this was before the 2000 Olympics – we were actually 1–0 up. The referee played an extra 15 minutes until North Korea scored a goal, which was offside [but not called].' Former Matildas captain Julie Murray recalls a similar experience: no matter where she started from, she was always offside. Murray also remembers that during the first training session the team completed on one tour, the North Korean armed forces performed a massive air showcase by having their 1940s warplanes fly over. Whether it was for the

team's benefit remains unclear. She also recalls, that because there was no television, when North Korea launched a rocket in a show of force near Japan while the Matildas were on tour, the first the team knew about it was when they heard about it from their families in Australia. Former team physiotherapist Kate Beerworth recalls another North Korea tour where there were 40 000 North Korean fans in a stadium that probably sat 30 000: 'There was certainly no OH&S on duty that day. We got out, but we were never going to win the game.'

Then there was the propaganda. 'Every afternoon about two o'clock, we had an old 1970s TV in our hotel room that would just pop on and show you half an hour of propaganda and then stop again', Ferguson-Cook says. Some of that out-dated propaganda, Sermanni recalls, featured deceased Romanian dictator Nicolae Ceauşescu as if he were alive and well some 20 years after his death. 'One time, we had a team meeting in the hotel carpark because the rooms were all bugged', Beerworth says. 'We thought Tom [Sermanni] was joking. But no, he wasn't.' 'You could also see the secret doors around the hotel rooms and you could hear people behind the walls', Ferguson-Cook says. They'd been warned about it, so weren't too fazed. 'I think some of us – because we thought, you know, they could see through the mirrors in the bathroom, which I think they probably could – we started to put on a show for them, dancing around in the bathroom.'

The teams did not have their phones because North Korea had, following its usual policy, confiscated phones at the air-port for the duration of the team's stay. 'Your first thought is that it must be a mammoth effort to take it off you', Sermanni

says. 'But then you get there and you realise there's only one flight that goes in on something like Thursdays and out Saturdays, in Sundays and out Tuesdays. One flight, one plane.' During the 2000 Olympic Games, the coach also confiscated the phones, this time to minimise distraction.

As it was difficult to leave the North Korean hotel outside of game times (chaperones immediately 'accompanied' (followed) them if they did), the players made their own fun. They played a lot of cards (Hearts, to be precise). When that got old, they resorted to games like hallway cricket and hide and seek. As the hotel was largely empty, the team had the run of it. Their North Korean minder, meanwhile, was intrigued by the glossy magazines the players had brought with them.

'It was quite tough as well, because every single meal they would bring us six or seven courses of food', Ferguson-Cook says. 'We knew that people out in the regions were starving, and we were sending food back because it was just too much, and we were trying to explain to them that we can't eat all this food, put it to good use.' On the way to and from training the team had seen people on the side of the road picking grass to make soup. 'The look on the waiters' and waitresses' faces ... They must have been so disgusted in us, turning away this food', Ferguson-Cook says. 'It was just tough. It was really, really tough.'

Operating on scant resources and with minimal media coverage, Australian women's footballers' experiences of leaner

times reflect playing in obscurity while their nation was unable or unwilling to watch and cheer them on. They reflect the scrimping, saving, fundraising, and taking leave without pay to tour, to move to Europe and the US to operate as journeywomen in the early semi-professional football leagues. Australia's female footballers have long made their own way in North Korea and beyond.

Without funding to bring players together regularly for training camps, players largely trained in isolation in their home states and then tried to form a cohesive unit when they met up at tournaments. Moya Dodd and her teammates would implore television stations like SBS to broadcast the Matildas' games. There was no interest. So the players would have to phone the results to family at home after matches such as the Matildas' stunning 1–0 defeat of Brazil at the invitational tournament held in China in 1988 as a precursor to the Women's World Cup. 'We played in an era of no mobile phones or personal computers, let alone Twitter or other forms of instant messaging, so getting results back home did require queuing at phone boxes', Julie Dolan recalls. 'I also remember receiving telegrams from my family wishing me good luck in various tournaments.'

'You had to book a phone call at our hotel – there was no direct dial and I suspected there was only one line out', Dodd says. 'So people tried to call home and would get a call back hours later – sometimes in the middle of the night – with alarmed relatives wondering if there'd been loss of life. Somehow it's not the same shouting "WE BEAT BRAZIL" down the phone at 3 am to your panicked parents ...'

Katrina Boyd recalls a tour when the phones in the hotel rooms failed to connect. The players hung up and tried again, hung up and tried again. No luck. The phone calls mightn't have gone through but the call charges did, something the team only discovered at checkout. Boyd estimates the team managers must have spent at least an hour negotiating to have the charges removed as the team could not afford them.

'Things were always needing to be pulled out of the bag, and it was through the extraordinary efforts of family and administrators that tours/events went as smoothly as they did', Dolan says of how players and administrators made women's football happen. 'As players we were also shielded from the behind-the-scenes dramas for the most part. Everyone did anything that was needed to make things happen.'

The kits they wore were second-hand men's uniforms. Everyone had to roll their oversized shorts or modify them to fit. Julie Murray says, 'I remember the AWSA president sewing up my shorts at the side so they didn't look like parachutes'. In 1988, the team got its first walking-out uniform, which she had to roll over about five times for it to fit. For the 1995 Women's World Cup, she says, 'I think we wore the shirts that were in the storage shed that the Socceroos didn't wear. I had an XL or XXL.'

'It was sort of first in, so it would be a mad rush to get the medium', defender Di Alagich recalls of any time the team received kit. 'And medium was men's medium so it was still massive. If you got there last, you'd be in XXL.' Another time, Murray recalls, the players were told they had to pay $25 to keep their uniforms after a tour – uniforms they'd literally

changed the stitching on to make fit and that would be pretty useless to anyone else. 'I mean, back in the day we never got to keep our strips, so even getting something to keep was pretty monumental, really. To have your own strip was amazing', Alagich says.

Adidas made the uniforms for the 1999 Women's World Cup, which was a vast improvement in quality. Except the kit didn't fit half the team because the sizing was wrong. 'I don't know why we waited until we got to Portland to get it', Murray says, 'but they literally had to do a whole new set'. The shorts were so small, she says, they were more like bike pants: 'Players would look like Warwick Capper' – the AFL player known for wearing very short, tight shorts.

Having your name and number on the kit was a huge deal and a rarity, Alagich recalls. But the numbers were peeling off from the '99 kit. 'It was', she says, 'the best moment and the worst moment', of the excitement at having the Adidas kit only to find it didn't fit. History repeated with the 2003 Women's World Cup kit: it was impossibly small. 'I mean, we were laughing hysterically at it, but we were also like: Oh, can't we even get this right? Like right before the World Cup', Alagich says. 'It was panic stations again, especially for the girls who literally could not get their shorts past their thighs.'

Official merchandise has been difficult to come by in the time the Matildas have existed, so fans have often made their own. Former Matildas team manager Jo Fernandes believes the team's hosts on a South Korean tour created the first unofficial – and slightly more orange than the team's official yellow – Matildas merchandise. 'They had these orange

t-shirts printed with "Matildas" on them and booked out a room at a karaoke place. It was fantastic. We were all singing karaoke together wearing these shirts', she laughs. 'I've still got mine.'

The difficulties extended beyond pitches and playing kits. In 2007, 'in Asia, even getting ice was challenging', Kate Beerworth says of the crucial ingredient needed for players' recovery baths. 'We were staying in a nice hotel in China because FIFA was paying for it. But the ice was like bottled, fancy, frozen Perrier water, and it was $5 for a tiny little bag', Beerworth says. Buying enough to make ice baths would have blown their budget.

During another trip, the team was in a hotel where there were no baths, only showers. 'Being in China, where you can buy anything, a couple of the coaches had seen this free-standing wooden bath', Beerworth says. 'And bless them, they'd bought it and carried it back on their heads to the hotel and we put it in the shower. That was hilarious. So we kind of bought this bath that kind of half fit in the shower but not really. It probably was not that OH&S, but we made it work.' Showers featured in helping out teammates, too. Once, when a player was running late for the team curfew in China, another cannily turned on the shower to make it seem like her roommate was there: 'It came curfew time and we had one less body than we were supposed to have back in the room,' one of the players tells us. 'So the shower went on, the bathroom door was shut, the lights went out, and when the knock on the door came, the staff checking in on us were none the wiser.'

During the 2010 Women's Asian Cup, Tom Sermanni had lost a bet. 'There was some banter going on about what if we qualify for the Women's World Cup. I said you can dye my hair and you can shave my moustache while you're at it. What people forget is how difficult it was to qualify for the Women's World Cup at the time.' As he says, 'Desperate times required desperate measures'.

The team subsequently qualified. 'I thought the players had forgotten about it,' Sermanni says of the bet. It appeared not. The players coloured his hair that night with cheap dye they'd bought from a Chinese supermarket. 'They probably went through a dozen towels with all the crap that comes out. I didn't realise what was involved.'

Sermanni learnt the hard way that the dye changes colour as it goes. 'So it started off at as a dark brunette and it started going more Donald Trump colour as it progressed', Sermanni says. Also, he says, 'people who don't know you well look at you like you like you're going through a mid-life crisis'. Sermanni had to sport that hair in public and on camera for a few more days: the team still had the final to play. Sermanni had been the only Western, grey-haired person at the tournament, and some referees didn't recognise him with brown hair. They thought Australia had replaced its coach.

And Murray recalls an earlier European tour in 1994, which included three matches in Samara, Russia, where cats fell through the ceiling while the players were collecting their bags from the Moscow airport baggage carousel. 'They must have had a false ceiling and we could hear this meowing. All of a sudden, when we were getting our bags off the conveyor

belt, these cats peed through [the ceiling] and fell straight through it', Murray says.

'Then [the Russians] said: "Ok, we're just getting on a bus to go to another plane." So we got in this beautiful bus and thought, ok, times are good … ' They drove to a military base and parked behind an old troop carrier. 'So they just [backed up the bus to it and [lowered] the ramp thing and we all got out of the bus and we all joined a line from the bus to the plane and did a little conveyor belt with our bags', she says. 'They started up the engines while we were on the plane, so you see this flashing flame go past us. We had a seatbelt that went around about four or five people.' With no air conditioning on the plane, it was also extremely cold.

Murray, who is by her own admission not a great flier and who had just finished reading a book that featured a plane crash, went up to the cockpit to make polite conversation with the crew. The navigator was sitting there plotting out the flight path with a paper map and protractor. The route didn't appear to be a direct one, which the navigator explained by pointing out the window: 'There was this *massive* electrical storm'. Murray didn't mention it to the rest of the team until well after they'd landed.

That same trip, half the players were felled by sickness. 'The doc had run out of all antibiotics and everything, and half of us got urinary tract infections, you name it. He was, like: "Oh, sorry, I just gave the last lot to Sunni [Hughes]". There were a whole bunch of us who were really, really, really sick after we had a welcoming barbeque or something where we all ate raw meat', Murray says.

Tours and tournaments in wealthier countries were equally memorable. Carol Vinson remembers tours when the trip to the stadium took more than hour, but the trip back only 20 minutes – a canny tactic to tire the team out. And during the 1986 Oceania Cup in New Zealand, Julie Murray, the youngest player in the squad at the time, sustained a meaty black eye. It prompted her teammates to refer to the New Zealand player who'd given her the injuries as 'Dingo' because she tried to kill the team's baby.

During a US trip, the team had been drinking copious amounts of water to stay hydrated, as athletes do. They were a long way between rest stops, so the bus driver pulled over near some opportune long grass to allow the players to relieve themselves. The players were squatting at intervals in the grass when one of them (Katrina Boyd, who told us this story, doesn't remember who) told the others they urgently needed to get back on the bus. Suddenly, the players noticed the distinctive glint of alligator eyes watching them and long snouts emerging from the grass. The players made record time pulling up their pants and legging it back to the bus.

Touring meant there were extra demands on some players, who were still at school and had to keep up their education on the road. After debuting for the Matildas aged just 16, Sally Shipard famously sat her HSC maths exam in Sermanni's business class seat, which he had kindly given up for her, on the return flight from a match in Los Angeles. 'We sent Doc [team doctor James Ilic] to the airport early', Tom Sermanni

says, 'and the NSW educational authority faxed the exam to him in the Qantas lounge'. Ilic then acted as invigilator, ensuring Shipard sat the exam at exactly the same time as her peers, albeit thousands of feet above the ground. Teacher turned coach Sermanni would always retain a touch of the teacher about him, regularly asking younger players such as Caitlin Foord and Sam Kerr if they had done their homework. 'And I can tell you the answer', Sermanni laughs. 'It wasn't yes.'

It was on such tours, where the pitches were poor and the opponents tough, that players would also hear terms that would stick with them for years. 'One of Tom's best terms in the world is "whooshka"', Alicia Ferguson-Cook says. 'When Tom says: "We need to be realistic about this, the pitch is terrible … " Say if we're in China: "So the pitch is terrible, the first 15 minutes, just help it on, whooshka, and then we'll earn ourselves the right to play"'. Explaining the concept, Beerworth defines 'whooshka' as a technical term for 'you just need to kind of kick it, make it happen, help it along'.

You could say Australia's women's football advocates have instinctively adopted the philosophy of 'whooshka' in helping the women's game on. They've plugged gaps and laid foundations and produced opportunities that were otherwise not available, either through lack of funding or through oversight. Through it, they've edged the women's game and the opportunities around it forward. Of course, whether for tournaments in North Korea, Russia, Papua New Guinea, China, or, closer

to home, the six Australia Cups instigated by Warren Fisher and the AWSA, or the 2000 Sydney Olympics, Australia's female footballers have had to find ways to both fund their football and draw attention to the game. Some of those ways have been more successful – and controversial – than others.

Two decades after it was published, the Matildas' 2000 calendar returned to the news headlines in the lead-up to the 2019 Women's World Cup campaign. Alison Forman, Katrina Boyd, and Alicia Ferguson-Cook were among the 12 players photographed naked in 1999 to raise money for the team for the 2000 Sydney Olympics. Reunited in 2019 to celebrate the calendar's 20th anniversary, the players had their photos taken again – this time fully dressed in matching outfits and holding framed prints of the calendar and their 'months'. Alongside discussion of the scandal that followed the calendar's original launch and a swathe of then-and-now contrasts of funding and resources, the anniversary press offered some much-needed, long-awaited recognition of the extraordinary efforts and the lasting contribution the 'old girls' made to the game.

Sydney won the right to host the 2000 Olympics in September 1993. Three weeks before the announcement, the IOC determined women's football would be included for the first time. The ill-informed Australian media assumed there was no competing national women's football team, but the AWSA, which had been selecting teams and arranging international tours and matches for over 15 years, knew differently, of course. While poor knowledge and a lack of media awareness highlighted how underestimated and neglected the

women's game and its organisation had been, the prospect of participating in the 2000 Olympics presented an incredible opportunity to redress the issue.

The meagre resources available to the AWSA meant the organisation could not provide for the Matildas; the players had personally worn the costs of performing in the international side. Yet through effort, a force of will, and love of the game, the Matildas' standing in world football was (and still is) much higher than that of their male counterparts, the Socceroos. The national women's team, and women's football as a whole, was largely ignored by those national and state organisations responsible for oversight of the men's game. (We understand now, as a result of the 2003 Crawford Report and the investigative work of journalist Ross Solly, that Soccer Australia was grappling with its own financial woes.) But despite this, the women's game's poorly paid and under-resourced administrators, managers, and players were already getting results.

The Crawford Report would later mandate that all aspects of Australian football would be gathered under the umbrella of the single entity Soccer Australia, which would be relaunched as Football Federation Australia (FFA) in 2005. If the report's findings had not been implemented, there is a strong possibility the AWSA would have continued independently. The women's game needed a higher profile – something media attention and, with it, a little more funding, could remedy. The idea that a calendar would be an engine for attitudinal change wasn't necessarily the first thing Shirley Brown (newly elected AWSA president) or Warren Fisher (AWSA CEO)

would have suggested, but they were persuaded by the benefits they were told it would bring the team. It certainly captured the media's attention, though not entirely as positively or productively as they would have hoped.

Although they hadn't fared particularly well in the 1999 Women's World Cup, the Matildas' host-nation status gained them automatic entry to the Olympic tournament. Greg Brown, who'd been coach in the lead-up to and through the 1999 Women's World Cup tournament, was replaced shortly afterwards by Chris Tanzey, a former Liverpool reserve who moved to Australia to pursue a career in football management. One of Tanzey's first, controversial acts as new coach was to replace star player and captain Julie Murray with the team's firebrand, Alison Forman. Murray would still be a key part of the Olympic team.

In his memoir *Offsider*, sports writer Patrick Mangan portrays his former employer, enigmatic boss of Prime Publishing, Ettore Flacco, as an exuberant Italian–Australian with a keen interest in fashion, semi-naked models, and football. Flacco's talent for persuasion would result in high-profile brands contributing to his football magazine, *Soccer Australia*. The publication featured articles on football between glossy photoshoots of barely clothed male footballers, with similarly attired women draped over them, as well as lush advertisements for clothing, footwear, and world-famous soft drink companies. When Flacco contacted Fisher to suggest the Matildas pose for a calendar, he aligned a persuasive sales pitch, years of experience 'in the field', and his own interests into a single project. The pair's first meeting took place at the

AIS. Flacco told Fisher he could make the Matildas famous as long as they were willing to 'tastefully' shed their attire. Fisher's initial response is reported to have been one of complete disbelief. Still, he was won over.

From there, things happened quickly. Three meetings were enough for those involved to agree to his plan. Only 12 women were required, which was fortunate as only 12 volunteered to participate. The AWSA board voted to approve the calendar, and within weeks the Matildas were photographed in an AIS theatre-turned-studio. Having posed alongside her 29-year-old teammate Sharon Black, the irrepressible Forman would be credited for her role in bringing the players to the project. In a recent interview, Boyd, one of three players to do a full-frontal nude shot, indicated that posing for the calendar was not that difficult a task – the players were happy to be part of it. In 2000, the striker Ferguson-Cook, a teenager at the time, underlined her pride at being involved – she had parental consent to participate and the picture still hangs on her mum's living room wall. She said that it was completely up to the individual players whether they participated or not; there was no pressure to take part. As Boyd noted, some of the team were far more comfortable being naked than others, and they were the ones who put their hands up.

Nude calendars were having a moment around the world. Earlier that year, the Yorkshire branch of the Women's Institute in England had produced the first really famous nude calendar to raise funds for charity, to support research into leukaemia. The Matildas calendar was published a few months

later. Since then, sporting teams and bare-chested firemen have trodden the same path. The USWNT cited cultural reasons for not doing one. Not because they didn't want to, but because they'd never have gotten away with it. Photographs of footballer Brandi Chastain removing her shirt in the 1999 Women's World Cup final – now an iconic image of an athletic sportswoman freely expressing her joy in world-class achievement – sent the conservative US media into meltdown over appropriate behaviour and decorum, even though she was wearing a substantive sports bra. A year or two earlier, before the women in Yorkshire made nude calendars famous, the Norwegian women's football team also produced one, but it did not sell well in a country where nudity has very little novelty value. It turned out that Australia was just the right market – retailing at A$20 each, the Matildas calendar remains one of the best- and fastest-selling Australian calendars. On the strength of pre-publication sales, the initial print run of 5000 was increased by a further 40 000. Flacco was happy and Fisher was too. But conversely, a lot of people were upset for a number of reasons.

Coach Tanzey was concerned the off-field distraction would detract from match play, and his concerns did seem to be borne out. Former Matildas manager Jo Fernandes, who started with the team eight months before the Olympics, remembers regularly being asked when the next calendar was coming out. 'The focus wasn't on the football', she says. Tanzey did sympathise with the players and understood why they'd decided to do it. He noted that had they been a Women's World Cup-winning side, for example, they would

have been given a great deal more support and wouldn't have had to make the calendar. Tanzey has claimed that he was the one person who stood in the way of further naked exploits, and in an interview at the time he predicted that the onslaught of criticisms that followed would be considerable and indiscriminate.

Olympic officials took no issue with the nudity or the approach to raising funds. The calendar's cover title suggested royalties from sales would be paid to the athletes to support their Olympic Games preparation. Olympic officials were, however, unhappy that the project's title included unofficial use of the word 'Olympic', which was in breach of IOC licensing agreements. The calendar also included a number of sponsors that were not affiliated with the 2000 Olympics. The second print run would have the problematic 'Olympic' and the non-affiliated sponsors removed.

By contrast, Australian netball players asserted that they'd never make a nude calendar. In April 2000, the national women's netball team decided to produce a clothed calendar to raise funds and awareness. When the players arrived for the photoshoot, the photographer pressured players to remove their clothes and the venture stalled. In an interview with the ABC in 2000, Katherine Harby, netball team captain, said, 'The producers felt that we as female athletes would gain greater publicity and mileage by taking our clothes off and producing a calendar semi or fully naked rather than producing a calendar showing our athleticism, which is of more interest to the young girls who play the game'. The national women's water polo team commended the Matildas for trying

to change their image – a key aspect of the project – but undercut this by suggesting their sport did not suffer from the same image problem.

The (largely male) Australian sports media was critical, including citing it as a depressing indictment of how women's sports and female athletes were viewed, and that women's sport should not have to stoop so low to gain attention. In the *Sun Herald* in November 2000, journalist Sue Williams' editorial suggested the 'stripping Matildas are hardly the kind of inspirational role models anyone would choose', and that the calendar carried a provocative invitation: 'if the Matildas don't score on the field, male fans could well do so in the changing room later'.

Defender Tracie McGovern, then 21 years old, noted how much the media's response wounded some of the players. For the most part, responses from AWSA and the Matildas involved, collectively described as 'the dirty dozen', was overwhelmingly positive. Forman was among those who highlighted how much fun the experience was. The players had taken part to raise the game's profile, generate funding to support their Olympic Games participation, and change perceptions and stigmatised stereotypes around female footballers' femininity. With varying degrees of success, the project managed all three. Brown and Fisher were glad of the attention to the players and the sport. As pointed out by Mary Crooks, then executive director of the Victorian Women's Trust, these women, operating at elite levels in their sport, simply did not enjoy anything like the level of funding or support their male counterparts did. Amy Duggan (née Taylor), who enjoyed

something of a modelling career on the side and is now a TV presenter, suggested that the calendar was a useful way to get some great professional photographs. Ferguson-Cook has since conceded she preferred being recognised for her footballing abilities, but maintains that she has no regrets. Today we might also ask ourselves if the calendar was any less or more degrading than having players such as Lisa De Vanna sell Freddo Frogs and raffle tickets in a bid to pay registration fees to play with now-defunct WNSL club Adelaide Sensation.

In her September 2000 article, 'A naked desire to win credibility', sports journalist Caroline Wilson observed that the launch party for the calendar, which was a 'standing room only' event, brimmed with television crews and journalists from all over Australia and farther afield. Yet no representatives from the men's game attended. Soccer Australia made a number of attempts to bring the women's game into its fold after the AIS announced Olympics-based funding of A$1 million for women's football. The promise of cash undoubtedly piqued Soccer Australia's interest, but the men's organisation still had minimal interest in the women's game. As AWSA president at the time Denis O'Brien notes, 'The relationship between the AWSA and the [then] Soccer Australia was always seemingly friendly but tense. There is no doubt that as womens' football became more well known, Soccer Australia came to the view that they should run it.' The AWSA had no intention of giving up the independence and 'the strong reputation' it enjoyed, and certainly not to Soccer Australia, where reputations and its management and running could be considered as a little weaker. O'Brien is confident this would not have

happened on his watch. At the same time, he believed there were moves within the organisation to elect a female president. It almost happened, but the Australian Soccer Association chairman intervened and O'Brien's tenure lasted until 1999. Fisher would eventually be replaced as AWSA CEO too, but not before the calendar was put into production.

Nevertheless, the calendar achieved the short-term goal of attracting media attention. The image the general public had of female footballers changed, perhaps dramatically, but necessarily too. The 12 players who posed – Tracie McGovern, Kim Revell, Alison Forman, Traci Bartlett, Sharon Black, Amy Duggan, Alicia Ferguson-Cook, Katrina Boyd, Cheryl Salisbury, Sarah Cooper, Sunni Hughes, and Bridgette Starr – reportedly earned less than A\$4000 each from the enterprise.

In January 2000, while still waiting for their money from the calendars, the Matildas took on the Czech Republic at the Bob Jane Stadium in Melbourne. The attendance of around 1500 people would to outside observers seem like a low number. But it is significantly more than the 50 people, including friends and family, who turned up to watch the first 'official' international test in 1979. Julie Dolan, who captained the side, was among those players handing out leaflets to encourage people to come and watch that early match. In the build-up to the Olympics, a 10 000-strong Sydney Football Stadium crowd watched the Matildas narrowly lose to China, ranked number two in the world at the time.

The Sydney Olympic Games offered a home advantage. Fisher talked up the team's chances and the media, knowing nothing about the team, ran with it. With the benefit of hindsight, the media hype and level of expectation was excessive. Australia had placed last of 12 in the 1995 Women's World Cup and 11th of 16 in the 1999 Women's World Cup. The expectation of medal placement, the pressure, and the subsequent public letdown was unfair and did not help the game's prospects. Still, the team prepared and performed admirably.

To help the players prepare for the nerves and the conditions of playing in front of large crowds foreign to the normally unwatched women's football, Tanzey made the team play friendlies against Canberra men's or boys' teams. 'We had to walk out to the FIFA anthem and then stand and sing our national anthem as well', defender Kate McShea recalls. 'We all look back now and laugh. He used to also play a crowd noise over the loud speaker so we could get used to playing without hearing each other.' 'I used to love the FIFA anthem. It was a real special occasion when you heard it', Alagich says. But hearing it so often diminished its specialness for her. 'It kind of took away the shine of that song.'

Despite appearances, going on to lose to two of the world's most highly regarded teams – the Germans (3–0) and the Brazilians (2–1) – and picking up a point against the Swedes, the Matildas punched above their weight, considering their minimal resources and respective levels of investment. The media mightn't have recognised it, but to finish 7th place in Olympics Games football was a substantial achievement.

Still, it was hard to get recognition for the players' hard

work and professionalism. At a 500 Club fundraising dinner in Melbourne prior to the Olympics in 2000 the Matildas were interviewed by sports presenter Eddie McGuire, who apparently asked if the women's team enjoyed two or three training sessions a week. Players who were participating in twice-weekly training matches against male teams – one against a national U15 or U16 line-up and one against a local Canberra team – as well as enduring up to a dozen training sessions a week, which began almost daily at 6am, were, apparently, very quick to correct him.

In addition to their industrious training regime, some of the players were also reported to be using legal but controversial dietary supplement creatine to gain an additional athletic edge. It was a substance more often associated with weight gain and some leading athletes such as tennis player Martina Hingis rejected it, citing its dangers. Creatine wouldn't prove any of the players' undoing, but another substance would. In 2003, the Court of Arbitration for Sport (CAS) found Anissa Tann – at that time the most capped Matilda with 102 caps – guilty of a doping offence. Tann had been using a protein drink as part of her training regime. While the drink itself had been cleared for consumption, tests revealed an unlisted, banned ingredient. Tann, who had had to rely on the ingredients list and couldn't have known about the substance, unsuccessfully appealed the two-year ban. Enacted on the eve of the 2003 Women's World Cup, the ban effectively finished Tann's football career.

In 2002, then-Opposition sports spokeswoman Senator Kate Lundy revisited the controversy around the calendar. She demanded an inquiry into the AWSA, implying there were questions around the appropriation of funds. Funding streams were now coming in from the ASC, the AIS, the series against China – the Chinese team had paid to play the Matildas as part of its own preparation for the 2000 Olympics – and the calendar, and people began to ask: 'Where is all this money going?' Former vice president of the AWSA Maria Berry and former team manager Sarah Groube, both heavily involved at the time, were frustrated that the people asking could not see where it went. 'There was a CEO [Warren Fisher], administrators, a bookkeeper, and up-keep. All the rest went to the national set-up, including coaching, and it probably still wasn't enough.' The organisation responsible for managing a national league and nurturing a national team ran a tight ship. Regarding the calendar, Berry says: 'The publisher took the largest proportion of the money, there were the costs, and printing. Then there was distributors. All that was left was what was given to the [players].' The matter was discussed in parliament because, as Berry noted, 'People see these blocks of money [A\$1 million from the AIS] and think someone must be taking something. But we were running [the AWSA] with practically no money. There was no money. Once you've paid the wages and taxes and all the rest, there really wasn't a lot left.' Berry remembers at least one occasion when 'Warren [Fisher] paid people's wages out of his own pocket'.

Senator Lundy suggested it was unfair that the players

had to participate in activities like the calendar to generate income, that they'd been exploited, and that the federal police should investigate missing and misappropriated funds. Berry fiercely defended the organisation and the players, who had taken an innovative approach to generating money in the absence of other funding. Questions may have been asked, but the AWSA knew its books were in order.

The 2003 Crawford Report was the authoritative response to increasingly obvious levels of corruption, complacency, and ineptitude by and within Soccer Australia. The government, most of the footballing community, and spectators alike regarded the report as necessary for the health and well-being of football in Australia. Primarily focused on the men's game, the outcomes would also affect women's football, particularly where recommended reforms all but forced strong and well-run, though relatively poorly funded, women's football organisations to affiliate with one another. The report's approach to women's football was well-intended and sought to bring the women's game into the fold to help it grow and to stave off unseemly questions regarding its finances. But the reforms only served to underline football authorities' depth of misunderstanding around the women's game.

Rather than resolve the challenges women's football faced – namely, a lack of funding, fair and equitable treatment, wages, support for injuries and rehabilitation, and respect – when women's football's organisation and administration were absorbed into state and national institutional bodies, it had the effect of setting them aside for further, much later consideration. Held in such stasis, the continuing impact has

been compounded, and was to some extent most recently highlighted in the earlier than anticipated Matildas' Round of 16 departure from the 2019 Women's World Cup, where it became evident that European sides have arguably enjoyed sustained investment during the same period and leapt ahead in terms of development.

The issues affecting women's football 20 years ago, such as a lack of appropriate investment and support, continue to affect the contemporary game – at local, state, national, and international levels. But if the Crawford Report, the self-funded tours, and the calendar drew attention to how players were forced to make their own way, investments such as the AIS Olympic funding marked the beginning of a change in the Australian women's game and created a sense that it might actually be possible to create a career in women's football.

When the 2019 Women's World Cup final played out in Lyon, France, all eyes were on the field of play as the USWNT, led by the tournament's top goalscorers Megan Rapinoe and Alex Morgan, claimed the team's fourth Women's World Cup championship with a 2–0 victory over first-time Women's World Cup finalists the Netherlands. In a sign of a job well done, few would know that the FIFA general co-ordinator who facilitated the smooth-running final – a woman moving unobtrusively around the tunnel and the sidelines – was Australian. Like so many key players in Australian women's

football, Jo Fernandes works almost invisibly behind the scenes to enable female footballers to succeed. She's also treading new ground in football administration.

Fernandes' foray into the sport came in 1997 when, after completing her sports science degree, she became the first employee of the ACT Women's Soccer Association, working under Heather Reid as an executive officer for 20 hours a week. Prior to that, the organisation had been run by a volunteer board. The salary was low, but it meant Fernandes benefitted from the foundations laid by administrators such as Reid, who have long tried to make working in women's football into a viable career. She subsequently built that part-time salary into a full-time paid football gig.

She would leverage that ACT Women's Soccer Association and some later AIS experience to become the Matildas' team manager, a position she would go on to hold for 13 years. As part of that role, Fernandes would organise countless complex travel itineraries, frequent embassies with players' and staff members' passports to obtain visas, and oversee innumerable training camps and tours to help facilitate the Matildas' first successful forays into Asia. She would also manage anything and everything from sourcing cakes for players who were celebrating their birthdays on tour to helping determine which kit each team would wear to prevent confusing colour clashes with the opposition. She would also arrange the iconic baggy green caps the players would receive after their national-team debuts.

Fernandes' adage has long been: 'If you put a dollar into women's football, you get more bang for your buck'. In

managing the Matildas, Fernandes and the other staff did things in the most cost-effective way to stretch the available money as far as possible. That involved trying to take as many supplies as possible from home on tour and also venturing out to local supermarkets and markets to pick up supplies like bananas – the team staple – and teabags. 'We'd also try to find local versions of muesli bars, which was sometimes a challenge with language barriers', Fernandes says. 'The test would always be if the players liked them.' Fernandes' husband Nigel also recalls carrying glucose jellybeans over to the team in his luggage: goalkeeping coach Paul Jones would pay for the team's jellybean supplies out of his own pocket and ask Nigel to bring them over when he joined the team on tour. The jellybeans were otherwise out of budget.

In addition to spending some time managing the W-League before becoming Football NSW's Women's and Girl's Development Manager, since 2008 Fernandes has also embarked on FIFA tournament general co-ordinator roles. The highest-ranking FIFA official for any given venue, the general co-ordinator gig involves being responsible for anything and everything related to the venue, from the training fields to the hotel, the security, the hospitality, the teams, the changerooms, and the merchandise. 'I didn't really know what I was getting in for', Fernandes says, but when the FIFA Head of Women's Football at the time Tatjana Haenni approached her to do the role, she said: 'Of course, you know, I'll do that'. Her first tournament was in the U20s Women's World Cup in Chile. In 2018, she made history as one of the two first ever female general co-ordinators at the [Men's] World Cup in Russia.

Look at anyone involved in administering women's football in Australia to date and you'll see quiet-achieving groundbreakers like Fernandes. Often unnoticed, they are the unsung heroes who have kept and keep the wheels turning. They're the referees, the canteen conveners, the coaches, the managers, the female participation officers, the competition co-ordinators, the club presidents, the strappers, the stretcher-bearers, and the linespeople. Often, they're more than one of these at once.

At a grassroots level, clubs such as Brisbane's The Gap have a women-specific subcommittee advocating for the club's female footballers' needs. Brisbane club Grange Thistle has recently employed a women's football development officer. Lynda Arkinstall played for 15 years before a knee injury forced retirement. Still reasonably young and fit, she became a referee. For the last 25 years, she's reffed matches, disciplined 'dickheads', talent-spotted, and recruited referees throughout Queensland. Matildas fans and W-League supporters Mandy Jamieson and Dan Smith have helped their local club by providing free beds for W-League players new to their home city.

At a national-team level, it's the support staff who go above and beyond so players can perform. 'When I was in the national team there were a lot of unsung heroes – things wouldn't have operated at times without them. Beersy [Kate Beerworth] put me up at her place after surgery and I remember Tommy [Sermanni] and his wife offering to host players at their house after award nights', former Matilda Lauren Colthorpe says. 'Tim Rogers, our Matildas strength and

conditioning coach, was another one. I'm not even sure he was paid for half of what he did originally ... He often said he just loved the girls and wanted to help us out as much as he could', she adds. She also recalls coaches who voluntarily went above and beyond: 'I think they saw the players working hard for little financial reward so they were happy to do the same for the good of the game.'

Sermanni has an uncanny knack for being at the fore-front of significant football change. He was the first full-time, paid coach – in a parallel with Fernandes' own experience, before that the position was voluntary. Sermanni, along with administrators such as Sarah Groube, started the national program working out of a classroom, a space they shared with other sporting groups, including futsal. It was a return to Sermanni's schoolteacher roots, but 'that empty classroom was a bit easier to manage', he laughs. 'The role appealed to me for a number of reasons', Sermanni says. 'The scope was large because there were both national and international facets to the program. There was also an opportunity to build something from scratch.' From there, he has been instrumental in women's football's greatest successes, not least Australia's step up into the extremely competitive Asia. 'I'd have renegotiated my contract had I known Australia was about to join the Asian federation', Sermanni jokes.

Moya Dodd represented Australia in football at a time when team members not only weren't paid, they had to self-fund tours. (Dodd still has the receipts from paying to go to FIFA's inaugural 1988 women's football tournament: 'I paid in two installments – $450 and then another $400 – because I had to save up.') They also had to sew their own badges on the ill-fitting, hand-me-down men's kits they wore. Dodd once wore polka-dot undies to demonstrate and protest the sub-par uniform quality. Like many female footballers of that era, unable to establish a financially viable career within football, she established one outside it: in law. She eventually managed to combine her existing law career into paid work in football administration. This includes stints as one of three women on the FIFA executive committee; as the first woman elected to the FFA board; and as AFC vice president. She's used those platforms and her diplomatic skills to advocate for women to have greater representation and participation in football and greater input into football decision-making. In 2012 alone, she was instrumental in gaining approval for a velcro-anchored, sports-safe hijab to enable women of Islamic faith to participate safely in football. That headscarf, free of choking hazards, has since passed all international safety tests and has been endorsed for international competition. Her influence and effectiveness saw her ranked seventh on Forbes' 2018 Most Powerful Women in International Sport list.

It's giant strides on from Dodd's primary school days when her school oval was segregated and although boys were allowed to play on it three times a week (Mondays, Wednesdays and Fridays), the girls were only allowed twice a week

(Tuesdays and Thursdays), a disparity she's arguably made it her life's work to rectify through normalising women's participation at all levels of football. Dodd's off-pitch advocacy and efforts to improve conditions has been a theme throughout her career. In her time as a Matildas teammate and roommate, she would take her rice cooker on tour to make sure everyone got enough carbs, as carb-loading is crucial to performance and the quality and availability of food was often variable. Players lined up outside her room with cups and Dodd shared out pre-match rice portions. 'It was a bit of a joke because I'm half Chinese, and I've got a rice cooker in my luggage', Dodd says. 'It was perfect because we only needed a powerpoint to cook. And I was the one laughing when they dropped by with their little white motel tea cups, wanting a pre-match meal. None of us wanted to play on an empty stomach.'

Still, it wasn't easy. She was one of three women in the FIFA executive committee room and, as a member co-opted for one year, she had no vote. 'On the first day I was advised not to speak', she said at the Equal Playing Field Equality Summit that ran during the 2019 Women's World Cup. 'So I thought, "Well, I'm going to speak at every meeting because after 108 years of having no women in the room, they need to get used to the sound of women's voices". And I noticed that women's football wasn't talked about terribly much other than by a few people. It was evident to me that the women's game had not been given much priority of consideration.' In the end Dodd was there for three years, and she recognised how significant her role was. 'As someone in a quota position, the entire point of your existence in that room is to represent those who

can't be there. I felt a special responsibility to represent women and women's football, as well as contributing more broadly,' she told the summit. 'The challenge I had was that less than 1 per cent of the 211 presidents of member associations were female and it's the presidents who vote. The constituency that I felt obliged to work for could not vote me in or out. They simply had no say as to whether I was there or not. Women are disenfranchised because their constituency is disenfranchised. The reality is that the people who fill those quotas are entirely elected by people who are already represented.'

Like Dodd, Sarah Walsh has pivoted from player to administrator. Walsh combines her advanced knowledge of football and football injuries with her marketing degree to increase football participation rates. Now the deputy CEO of the Professional Footballers Australia (PFA), Kate Gill transitioned from player to player advocate, championing improved contracts and conditions. And, like a number of their peers, both Walsh and Gill have capitalised on the increasing broadcast interests in women's football to foster supplemental commentating gigs.

'This next generation is hopefully going to be another generation that's going to stay involved in the game and hopefully be the decision-makers', Sermanni says. Speaking of players who stay in the game, he says, 'One of the interesting things I found, which I love, is when players become coaches. The first thing they say is: I didn't know you had to do that stuff. They think you aren't doing things behind the scenes, that you turn up in the morning and do your crossword,' he laughs. 'They don't realise the hours the coaches

and team managers and physios are doing.' Or the hours the referees are doing, for that matter.

FIFA and W-League referee Kate Jacewicz, who has officiated nine W-League grand finals, initially picked up the whistle because her brother's team needed a referee. 'He was six or seven and I was 12', Jacewicz says. 'It was before I did my referee course. I was able to do my referee course at age 13, so I think later that season or maybe the next season my mum took me along to my first junior referee course. I think it was just my mum and I, as in the two females, there. My mum did it for moral support, really. I think she just wanted to understand things, but she's never refereed a match.'

Like her mother, who took on multiple roles at their local club – 'She was the registrar, the secretary, and the canteen lady, and everything' – Jacewicz coached and played in addition to overseeing matches. Her playing peers included Matildas Tameka Yallop (née Butt) and Aivi Luik, and she once coached Elise Kellond-Knight and Casey Dumont.

'I enjoyed refereeing because, I don't know, there was just something about having control of a match … You kind of got to live vicariously through both teams … You can feel the competitiveness from the match as a whole from both sides. You just play the neutral. I guess that's what I felt from a young age,' Jacewicz says. 'I wouldn't say I saw a pathway professionally in terms of being able to make a living [from refereeing], money-wise', Jacewicz says. 'But certainly I realised in my late teens I could never play for the Matildas, but I could potentially go to the World Cup as a referee. So that's when it started to become more serious.'

Jacewicz quickly gained a lot of early experience that helped her career long term. 'Because I started so young – I started at 13, and on the Gold Coast, especially, we didn't have a lot of referees so I was refereeing senior men's football at age 17. I'm quite a tall person, so I could kind of fit in – I didn't look out of place.' This experience meant Jacewicz was well placed to start refereeing in the W-League and become a FIFA referee at age 25. 'I'm only 34, but I've been refereeing for 22 years, and over half of that has been at a senior level', she says.

Her next goal, which will be realised in the 2019/20 season as she's been named the first woman to receive the call-up to the A-League referees panel, is to be selected to officiate in the A-League, particularly as she's had video assistant referee (VAR) experience through the 2019 Women's World Cup. It's relatively new territory, and one Jacewicz is keen to explore here and overseas in both the women's and the men's games. 'Certainly the World Cup has opened up a lot of doors. I do have a goal of becoming a full-time referee', she says. 'Now I've had VAR experience, I think VAR also opens up a lot of opportunities internationally.' Sensing that VAR might open up an additional, complementary career path, Jacewicz says: 'There might be more pathways as a female going into the male game as a VAR.'

Long-time football supporter Fatima 'Fatty' Flores is perhaps best known for her crowd-stirring active fan support in the stands. She too is trying to improve the women's game, both through active support and, having identified a gap in the market, pivoting from high school physical education

teacher to players' agent. 'The formula that is currently in place for men won't necessarily work for women', she says. Improving contracts to enable players to earn a wage high enough so they can concentrate on their sport full time is a given, but Flores is also looking to work closely with players to find mentors and connect them with business partners. That and to help female players understand their own value and feel confident to negotiate accordingly.

Neither Fernandes' nor Dodd's nor Gill's nor Walsh's nor Jacewicz's nor Flores' career paths existed before they created them. Like Elaine Watson and Heather Reid before them, by improving not just their own conditions but the next generations', and encouraging and mentoring other women to do the same, they're kicking Australian women's football on.

The other unsung heroes in women's football are, of course, players' families. Start typing 'Clare Polkinghorne' into a search engine, you'll likely get a search suggestion for 'Clare Polkinghorne brother'. Younger brother Tom is such an integral, charismatic part of her support crew, he's becoming well known in his own right. But as the younger sibling of a footballer – a reversal of the stereotype of a younger sister being dragged along to her older brother's football matches, if you like – Tom has lived Clare's journey alongside her. As have all the Polkinghornes and the other players' families.

In recent years the Matildas' fan support has been on an impressive upward trajectory. But families have always been

Australian female footballers' main support network. Shell-harbour-based Simone Foord famously drove her daughter Caitlin Foord, now a Matilda, up to Sydney up to five times a week for five years so Foord could attend training and competitions, even though everyone told her that a four-hour return trip was too arduous a commitment.

Before Clare Polkinghorne was old enough to drive herself to training, on a normal weekday her mother Britha would first collect Tom from school, then Clare. 'We had to make sure we were home by 3:50 pm in order to get Clare to training on time', Tom says. 'Then our father would go directly from work to watch Clare train and bring her home afterwards. It was a team effort. But now, as an adult working a full-time job, I have a new appreciation for how committed our parents were to seeing her succeed. Getting home at 8 pm every night after working a full workday, for example, must have been tough. But our father never ever complained.'

Having lived through the ascendance of women's football, Tom's well placed to recognise its significance. 'It's been a kind of wild ride, contrasting the previous Matildas crowds of 600 people of mostly family and friends with the 20 000 who packed out a stadium during a mid-week friendly against Brazil', Tom says. 'We've gone from being the majority fans to the minority', he says, something he's completely comfortable with because it's a sign of progress. It also means they can now just be supportive family members: 'It's good that we don't have to take on the main fan role'.

The Polkinghornes' home, like that of many other players' families, has become a second home for other players. Lydia

Williams has stayed there, and Brisbane Roar US import Celeste Boureille stayed with the family and now considers the Polkinghornes second parents. Christmas Day sees 'orphans' like Boureille, Yuki Nagasato, and Maddi Evans – in Australia for the W-League season – joining in the family celebrations.

Such teammate family support – not to mention the support of teammates who would become like family – goes way back. At the age of 16, Queenslander Alicia Ferguson-Cook moved to Canberra on scholarship with the AIS, a move timed for the start of the school year in January. 'For the first six months I was actually by myself, which was really tough, actually', she says. 'Like it was *really* tough. I probably spent a good couple of weeks bloody crying every night just because I missed everyone, I had to start at a new school, I had to make new friends ... I knew what I was doing was for the right reasons, but it was just tough. Because Julie Murray's family lived in Canberra, whenever she came down she kind of took me under her wing and looked after me and that kind of stuff just because I didn't really have a support network down there.'

Matildas sponsor Hyundai filmed a series of ads that played on high rotation during the 2019 Women's World Cup. In them, players wrote and sent letters to their mentors and closest supporters, thanking them for their help. Sam Kerr thanked AIS strength and conditioning coach Aaron Holt, whose rehab help saved her career. Alanna Kennedy thanked her mother for encouraging her to chase her dreams and for being the reason she could be a Matilda. Lisa De Vanna thanked Matilda great Cheryl Salisbury, who recognised something in her as a raw-talented 14-year-old and made her

believe she was capable of becoming a Matilda. Clare Polkinghorne thanked her father for his unwavering support and encouragement, not least his traditional pre-match message to always 'work hard and have fun'. Deliberately tearjerking, but nonetheless touching, the ads tapped into the underlying emotion and sentiment surrounding women's football: that without the support of coaches, administrators, teammates, and family members willing to go above and beyond, the players would not be where they are today.

Chapter 4

KICKING DOMESTIC GOALS

The semi final of the 2011/12 W-League (Australian women's elite professional football competition) had it all: state-of-origin rivalry, last-minute equalisers, red cards, penalties, broadcast controversies, and a coach so passionate he was sent from the sidelines. Sydney FC had been leading Brisbane Roar 1–0 when Brisbane Roar striker Emily Gielnik equalised just before full time. Shortly afterwards, Sydney FC striker Kyah Simon picked up a second yellow and was sent from the pitch after committing a late, slide-tackle foul on Vedrana Popovic. The incensed Sydney FC coach Alen Stajcic vented his frustration at officials so vehemently that he was sent off. He continued to rage, contained in a room under the stands after he tried to keep issuing instructions to his staff and players.

With neither team able to break the deadlock, the semi final went to extra time and then penalties. Fans inside QSAC and the viewers tuning in to the ABC TV broadcast watched on anxiously. Then, just as the first player stepped up to take the first kick, the ABC broadcast cut out. Fans inside the

stadium witnessed Brisbane Roar secure its fourth consecutive grand final berth with a 4–3 win on penalties. Fans at home took to social media to beg for the broadcast to come back.

If ever there was a match that demonstrated that the W-League could produce quality football competition and heightened emotions, that the stakes were high, and that the women, their coaches, and the fans were heavily invested, this was it. A vibrant demonstration of the best qualities of the game, it also highlighted how much the set-up behind the scenes needed to improve. The ABC broadcast had switched to another program due to simple oversight: when scheduling the match, the station hadn't allowed for a buffer should the match go to extra time. Once the pre-scheduled switch happened, there was no chance of reversing it. Unless they were physically at the match, fans were involuntarily kept in the dark.

Speaking on the *Total Football* television program after the 2007 Women's World Cup, Heather Garriock flagged the need for a national league in Australia – not just a short burst of round robins, but a full home-and-away league akin to the A-League (the Australian men's top football division) that would ultimately produce more players and greater squad depth and, if they were lucky, garner television coverage.

Coach Tom Sermanni concurred. Having steered the Matildas to a quarter-final berth at the 2007 Women's World Cup, he spoke from an authoritative position when

he stressed the need for a national professional competition. The only way Australian women's football could improve to consistently compete on the world stage was through establishing regular top-tier football. By Sermanni's reckoning, Australia needed to implement a domestic source for players for three reasons: to keep the footballers playing at the highest possible level and help identify late developers and/or players who had not come through the age-group system; to provide playing opportunities during the significant dead spot in the international playing calendar (from September to February); and to build a domestic profile for the game comparable to the work being done via the A-League. 'We'd just come back from a pretty decent 2007 Women's World Cup. You have that momentum for a short period of time', he says of how they leveraged that success into a domestic set-up. Until then, there were largely state-based programs, but no clear pathway or ability to take the game to the next level. 'We had all these programs and all these players training', Sermanni says, 'but there was no purpose behind it. So it became difficult to keep the momentum.'

Implementing a national league made sense not just for the players but also for the development organisations. They already had coaches and players in place through state- and institute-based programs, so it was a case of merging them into a national program under the A-League branding. The academies of sport were interested because such a league would help them fulfil their missions to develop players. The AIS was interested because it would enhance the institute's ethos of developing talent for the national team. 'There was

a real partnership. The sell was the need for it based on all of those programs', Sermanni says. So, through a collaborative effort of some key stakeholders such as the AIS and state-based organisations and coaching staff, supported by a mixed pot of funding, including money from the AIS, the semi-professional W-League kicked off the following year.

'It was more just a rebranding thing, because we'd always played in a national league', Alicia Ferguson-Cook says of that new league. 'Nothing really changed on a daily basis. We were just training five days a week and playing against the same players in a different way.' Still, it elevated fans' awareness of women's football: 'It was on the back of the A-League, so they'd gone pretty big on that, and with it being aligned with the A-League clubs, I think it gave us a bit more respect, I suppose, a bit more visibility.'

That visibility included a marketing campaign for seasons 1 and 2, which ran in 2008 and 2009 respectively, that featured the tagline 'football with style'. Posters featured players such as Canberra United's Thea Slatyer and Grace Gill, Adelaide United's Angela Fimmano, and Queensland Roar's Jenna Drummond (née Tristram) looking simultaneously glamorous and athletic. Professionally made up, and with their hair styled and extended, the players were captured attacking the ball or mid-volley. The FFA aimed to counter stereotypes that football was 'unladylike' and market it instead as stylish, feminine athleticism.

'I think the players liked it because it gave them a profile – showed that [the administrators] were taking it seriously and putting some effort into it', Sermanni says. Drummond

agrees. 'It was all very exciting because we never really had a marketing campaign', she says. 'You do headshots and things like that, but nothing as extravagant as having hair and make-up done. It was full glam. It was hair extensions, full make-up. It was in an actual studio. It was different and everyone was very excited.'

'It took a full day of prep and shooting, where my shot, in particular, had me lying on an angled piece of perspex glass and repeatedly "volleying a ball". There was no ball. But I can tell you, I was sore the next day!' Gill says. The campaign posters were printed in a range of sizes. 'Westfield had these massive banners hanging in their malls across the country', Gill says. 'The posters were on table tops in food courts, around the city and, as I'm still occasionally reminded of, on the walls of young aspiring footballers.'

Things have moved on even further as we write this book in 2019. Sam Kerr's prolific goal-scoring for clubs in the W-League, the NWSL – the first player ever to score 50 goals – and the Australian national team (including four goals against Jamaica in the 2019 Women's World Cup), and those astonishing back-flips – the spectacular goal celebration synonymous with the Kerr brand – prove much more marketable fodder for contemporary female football advertising. But as a way of finding a middle ground to launch women's football into the mainstream, the early seasons' campaign went some way toward finding a balance between reductive stereotypes, such as 'attractive player posing with ball' accompanied by a cliched or corny catchphrase. The players in the ads were portrayed in the technicolour of their full kit (not

semi-naked), in acrobatic action, performing football-specific moves. Although the players were still shown in a somewhat sexualised light, the posters were less exploitative, less oriented toward the male gaze, and catered more to an aspirational audience of girls and women who could see a player they might be able to become. It was a great leap forward from the controversial Matildas nude calendar.

Coincidentally, those posters brought Drummond to the attention of the man who is now her husband. The physios who looked after the Brisbane Roar women's team also looked after the Brisbane Lions AFL team, so the Lions players, including defender Josh Drummond, were aware of the posters and the physios' connections to the women's team. 'Josh, when he was single, asked my physio if there were any single [female footballers] and my name came up and the poster got mentioned.' The couple are now married with two kids. 'So the poster helped me out, didn't it?' Drummond laughs.

With over a decade of consecutive seasons now complete, the W-League is Australia's longest running national competition for elite female footballers, each season incrementally improving on the last. Teams vie for premiership points throughout the season, which runs from November to February, and teams compete for both the premiership, which is determined by the season results, and the grand final—determined championship.

Football benefactor Frank Lowy's chain of large-scale shopping centres, Westfield, attained naming rights for the first W-League – a position of prestige for sponsors who pay enough to have their brand come before the tournament title and therefore be associated with the product. Westfield has maintained the same level of sponsorship across the life of the competition. The W-League's inaugural season featured eight teams. Seven of them operated under A-League branding – Adelaide United, Queensland (later Brisbane) Roar, the Central Coast Mariners, Melbourne Victory, Newcastle Jets, Perth Glory, and Sydney FC – while the eighth club, Canberra United, operated as a standalone enterprise. The league lost the Central Coast Mariners in 2010 due to lack of funding, but then gained Western Sydney Wanderers in 2012 and Melbourne City in 2015, bringing the league to a competition between nine teams.

It was no surprise that traditionally strong states featured heavily in the W-League's first few seasons. Queensland/ Brisbane Roar, Sydney FC, and Canberra United all jostled for premierships and championships before Melbourne City arrived on the scene and claimed three straight championship victories. But the league also quickly met one of its key milestones for identifying talent, with standouts such as Michelle Heyman, who had not come through established football programs, earning the league's Golden Boot – the award granted to the player who scores the most goals in a given season – and a Matildas call-up. Heyman didn't even know who Tom Sermanni was when he gave her his details at a W-League awards ceremony – perhaps a sign of her

outsider status and how little-known the Matildas were at the time.

Just as Australian women's football has struggled at the national and international levels, the domestic league met with challenges too. 'Despite a report drafted by [sports lawyer] Eugenie Buckley to the contrary, the W-League was formed with only A-League clubs in mind', Heather Reid says. Initially, the plan was to align the W-League teams with the A-League teams, which were themselves just three seasons in. It seemed sound – W-League clubs could leverage A-League clubs' existing branding, resources, and facilities. But in practice, it played out a little differently.

The FFA was responsible for travel and accommodation costs – no small feat given Australia's size and the expense involved in travelling such long distances. The expectation was that the A-League teams would handle the admin. But with the A-League teams too busy trying to establish and shore up their own league, there are stories of A-League clubs not making gym or medical staff or equipment available and prioritising the best training pitches for the men – either deliberately, or through oversight, or a combination of the two. With the exception of coaches such as former Socceroos Ange Postecoglou, who was coach of Brisbane Roar men's team at the time, quietly coming to watch the Brisbane Roar women's games at Ballymore, the men's and women's teams for the most part trained and played in isolation. There was no cross-promotion or overlap.

An exposé on the SBS website by football writer Ann Odong, to which players contributed on condition of

anonymity, cites examples of issues the women's teams faced and continue to face. They include not having full kits available for the start of the season, and the kits they had being ill-fitting because they were not specifically designed for women's bodies. Some W-League teams were forced to find their own pitches to train on because the available pitches were sub-standard. That sometimes meant they didn't have access to showers or toilets because the facilities were locked while they were training. Matchday venues at times ran out of water and ice – not just an inconvenience but a hazardous situation, given that W-League matches are often played in the heat of the Australian mid-afternoon summer sun.

Even implementing double headers – a solid marketing strategy to piggyback on crowd numbers and broadcast coverage – was a mighty challenge. 'Now, the men's team runs out onto the pitch almost seamlessly after the women's game finishes', Sermanni says, 'but I remember trying to get a double header was almost impossible because you had to start it almost the day before to allow the ground to be clear [for the men's team to prepare]'. He recalls one double header equivalent played as a precursor to the W-League at Suncorp Stadium where the tech crews started playing all the A-League advertising and music during the women's game. When Sermanni and others asked what was happening, and couldn't they see there was a game going on, the mystified response was: 'Well, we've got to test the A-League adverts'. 'I was absolutely smoking', Sermanni says. The crew eventually, reluctantly, stopped testing the A-League sound.

Another striking example followed after Brisbane Roar secured the 2017 W-League premiership – the Brisbane Roar players were allowed just enough time to hold the premiership plate aloft for a photo before they were shooed from the pitch. The male players, trailing in ninth position in their competition, were already warming up behind them, trying to ignore the trophy. The league winners were also relegated to the spare, far smaller, changeroom – a fusty-smelling former storage area fitted with lockers, but there was no air-conditioning or hospitality table with fruit or power drinks, just an esky. The players' strips were not hung; their training kit not neatly folded. The difference between the luxurious, four-bed massage table room for the men and the dusty, single-bed room for the women provided a stark reminder in plain sight: the men, despite their form, are more important.

As the A-League teams' administration did not step up in those early years, state federations had to do it instead. W-League teams mostly operated on shoestring budgets in isolation from their A-League equivalents, even though they carried the club branding. It was an unsustainable situation, but fortunately there was an example of how it could be done. Canberra United demonstrated a different model; based in the Australian Capital Territory, initiated by the state football association Capital Football, and driven by the resourceful and industrious Heather Reid, the club was much more successful in supporting its team. 'The club set a benchmark across the W-League in terms of professionalism and support of their players', Gill says. 'We received small reimbursements

that would cover some costs – I know this is something that wasn't common across other W-League clubs, especially in the very early seasons.'

In 2019 the FFA announced a policy change that will allow A-League, W-League, and Y-League (men's youth) teams a greater degree of independence and 'commercial self-determination', namely to be more entrepreneurial around sponsorship and revenue-raising, as well as in developing infrastructure and recruiting players. The changes, which also seek to ensure the clubs take responsibility for their own sustainability, could lead to the removal of salary caps and, eventually, the development of a transfer market to trade, and potentially generate revenue from the sale or transfer of, players between clubs. Those involved could do worse for themselves than to study how Canberra United has been operating since 2008. Having had the full support of the federation running it rather than being an add-on, Canberra United's standalone status afforded it a greater degree of independence when it came to financial management and adhering to the rules and regulations that bind the A-League club set-ups. In a 2013 interview, for example, Reid was pressed to discuss Capital Football's annual report, which revealed that the independent W-League club spent A$326 100 the previous season and generated revenues of A$327 000. 'The more income we generated, the more we could put into the team', Reid said.

The club was self-sufficient through a combination of an ACT government grant, gate receipts, sponsorship, and merchandise sales. In Canberra, a number of sporting teams

in national leagues run concurrently with the W-League: basketball, netball, and cricket. Rather than compete for audiences, they joined forces. 'We ran a Summer of Sports promotional campaign', Reid says. 'We helped promote each other's games. It was great. The basketball players would come and watch the football, and the girls would all go to the basketball. It helped everybody.'

Whether they were affiliated with A-League clubs or not, the W-League clubs' budgets were small. It forced W-League administrators to think creatively to ensure talent and opportunity were evenly distributed, to both counter the anticipated dominance of strong footballing states such as Queensland and New South Wales and to help the W-League as a whole live up to its aim of developing female footballers. One such solution was the implementation of a fly-in-fly-out (FIFO) roster of players. It was an innovative, if imperfect, way to provide playing opportunities for fringe and up-and-coming players as well as try to ensure fairness. The FIFO players trained with their home-state squad throughout the week, then flew interstate to play for their official W-League club team.

Although the system was less than ideal – it would have been preferable for players to train with their respective teams full time – it was an inventive way to work within the league's minimal budget. It also gave emerging players in states such as New South Wales and Queensland, which boasted the majority of the national-team players, a chance to earn invaluable game time. 'We could easily have kept them there and kept them on the bench and given them a little bit of game

time, but I think what was best for their development was to go and play games', former Brisbane Roar coach Jeff Hopkins says. 'It worked for us because we gave them game time and developed them as players, and they eventually came back to us as better players. And obviously it helped the opposing clubs to maybe put out a stronger team, which helped build the general strength around the league.'

Now national-team regulars, Katrina Gorry and Laura Alleway were two such emerging players. Alleway had not made state representative teams before she was selected for the national team, and was therefore the kind of late developer the W-League was designed to identify and nurture. 2014 Asian Women's Player of the Year, Gorry was just old enough to play in the W-League when it started, but not yet experienced enough to compete against the likes of senior Brisbane Roar players such as Kate McShea and Alicia Ferguson-Cook. Gorry paid her own way to fly interstate to play for Melbourne Victory for a season. The next season she played for Adelaide United. The year after that, coach Jeff Hopkins invited Gorry to join the squad but told her he couldn't guarantee her game time, so she returned to Melbourne Victory, even missing her school formal because it was a choice between that and being in the Starting XI (starting team) for the first time. She chose the Starting XI and played so well she was selected to start for Melbourne Victory for every game for the rest of the season.

Gorry broke into the Brisbane Roar team in 2012 – the same year she debuted for the Matildas – and has played for it ever since. While she would have preferred to stay in her

hometown and play for the Brisbane Roar from the outset, the experience of training with some of Australian football's most talented and experienced footballers as well as realising she wasn't yet good enough for the Brisbane Roar motivated her to improve.

Though successful, the FIFO option was still an awkward set-up, particularly in the weeks preceding crunch matches between the teams. At one stage, former Matilda Jo Burgess was training with Brisbane Roar but playing for Sydney FC. She could not train with Brisbane Roar in the week leading up to the now-infamous semi final against Sydney that saw Stajcic sent from the sideline. (She couldn't, after all, know Brisbane Roar's tactics heading into the game.) 'It was tough because you can't do any tactical sessions with your own side and Fridays we weren't allowed to Roar training because that's when they'd do their tactical sessions', Burgess says. 'I guess it's hard to gel with a team when you're not training with them.' But the FIFO roster was temporary and only ever designed to help players and the W-League get a solid footing. With increased funding, including player salaries, the league and players moved on from the set-up.

The most troubling aspect of the arrangement is that, due to budget constraints, most W-League teams have largely been game-day FIFO teams. The prohibitive cost of putting teams up overnight has meant many of the teams have had to fly in to a given city on game day, starting their day before dawn or even the night before, staying with teammates or having to get up extremely early to make the drive. (Fortunately for Brisbane Roar, Brisbane Airport Corporation

sponsored the team, which enabled many of the players to park at the airport.)

'One thing I do remember is we didn't often travel the way that we should have done', Hopkins recalls. 'We'd often travel on the day of the game, get to the airport, have something to eat at the airport – no hotels or anything like that for a lot of the games – then travel straight to the game, play the game, jump straight back on the bus, and straight back to the airport. So in and out on one day made it very, very difficult', he says. 'Even at times we'd travel early in the morning and then we'd maybe sit in a Coffee Club or a café for three or four hours waiting leading up to the game because we didn't have the budget to book into a hotel or anything like that. Again, sometimes or a lot of the time, the preparation wasn't how it should have been.'

Hopkins says it would have been understandable if the players had complained, but they rarely did. 'They just got on with it. And some of the performances they put in despite the preparation was just amazing.' Flying back the same day makes recovery incredibly difficult – there's no opportunity for rest or room for ice baths, for example. But teams did find ways to manage it. 'The best games were when we'd play maybe in Canberra or Newcastle where we actually couldn't get a flight out so we were forced to stay, to find the budget from somewhere', Hopkins says. 'So we'd stay over and then we could do [recovery] properly.'

Even when W-League teams aren't flying in and out, few teams had or have true home pitches. Their nomadic life – which invariably involves playing on pitches far from public

transport, with the occasional major stadium double-header pitch thrown in the mix – provides them with little to no home advantage. Pitch surfaces vary in quality, but are often far inferior to those the men train on. Interestingly, the PFA's *2017/18 W-League Report* noted that more than 53 per cent of players would prefer to play standalone games rather than double headers because the timing – often during the hottest part of the Australian summer day – leads to sub-optimal performances. Double headers may lead to greater exposure, but as one player flagged, they don't help win championships. But as another player acknowledged, this would mean not necessarily having access to good pitches – they wished it was not an either/or option.

Such absence of home grounds also makes it impossible for fans to travel to support teams. Matches are often played in suburbs so far-flung they are not technically in the actual cities that give the teams their names. Travelling to the games means that fans need to be able to drive and to carve out significant chunks of the day to allow for travel. For players, it means there is no consistency in pitches and preparation, and the absence of things as simple as changerooms and lockers set up to cater to their needs. W-League teams have essentially been camping out in various facilities for 11 seasons now, not ever quite able to truly call a place their own.

The location and quality of the pitches aside, a bigger issue hampering the W-League's fan uptake was that, until the 2018/19 season, the games were not visible to most people. With just one match broadcast per week – a match arbitrarily determined before the short season commenced – it was,

for the league's first 10 years, nigh on impossible for fans to fully support their teams. Often, the crunch, finals-deciding matches would be played out unseen beyond the spectators who could physically be there while a match that would not influence teams' overall standings was broadcast. Still, that was the best they could get at the time, with the ABC the only broadcaster willing to cover the competition. Even then, that slot would periodically get bumped for other events the ABC deemed more important or had pre-scheduled, including, without fail around finals time, golf.

When the ABC, itself a victim of budget cuts, announced in 2014 that it would be ending W-League and Women's National Basketball League (WNBL) broadcasts due to 'declining audience interest in local sport', it marked the end of more than 30 years of women's sport coverage. It also confirmed what women's sport advocates already knew: when money was tight, the budget, coverage, and support for women's sports was the first to go. Although the ABC's coverage ended up being salvaged through sheer community outrage and pushback, and although cynics might suggest the ABC cannily leveraged women's sport to have some funding reinstated, it's worth noting that the men's sports coverage was never in doubt.

The announcement that every 2018/19 W-League match would be broadcast courtesy of a federal government-funded Foxtel set-up was met with relief: it was finally happening after more than a decade of second-rate coverage. Key games were simulcast on the original women's football supporter, the free-to-air SBS, as well as the My Football Live app. Game days

spanned the weekend and introduced a televised Thursday night fixture, alongside the usual Friday night, Saturday, and Sunday fixtures. The FFA also reached a deal with American video streaming service ESPN+ to broadcast A-League and W-League matches in the US. It finally felt like things were beginning to shift. But when Foxtel later announced that it planned to abolish 'non-marquee sporting content' after posting a 2018 financial year loss of A$417 million, it was unclear whether the deal to broadcast every match would continue – the subtext of the announcement was, undoubtedly, that sports such as women's football fell into the non-marquee, or lesser, category. This was particularly brutal given that Foxtel had only a year before been awarded a A$30 million federal government grant designed to boost coverage of and support for women's and niche sports.

To date, Australia's W-League coverage has been primarily linked to broadcast deals, but with few sponsors beyond Westfield and with even fewer broadcasters lining up for the rights, the FFA has been forced to take what it can get. A cursory glance at other leagues and other codes suggests that long-term, free-to-air broadcasts and/or live streams of every match will be the only way women's football will truly be viably visible. If you can't see it, you can neither support it nor be it. This is something fans and players alike agree on. The *2017/18 PFA W-League Report* found that players themselves would prefer live streaming and other expanded coverage, including online access for international viewers akin to the partnership with YouTube that the NWSL has established. Some 66.7 per cent of them indicated live streaming

of all matches was their preferred option; just 7.7 per cent thought the coverage should stay as is. The US might offer the clearest achievable example. It recently broadcast all of its NWSL matches live and free via YouTube and the NWSL website.

Running concurrently with the recent moves to gain more publicity for women's football, and not to be underestimated, is social media, which exploded in popularity around the same time the W-League launched. In the absence of broadcast coverage or media interest, social media accounts such as the FFA-auspiced Girls FC, and Matildas and W-League, which were run by a contractor, provided an avenue to connect fans with players and football through behind-the-scenes content, even if it was one the FFA paid little attention to. Australia's female footballers have gone from not having accounts at all to being savvy social media users who share content that supplements, extends, and even drives media coverage. They speak directly to their fans and media, controlling the narrative and sparking interest in women's football as a sport and a brand. This social media and other media coverage also gives current players something they can keep and look back on. 'That's a major change', Drummond says. 'I reckon I have two photos of me playing professionally or semi-professionally. These players, they have so many photos and videos of themselves, which is fantastic. It also makes you feel a bit sad. At least there were things like the internet and

Wikipedia when I played. That generation [before me] doesn't have anything.'

Just as the lack of home grounds and stable broadcast coverage affects the sport, not having a full home-and-away season also remains one of the W-League's handicaps. The uneven season has led to some skewed top-four finishes over time; favourable draws have meant teams finish the season being matched against less-successful teams and have an advantageous run to the finals. That's on top of the pressure of the too-short season, which means a single loss can make or break a team's season overall, or a single injury can mean a player misses the season altogether. The season has in recent times increased from 10 to 12 games plus finals, but analysis of the Matildas' 2019 Women's World Cup campaign makes clear that the W-League needs serious investment and significantly more games if it is to compete with quickly advancing European leagues. The UK alone has a 35-game season as well as Champions League games, and countries such as Italy and Spain are starting to strongly develop their leagues and player pathways.

Former Brisbane Roar coach Mel Andreatta suggests that one possible way to accommodate the additional games required to give the W-League a minimum full home-and-away season could be through using mid-week fixtures, which is common practice in international leagues. That would mean, for example, that Brisbane could travel to Sydney, play Saturday against Western Sydney Wanderers, stay there, train, then play against Sydney FC on the Wednesday night. Another option could include scheduling away games close together

geographically and chronologically, for example following a Perth game with an Adelaide one. This would, of course, mean that clubs would need to be able to afford accommodation costs and access away training facilities. Even with these additional games, the W-League could be extended by a minimum two or three weeks without encroaching on the NWSL schedule.

It's difficult to imagine how a couple of extra rounds could be that much more expensive when all other elements are already in place, but lack of budget remains the primary cited reason for why the season cannot be lengthened. The change is sure to happen, but 'when' is the ultimate question. As the media picked through the ashes of the Matildas 2019 Women's World Cup exit, some claimed that the W-League was stagnating. These claims may, just as other women's sport wage increases did, force the FFA's hand through sheer fear of being left behind European leagues. Whatever it takes, and however it happens, those extra rounds need to be implemented.

Tom Sermanni doesn't believe the W-League is stagnating – as he points out, a competition that attracts solid numbers of players from one of the world's top leagues, the NWSL, is not one that's resting on its laurels. Recent seasons have included Scottish national-team player and leading goalscorer Kim Little, current USWNT player Emily Sonnett, and Welsh national-team player Jess Fishlock, who some consider to be one of the best players never to have been to a Women's World Cup. The co-captain of the USWNT Megan Rapinoe herself trained with and made a two-game guest appearance for Sydney FC in the 2011/12 W-League season. This was just months after she sent in the iconic 2011 Women's World

Cup cross that enabled Abby Wambach to head, in the 122nd minute of the quarter final, in a goal against Brazil – to date the latest ever World Cup goal, women's or men's.

'The Australian is still by far the youngest league in the world', Sermanni says. 'If the league was stagnating, the Matildas wouldn't be coming back to play in it. To say the league has stagnated is a misnomer.' Given that even Sam Kerr, whose offers abound overseas, is returning home, he has a point. (As Tameka Yallop says, 'The W-league has always meant so much to me as I was 16 when it first started and have always enjoyed coming back to Australia to play in front of family and friends.') Sermanni believes, though, that the league requires further investment and development, not least by growing the number of teams in the competition and getting to a minimum of two full rounds.

It's had its teething issues, but the W-League has made some decent inroads in its first decade. 'I think it's been a great success story, if I'm being honest. I believe it's one of the best things we've put in place to help the women's game', Sermanni says. 'You either get in and you get started and then you fix it as you go, or you wait for the perfect model and you'd probably still be waiting for the league to start. I'm obviously in the camp of getting started and fixing as you go.'

And, as Hopkins says, there have been some great times. During the W-League off-season and when the Brisbane Roar team reverted to QAS branding and played in the U16 boys

league, midfielder Lauren Colthorpe messaged Hopkins to say she was running late to a Gold Coast game but was on her way. Shortly after, 'I looked out the window and I saw Loz walking across, and she had with her about an eight-week-old puppy, a little sausage dog. I knew what was going to happen as soon as she walked in with this little sausage dog: the girls would just go crazy about the dog.' Finishing off the team talk, he said: '"Right, you girls have got one minute to pet the dog and then get yourselves focused on the game." The players looked around, unsure what he was talking about until Colthorpe walked in with the puppy and the team fell about fawning over him. After the allotted minute had passed, Hopkins told them 'time's up' and took the puppy out to his wife, who looked after him for the match's duration. 'I think within a month we had one as well', Hopkins says. 'And we actually dog sat for Loz a couple of times when she went away for the Matildas camp.'

While almost the first decade of the W-League maintained the status quo, recent seasons have made incremental improvements, reflecting women's push for equal rights around the world. The minimum A\$10 000 wage, instituted in 2017, is climbing year on year. Viewership and crowd sizes are, on the whole, increasing, and for the first time we're beginning to see active support organisation emerge in the stands. Through the work of the FFA's volunteer of the year Chris McAllister, for example, Brisbane Roar's active support The Roar Corps has grown into a burgeoning fan group with its own merchandising, songs, drums, and organised meetings with players and administrators.

As it was designed to, the W-League's scheduling fills the breaks in the calendars other schedules don't. For Australian players hoping to ply their trade year-round (the *2018/19 PFA W-League Report* outlines that 12 domestic W-League players currently play in the NWSL), it provides a window, however short, in which they can play at home, see family and friends, earn some cash, and maintain strength, conditioning, and match fitness before heading back to the US or Europe for their longer seasons.

The W-League has also provided an exchange program of sorts, with US and other countries' players (often on the recommendation of Australians they've played alongside overseas) also taking up the opportunity to play during their off-seasons. They bring with them ball skills and fanbases they introduce to the W-League, increasing the standard of and following for women's football overall. There was talk during the 2019 Women's World Cup of the NWSL and W-League strengthening ties to ensure the two could improve and be competitive with the rising stars of European women's football. While it remains to be seen if that unfolds, with many Australians and Americans already making that northern–southern hemisphere trek depending on the season, it's likely to be a symbiotic and effective relationship.

Chapter 5

SHOW THEM THE MONEY

In the days after Katrina Gorry was flown business class to the Philippines and feted as 2014 AFC Asian Women's Footballer of the Year, she fielded media interviews on short breaks out the back of the Brisbane café where she worked part time. She was only able to do this because her boss was accommodating. The café's regular customers were none the wiser to Gorry's accolade and whirlwind few days. Answering media questions near the unglamorous café back entrance was a stark contrast for Asia's best female footballer, who went from a black-tie function to a low-paid service industry job in the space of 24 hours, but it is one that's illustrative of her and other female footballers' predicament – her phone was running hot, but interviews don't pay bills.

Australia's female footballers were excelling on the football pitch, but in the absence of true funding and support, they were propping that success up with, and managing it in between, other jobs. Gorry's is just a recent example of this long tradition. Outwardly, players such as Cheryl Salisbury and Joey Peters were representing Australia at the highest level

of women's football. But Peters was cleaning toilets between training sessions and Salisbury moved from jobs such as working on a chicken factory production line to fronting up, cap in hand, to collect the dole. (As former Matilda Lauren Colthorpe recalls, heading into the 2007 Women's World Cup, 'a third of the team was on A$10 000 a year, and our highest paid player, Cheryl Salisbury, was still earning less than someone who worked full time at a supermarket'.) Players such as Sue Monteath had to stretch her teaching salary further than usual when she took leave without pay to go on tour; Tameka Yallop worked at a paintball centre; captain Melissa Barbieri worked as a first-aid officer; Chloe Logarzo as a landscaper. Meanwhile Moya Dodd and Sacha Wainwright established careers as lawyers. They weren't quite at the stage of doing the men's teams laundry, as had infamously happened to players in the UK, but Brooke Spence, Kim Carroll, and Clare Polkinghorne worked behind the Brisbane Roar reception desk while their male counterparts' considerably higher salaries meant they didn't have to consider receptionist work at all.

Whichever way you look at it, making it work involved a juggle. 'Basically, you either worked or studied full time during the day, because we always trained at night and in the morning', Jenna Drummond says. 'I worked part time and did uni, but my mum and dad supported me. I was really fortunate. If I hadn't had that, I would have had to work more.'

The story is similar no matter which player you ask. 'It was impossible to keep a job outside of football most of the time', Colthorpe says. 'We were away too much, so unless

the players were working for a family member or friend who understood their commitments and gave them time off, it was hard for those who weren't studying to try and get experience and build a career for post-football. I was on Austudy while studying after the 2007 Women's World Cup, then I jumped up a tier in the contracts and my student allowance was cut, but my Matildas contract was similar to what I was getting from Austudy.'

Melissa Barbieri's experience on the dole was similar: 'We would have to declare every time we left the country and then had to restart every time we came back home. We had student payments or even just normal dole because we couldn't get work because no one would employ someone who had to train all the time.' Things improved only when she came across a supportive employer, Good Samaritan primary school principal Bob Brown, 'who basically hired me knowing that I would have to be away a lot of the time, and all the office staff supported my employment, even though it would mean covering [for] me while I was away'. From then on, when she was in the country, Barbieri worked at the Melbourne primary school as a first-aid officer.

Former Matilda Jo Burgess says, 'It was a massive battle for me personally, paying rent and trying to juggle a full-time job plus full-time training and playing. I lived off takeaway [because] I had no time to cook. At one stage I was getting home between 9:30 pm and 10 pm and getting up for work at 2 am. I was constantly tired. I often wonder how much better I would've performed if we were professional athletes that didn't have to work.'

For Di Alagich, pursuing her dream of playing football required moving from Adelaide, where there were few elite female footballers, to Canberra to gain experience playing with Australia's best. 'I didn't make the first AIS intake in '99', she says. 'They offered for me to train with the team, but I was living in Adelaide at the time, so I basically packed up and went.' A friend of a friend who managed the Canberra Motor Village rented her a cabin for $80 a week and gave her a job maintaining the grounds. Alagich was earning about A$300 a week before rent and the cabin she was in didn't have a toilet, so she had to brave the communal bathrooms in the middle of the Canberra winter.

'I couldn't even afford a car', she recalls. 'So I had a bike. And I used to get ice on my tyres and have to try and scrape the ice off to get home. And it was pitch black ... I used to be so scared I used to sing on my way home.' Still, she says, just the opportunity to train with the team in the hope of making the Olympics was worth it: 'It was just the love of the game. I'd do anything to represent my country ... We always joked that we made the decision to play for our country rather than be financial.'

Grace Gill worked full time for the eight years she played for Canberra United, but she was the exception to the rule. And she had an incredibly supportive employer (in the public service) who would let her take the occasional Friday or Monday off to allow time for travel. Kate McShea also credits a flexible employer for being able to make the juggle work. 'I was fortunate for most of my career to work at a physio practice as a physio aid, and then I got a job at the

QAS [Queensland Academy of Sport]. Thankfully both those employers were obviously sports-minded and willing to work around me, but I know other girls who worked at Maccas or kebab shops and a lot of the younger girls had to rely on their families for financial support, which I did as well.'

An additional challenge was that players were also encouraged to stay in Australia and prepare for major tournaments rather than play overseas, which meant they lost potential extra income. 'I guess players just had to be wise with their finances but there was a lot of struggle, particularly from older players close to retirement, not having much money behind them', Colthorpe says. 'It was a stress I carried while playing, not getting ahead financially and worrying about the future. It's something the current national team players don't have to worry about and I think that's great. Having financial worries while you're trying to prepare for a major tournament, for example, isn't ideal.'

Fast-forward to the present where the players are earning a 'liveable' wage. It's clear female footballers' wages have increased significantly. 'To be a player now and know you're setting yourself up financially while doing what you love must be unreal', Colthorpe says. As every female footballer understands, the increases have been incremental and hard won. Looking back at her own representative days, Drummond sums up how each generation, including hers, benefitted from the hard yards of the ones before. 'You were not getting paid for anything, but everything was getting paid for. You had to pay your way until you got there, of course', she says. 'But as opposed to the generations before, who had

to pay their own way. They paved the way for us, and we've paved the way for the next generation.'

For almost the first 10 years the W-League was around (as well as in the various leagues before it), the players were paid very little – and often nothing – in the way of wages. Some 85 per cent of the players earned less than $5000 per season; the majority played for free. Players were given $100 a week to cover expenses: petrol money for driving to training. 'It was nothing', former Brisbane Roar player Ellen Beaumont says, 'but having been paid nothing for my entire career prior to that, that $100 petrol money felt, in the short term, like a lot'. Regardless, it did not stretch anywhere near enough to cover players' rent or groceries, much less the top-level health insurance they were contractually required to have, which they had to pay for out of their own pockets. Some players had to pay for gym memberships too, as their clubs either could not provide a gym in-house or were not willing to cover the fees.

The cashed-up Melbourne City club, owned by the City Football Group that also owns English Premier League club Manchester City, set the W-League benchmark. It offered higher-than-base wages for its female footballers and provided both the women and the men access to the same training facilities and medical support. Melbourne City's integrated, funded approach meant the team recruited top-tier players such as Lydia Williams, Jess Fishlock, Steph Catley, and Kim

Little, and in a 'threepeat' the team unsurprisingly won the league in its inaugural season and then the next two. With some proper investment, it was a sign of what a club could – and should – be.

The 2017/18 season saw a significant wage bump across the W-League, with all players earning a base salary of A$10000 per season, with higher tiers for those with more experience. While it would be good to be able to say that the increase came about because the FFA recognised the players' talents and worked to rectify the disproportionately small salary, in truth it happened only after Melbourne City's benchmark, combined with improvements in other women's sporting codes, forced their hand.

Cricket Australia led the way, with base salaries for national female team players consistently higher than any other codes', and in 2017 implemented a landmark deal that saw players' total salaries rise from A$7.5 million to A$55.2 million. Not to be outdone, Netball Australia increased the average semi-professional netballers' salary from $40000 to $67500. With the AFLW recruiting players such as former Matildas goalkeeper Brianna Davey and boasting an opening-match crowd so large punters had to be turned away, the combined public relations pressure from other sports, embarrassment, and the fear that their players might be poached meant the FFA suddenly found the base salary that had been missing and seemingly impossible to implement for almost a decade.

Though still a way from enabling fully professional football careers, the cash was a welcome injection for the players

and, when combined with incomes from NWSL and national-team salaries, enabled players to eke out a living. It also opened other doors. As Heather Garriock wrote in a long piece for the Optus Sport website before the 2019 Women's World Cup, earning an actual wage makes you seem a lot more legitimate to financial institutions when you're trying to apply for such adult things as mortgages – which were out of the grasp of previous generations of female footballers unless they obtained them through other career channels.

The financial implications extend far beyond applying for a mortgage. As former Brisbane Roar player Rebecca Price notes, having to commit to full-time, unpaid training forces players to pick up casual work, which is often low-paying and physically demanding. This means they have to work more hours to earn a decent salary while also pushing their bodies to the limit as they try to juggle the demands of elite athlete training with casual manual labour, both exacerbating their chances of injuries and reducing their ability to recover quickly.

The jobs players worked – and still work – to enable the necessary flexibility are diverse. Footballer turned rugby union player and Queensland Reds captain Lori Cramer works as a concreter; Lisa De Vanna worked at Big W and in a petrol station; Leena Khamis and Alanna Kennedy each worked in sports retail stores (Kennedy recalls selling Socceroos jerseys); Teresa Polias is a full-time primary school teacher; Larissa Crummer is an apprentice plumber. Thea Slatyer worked a variety of jobs, including as a rope access technician scaling buildings such as the Sydney Opera House to do repairs and cleaning, and as a horse-mounted security officer. Meanwhile,

Melbourne-based Melissa Barbieri sold much of her Matildas memorabilia and also some memorabilia donated by male footballers Mitch Langerak and Archie Thompson to fund accommodation and living expenses for a season playing for Adelaide United. Once she reached her target of A$5000, she shared the rest (a further A$2000) with her teammates.

While all of these jobs are flexible to cater to training demands, they're also the kind that tend to disappear without any sick leave or other support when injury strikes. It is, after all, difficult to walk around or lift things in a café or a retail store when you're trying to rehabilitate a knee or ankle injury. As PE teacher turned player agent Fatima Flores says: 'Players juggling both football and work too often find themselves in the unenviable position of choosing between an important football match and an important work commitment that clash'.

To escape this Sisyphean cycle, players have needed to add study to the mix in the hope it will improve their job prospects, which means they're pulled in essentially three different full-time directions: football, work, and study. So while on tour, it's not unusual to see players such as Clare Polkinghorne, Tameka Yallop, and Elise Kellond-Knight studying criminology, business, and pharmacy respectively, reading textbooks and making notes while waiting for the bus to training or doing assignments in their rooms between training, physio, and media commitments. Fortunately, institutions such as Queensland's Griffith University have offered some players scholarships, which has made it more affordable and enticing to study. Such elite athlete study programs also

come with in-built support, so players can obtain extensions or defer exams when needed if they're away on tour. Tom Sermanni says they also worked to recognise supportive employers. 'We implemented an employer recognition scheme to thank employers who provided players with flexible working conditions and, as required, time off to meet their sporting commitments', he says. 'The scheme involved inviting them to the W-League games and giving them a signed plaque.'

It's impossible to count how many players have been lost to the game because the juggle got too bone-wearying. (The *2017/18 PFA W-League Report* acknowledges this is a continuing issue, with 51 per cent of respondents saying they may leave the game early due to financial reasons and 31.5 per cent because they can't achieve a work–life balance with football. Unsurprisingly, 85.4 per cent said better pay would prolong their W-League careers.) Kylie Ledbrook, who'd been in the 2010 Women's Asian Cup-winning squad and was a stalwart for Sydney FC, retired from the W-League for five years to work full time as a McDonald's area manager and start a family with her partner, fellow footballer Renee Rollason. She only returned once she felt financially secure enough to do so. Other players remained in the game, but delayed meeting milestones their non-footballing peers were hitting.

To save money, players who didn't have to move interstate often stayed living with their parents; they delayed buying houses or having children. Other effects such as low superannuation are less visible but are likely to have significant effects later in life. Such stresses raise the question of whether football has been a sport accessible only to wealthier players, or players

whose parents or partners have the means to support them. The little funding that was available was (and still is) unevenly distributed. Within teams, some players have been sponsored by sporting brands such as Nike, while other players remain unsponsored. Some of the sponsored athletes have quietly given some pairs of their own boots to the unsponsored players. In Garriock's case, Matildas coach Tom Sermanni personally bought her boots for the 2011 Women's World Cup because she preferred wearing Adidas, which wasn't at that time sponsoring female footballers, when the team was sponsored by Nike.

Former Matilda Ellyse Perry and current Matilda Sam Kerr are standouts and contrasts in the salary stakes – Perry, who was earning wages from both football and cricket, was likely the highest paid female footballer in Australia until Kerr recently took over the mantle. Perry was a fringe player at a time when football was making giant strides in its standard. She was estimated to be earning around A$150 000 a year due to her combined income from both sports – the same amount budgeted for entire W-League teams' salaries. She was also being named most marketable Australian athlete – female or male – while her teammates were living at home, working low-paid, physically demanding service industry jobs, and juggling training commitments at the same time as competing for coveted W-League and Matildas spots. The issue wasn't that Perry was being unfairly compensated for her skills and marketability – she likely could and should have been paid even more. It was that the other players weren't being paid much, if at all.

The media discussion around whether Perry would choose football or cricket or if she could continue to juggle both in some ways overshadowed the question of why she had to play two sports to earn one full-time sporting salary. Around the same time, her W-League team, Canberra United, issued her an ultimatum: commit full time to training with football or find another club. Canberra United was understandably and admirably trying to develop greater professionalism, but it was ultimately asking for professional commitment on less than professional wages. The Sydney-based Perry moved on to Sydney FC and continued juggling football and cricket – something that proved good PR for both codes. But in the end the decision was made for her. Although Perry attended some training camps beyond the 2011 Women's World Cup, she was not selected for any more international football tours. She has since quietly applied her full focus to cricket, where she is excelling and where wages have long been higher than football's.

The 2018/19 season saw the FFA implement its first ever W-League marquee player. The talented, popular, crowd-drawing Kerr, recently named Young Australian of the Year, coming off a bumper season in the NWSL and rumoured to be fielding offers from top European teams such as Olympique Lyonnais (Lyon), was paid in the vicinity of A$400 000 to play the W-League season as Perth Glory's marquee. It was win–win, with Kerr keen to return to her hometown of Perth and the league and sponsors such as Nike keen to capitalise on her capacity to draw crowds and interest. Off the back of that marquee signing and

subsequent sponsorship, including beating male athletes to be the face of Nike Australia, Kerr is reportedly set to become the first Australian female footballer millionaire.

The circumstances around Kerr's higher earnings are different: hers come at a time when her teammates are, though not as well remunerated as she is, earning base salaries above minimum wage; she is unrivalled in her footballing talents, breaking all manner of footballing scoring records, so there is no question about whether her income is warranted; and she is dedicated to football and football alone. (Although Kerr played AFL when she was younger and the AFLW would undoubtedly love to poach her, she has said she will not be switching codes during her football career. 'It's an AFL thing at the moment to try and snag some players from other codes, but honestly, if anyone in the Matildas was to leave for the AFL it would be stupid', Kerr said in 2017. 'We travel the world, we play in Olympic games … Nothing compares to it.') And as one of the first players to benefit from the strides her predecessors and peers made on conditions and wages, Kerr owes an undeniable debt of gratitude to the players who played before and alongside her.

It was a gutsy, terrifying move for the Matildas to go on strike in 2015. It was something no Matildas team had done before and it saw the players give up a chance to travel to the US to play friendlies against the top-ranked USWNT. But things had come to a head. After six months of collective bargaining

agreement (CBA) negotiation had stalled, the players were off contract, not being paid, and if they'd been injured they were not covered by insurance. If they had embarked on the US tour, the CBA likely would have remained unresolved, with the FFA knowing the players' desire to play exceeded their desire to be properly remunerated for it. But with players stretched beyond their means, continuing on a Matildas salary of A$21 000 per year, on par with Australia's poverty line, was untenable. Something had to give.

The dispute wasn't just about money. It was about respect and a willingness to invest in the future of women's football. The players were feeling crunched – the FFA (and the general public) demanded nothing short of full commitment and professionalism, but were not willing to provide the cash that would enable both. Former Matilda, now deputy CEO of the PFA, Kate Gill, says the strike 'was a game-changing moment' and 'the right and only decision the team could have made to advance their rights as professional athletes … This decision by the team was the catalyst for the seismic shift we have seen in the desire to professionalise women's sports from all the major codes.'

For Melissa Barbieri, in particular, it was a gut-wrenching decision: she had recently had a child and it was tricky to juggle a low-paid football career and parenthood. The US tour would have been her last before retiring. 'It was a huge decision for me. But I boycotted prior to the retirement to help my teammates', she says. 'The provisions for mothers did not get better, though, even after that boycott, so there was still no way I could continue. But it felt good to see that

I had been able to help impact the way our future generation was treated.'

The Matildas' demands were ultimately modest and in the interest not only of the players but the sport. First, they outlined basic minimum standards for full-time commitment and commensurate full-time pay that reflected the FFA's ambition for the team – not full-time commitment for part-time pay. (While the USWNT faces its own pay parity battles, the team was at the time at least paid a base salary of US\$70 000, more than three times the Matildas' A\$21 000, and the English FA paid the Lionesses double the Matildas' salary, at around A\$40 000 a year.) Second, they were working toward equality of pay and opportunity with men's teams. Third, they aimed to establish a full-time, professional career pathway for female footballers to achieve the FFA's goal of football being women's sport of choice. As Lydia Williams told media at the time, the requests were about laying a solid foundation to feasibly allow women to participate in and grow the game. The players were doing their bit – they were simply asking the FFA to meet them halfway.

Other pressing player needs included medical insurance – the players were spending inordinate amounts of their low wages servicing the top-level health cover required by their contracts while their male counterparts' health insurance was covered by the clubs and federation. The provision of maternity leave was also not well determined or implemented. 'There was no policy to bring a child along', Tom Sermanni says. 'Everything was Socceroos-centred. They didn't have a policy either because they didn't have children with them.

We had to say: "Well, we're not the Socceroos".' Officially, team manager Jo Fernandes' son wasn't supposed to tour with the team, but the FFA turned a blind eye. Later, Heather Garriock's playing career was cut short because there was no maternity leave agreement and the FFA was unwilling to implement an adequate one. The still-breastfeeding Garriock wasn't offered any support to bring her baby on a two-week US tour. The PFA paid to fly Garriock's mother over to help, but the set-up was far from family-friendly: Garriock wasn't even allowed to sit with her baby on the plane.

Stung that the sport she'd given everything for wasn't prepared to support her, Garriock eventually took the FFA to court. It was a bittersweet act given she knew the outcome would not benefit her, but she hoped it might benefit future generations. While other codes such as netball are making headway with maternity leave policies, this is something that remains relatively unresolved in women's football in Australia.

Barbieri's experience was similar to Garriock's. 'Having an inclusive feeling at camps for mothers is a massive deal. I had to leave my daughter home with my mother for six months in 2015 [preparing for the Women's World Cup], only seeing her two days out of seven because I was in Canberra', she says. 'I was lucky – my mother was retired and could help me, but I couldn't pay her.' Nor would Barbieri's mother have accepted money anyway. She had supported Barbieri's football ambitions for decades, including cooking and taking lasagne to National Championships so Barbieri and her teammates could have sufficient carbohydrates to fuel them for their

games. Caring for Barbieri's daughter was another way of continuing that support. Barbieri also points to the less-discussed fact that players are often delaying having children and some face challenges with falling pregnant later in life, once their careers are over. 'We are forced to leave motherhood late and it means some of us aren't able to have children, which is very sad', Barbieri says. 'We aren't taught about IVF and our options down the track if we are finding it difficult to have children because of our age etc.'

Lisa De Vanna was the sole Matilda who did not go on strike – a lonely and challenging road to take, but one that De Vanna, who does not believe players should be paid to play for their country, was firm on. While a unified front would have been ideal, in the end the Matildas achieved some improved wages and conditions – still very modest but manageable base salaries of A$41 000 a year for top-tier Matildas and A$30 000 for second-tier ones, with training camp and match day per diems. De Vanna benefitted too.

While the USWNT was undoubtedly disappointed to have the 2015 friendlies cancelled, it was not something the players could begrudge the Matildas. Though they are better remunerated than their Australian counterparts, they understand the long-term struggle to obtain fair wages for fair work, and have instituted multiple legal actions themselves. The lead-up to the 2019 Women's World Cup included USWNT players launching a class-action lawsuit to sue their governing body for 'purposeful gender discrimination' for failing to implement equal pay for equivalent work. Having won four out of a total of eight possible Women's World Cups

as well as four Olympic gold medals and eight Confederation of North, Central American, and Caribbean Association Football (Concacaf) Gold Cups, the USWNT, ranked first in the world, is far more successful than its male equivalent. The United States men's national soccer team (USMNT) has never won or even come close to winning a World Cup or Olympic tournament and did not even qualify for the 2018 World Cup.

Despite this success, the USWNT earns less than 40 per cent of the men's salary for equivalent work. All this was while the USWNT was being told US Soccer's pockets were empty and the women's team wasn't generating enough revenue to warrant equal pay. It now appears, as the lawsuit is alleging after going through the financial statements, that the team was actually benefitting US Soccer's bank balance. The federation had initially projected a US$420 000 loss for 2016 but later revised its figures to predict a profit of almost US$18 million, due in large part to ticket and merchandise sales from the USWNT's 2015 Women's World Cup victory tour. The figures reportedly also showed that while the men's team – one that has now been shown to be both more expensive and less successful than the USWNT – was set to lose US Soccer US$1 million, the USWNT team was actually set to earn it US$5 million. The *New York Times* pointed out the team is not only *not* being paid equally for equivalent work, it is actually being paid *less* for working harder, as the team played 19 more games than the men between 2015 and 2018.

The pattern is repeated around the world, whichever women's football program you look at. The Japanese national women's team, the Nadeshiko, travelled economy class, even after winning the 2011 Women's World Cup. The less-successful men's team travelled business class. In 2011, Brazilian club Santos infamously dismantled its entire women's football team as it sought to scrape cash together to service star footballer Neymar Jnr's multimillion-dollar deal and ward off transfer offers to keep him at the club. (The women's team total operating budget was 1.5 million reais a year; the club was then paying Neymar almost that – 1 million reais – each month.) Neymar later left anyway, with Barcelona paying a transfer fee of more than 57 million euros. It took until 2015 for Santos to resurrect its women's team, and that team is still far from supported. Shortly after the 2019 Women's World Cup, the team had to travel a circuitous route to a game and stay overnight in Brasilia. An error with the hotel reservations meant the players spent part of the night in the lobby until they found alternative accommodation around 1 am. After the match, they had to start their return journey on a 4 am flight.

In stark contrast to Neymar, fellow Brazilian and five-time FIFA Women's World Player of the Year Marta, who famous Brazilian footballer Pelé himself dubbed 'Pelé with a skirt', has struggled to find commensurate, steady-paying football work. She earns but a fraction of the salary earned by male players like Neymar, but even then many of the US- and Sweden-based football clubs she's played for have collapsed

financially. While Neymar secures giant transfer fees, journeywoman Marta has to work to secure a new, lower-paid contract with a new club. She flagged this pay disparity after becoming the first woman to score in five Women's World Cups – her 16th goal put her on par with male counterpart German striker Miloslav Klose, who scored 16 goals in four [Men's] World Cups. (She later overtook him when she scored a 17th.) As she celebrated, she pointed to her boots, which featured a pink and blue symbol signifying equality. Her football boot sponsorship deal reportedly expired in 2018 and Marta elected not to sign a new one because boot brands were not offering deals equivalent to those they're providing male footballers.

Brazil's failure to support and invest in its female footballers is legendary, something Marta again addressed in the moments after host nation France extinguished Brazil's 2019 Women's World Cup dreams in the knock-out stage Round of 16. She urgently implored women to 'want more, train more, take care of themselves more because there's not going to be a Formiga forever, there's not going to be a Marta forever, there's not going to be a Cristiane'. She was referring to the generation that kept on keeping on despite receiving no support and no money. Midfielder Formiga who, at 41, had just finished playing in her seventh Women's World Cup, is likely the last player ever to be born during Brazil's prohibition of women's football. (Attitudes similar to those expressed by the English FA saw women banned from playing football in Brazil between 1941 and 1979.) Brazil, once a football powerhouse, has begun to fade as it hasn't invested

in its future women's football generations. In that same post-match interview, Marta asked the next generation of female footballers to take up the fight: 'Women's football depends on you to survive. Think about it, value it more … We're asking for support. You have to cry at the beginning and smile at the end.'

The worldwide disparity extends beyond the football pitch to include women in management roles too. The English FA released its first ever gender pay gap report in March 2018, decades on from when its preceding administrators had banned women from the sport. The report, required by law and featuring what the English FA termed 'voluntarily disclosed contextualising background information' to explain the results, revealed an unsurprising 23 per cent gender pay gap tipped in men's favour. This was, the FA said, due to a problem with the 'pipeline' to installing women in senior management roles and that the organisation needed – and was working on developing – a better pipeline. Doctoral researcher Amée Gill called that theory into question. She suggested that, with just 7 per cent of board positions held by women, there are likely more complex cultural and structural barriers at play. But to be fair to the organisation, the fact that it is acknowledging such disparity and making efforts toward rectifying the gap are giant improvements on the English FA of old.

Pay disparity and its long-term effects is something former USWNT great Abby Wambach identified in her 2018 Barnard College commencement speech. In it, she discussed how athletes such as basketball player Kobe Bryant retired from

their sport of choice with something she didn't – large bank balances – and how that translated to freedom (or, in her case, a lack of it). As she put it, those athletes' hustling days were ending; hers had only just begun.

Earlier in her career she had been grateful for some pay – any pay. By her retirement she'd come to realise that no amount of gratitude for the amount of pay they did receive – which was more than their predecessors – could or should replace what was required: true pay parity. As a player, she was in a position where she had to be amenable and avoid making demands that might have jeopardised her selection chances. But looking back, she wishes she had pushed harder for pay parity, because that was when she had the platform and something to leverage. She endeavours now to help achieve that parity, and to help women understand that they can both be grateful for their opportunities and still demand more.

Such pay parity has been supported more widely by women in other professions, including actors involved in Hollywood's adjacent Time's Up movement, which aligned itself with the USWNT's cause. Some of its members, including Natalie Portman, Jennifer Garner, and Jessica Chastain, posted an image on Instagram wearing their USWNT jerseys with a caption stating that it was time US Soccer paid its female footballers the salary they deserved. Fans have been on board with it too, including two 2019 Women's World Cup fans sporting customised USWNT jerseys that featured the words 'equal pay' instead of a player's name and '= $' instead of the traditional player number. Incidentally, Nike CEO Mark Parker reported that the jersey the fans had customised was

to date the highest selling jersey – women's or men's – sold on Nike.com in one season. It's undoubtedly small consolation for the USWNT, but the lack of pay parity extends beyond the players: USWNT coach Jill Ellis too has been comparatively underpaid, being remunerated less than even the U20s coach, despite outperforming all of US Soccer's male coaches.

There's no question pay parity is a way off for any female footballer, but there have in recent times been some innovative salary improvements. Nutrition bar company LUNA Bar contributed US$718 750 – or US$31 250 per player on the 23-player roster – in sponsorship to the USWNT to close the pay gap and bring the team's 2019 Women's World Cup playing bonuses in line with the men's team's. 'As you can imagine, this got us pretty fired up. We knew we had to do something. And do it now', LUNA Bar said in a statement made on Equal Pay Day on 2 April. 'And let's be clear, this isn't about bravery and determination – which they rock in abundance. Or even about the money. It's simply because, well, they deserve it.' After the announcement, USWNT players Megan Rapinoe, Alex Morgan, and Christen Press told media it was incredible to have something positive to say about female footballers' salaries – so much of the coverage to date has concentrated on the negatives of the players having to sue their federation. Other sponsors such as Visa and Adidas are moving in a similar direction, explicitly moving to equally or even additionally fund women's football to help it achieve parity. And, in a move that likely made men's football organisers stop dead in their tracks, days after the USWNT won its fourth Women's World Cup, Senator

Joe Manchin tabled a bill that would prevent federal funding being used for the 2026 [Men's] World Cup until US Soccer enacted equal pay.

Similarly, in Australia the FFA and PFA announced a step toward achieving pay parity on the eve of the Matildas' 2019 Women's World Cup campaign: from 2019, W-League and A-League players will receive the same hourly rate for their work. Their annual football salaries will differ due to the part- and full-time nature of their leagues. W-League players will receive a minimum of $16 000 a season. It's still not a full professional salary that would allow players to concentrate solely on football, but it's at least remuneration-based acknowledgment of the issue the USWNT is having to argue in court: that female and male footballers are doing equivalent work. Recent years have also seen the complementary W-League and NWSL provide year-round training, playing, and money-earning opportunities for US players as well as Australia's own, such as Alanna Kennedy, Sam Kerr, Ellie Carpenter, Emily van Egmond, Clare Polkinghorne, and Steph Catley.

Just one woman made the 2019 Forbes' 100 highest-paid athletes list. It was tennis player Serena Williams, and even she only scraped in at number 63. No female footballer made the cut. Australian tennis player Ash Barty is a way off making the Forbes list, but her barnstorming climb up the 2019 tennis world rankings would have catapulted her ahead of most female footballers. In a year when female

footballers' low salaries are a major talking point, male foot-baller Lionel Messi topped the Forbes list with a reported combined salary, bonuses, and endorsements of US$254 mil-lion. Alex Morgan, who is estimated to be the US's top-paid female player with earnings of over US$1 million annually, reportedly makes more of her money from sponsorships than from her football salary. As financial website money.com pointed out, Morgan's annual earnings and net worth of an estimated US$3 million are, though impressive, still modest compared with those of male footballers such as Cristiano Ronaldo and Messi. With disparate figures such as these, it's unsurprising that the gender-focused issue of the specialist sports website Sporting Intelligence annual salary survey con-ducted in 2017 found that football's gender pay gap was even greater than those of politics and medicine.

The USWNT and the Matildas have been able to argue for improved pay conditions thanks to their on-field success – it's easier, after all, to make an argument for better pay when the governing federation is flush with prize money. But it's a double-edged sword: with the increasingly high standard of women's football, it's near impossible to achieve such a high standard without investing in players and the conditions under which they play and train. So players such as Megan Rapinoe are risking a great deal by fighting their federation in the courts while trying to maintain a rate of on-field suc-cess so the federation can't justify undercutting and failing to improve players' pay and conditions.

Two weeks before the 2019 Women's World Cup kicked off, Rapinoe used her popularity and platform to draw

attention to the gender-based investment disparity beyond her own football association: that despite having almost unlimited resources, FIFA has not invested adequately in women's football and was not doing enough to close the gap. Australia's PFA upped the ante four days out from the 2019 Women's World Cup kick-off, launching the cannily timed Our Goal Is Now campaign that maximised pre-tournament interest and media coverage as it called for equal prize money. The crowd at the 2019 Women's World Cup final also booed FIFA president Gianni Infantino and chanted 'equal pay' during the presentation ceremony. It wasn't a stretch to ask for equal pay considering that FIFA's two top executives were being paid more than the 2019 Women's World Cup-winning team would be, and that FIFA has almost $3 billion in reserves – 66 per cent more than it predicted – which Women's World Cup pay parity would reduce by a mere 11 per cent. PFA CEO John Didulica did not rule out bringing legal action for discrimination after the tournament.

FIFA had actually increased the 2019 Women's World Cup prize money to A$43 million (US$30 million), with A$5.7 million (US$4 million) for the winning team. Those are seemingly large figures, except when compared with the money offered for the equivalent men's tournament: A$574 million (US$400 million) and A$38 million ($US38 million), respectively. The women were set to earn just 7.5 per cent of the amount the men's teams earned in 2018 in the equivalent tournament. The men's pool money has already proactively been increased to US$440 million for the 2022 tournament. Didulica dispelled the myth that the

men's game's figures came about because it generated greater revenue. FIFA's prize money calculations, he said, were much more arbitrarily determined than that.

The PFA campaign ran with the wage-parity tagline 'Is it too much to ask?', but the campaign could well have been asking about things other than money. Equity in both pay and respect was the overarching theme of the 2019 Women's World Cup – something that started with inaugural Ballon d'Or winner Norwegian forward Ada Hegerberg boycotting the tournament to protest against the lack of respect shown to female footballers in Norway. Speaking to the BBC for its #ChangeTheGame campaign, which aimed to showcase female athletes in previously unseen ways, she told them it wasn't always about money; it was also about attitude, opportunity, and respect. One day, she said, the 'men in suits' would understand what she was protesting and why.

The boycott was an interesting stand for the 23-year-old to take as, from the outside, Norway looked to be leading the world, at least in pay parity. In 2017, the Norwegian Football Association (NFF) and Norway's players' association (NISO) signed a ground-breaking agreement that brought the women's team a pay rise of 2.5 million Norwegian kroner (A$302750) in 2018, with both national teams receiving six million kroner (A$726900) each after some of the sponsorship for the men's team was more evenly distributed. But it demonstrates that achieving equality in football goes far beyond wages, something that was perhaps encapsulated when host DJ Martin Solveig asked Hegerberg, just moments after she was named the world's best footballer, whether she could twerk.

Female footballers have in recent years been protesting against the lack of pay parity and related issues in big and small ways. The Scottish national women's team held a media black-out while in dispute, and eight former Brazil players penned an open letter criticising the Brazilian set-up and the lack of respect they were shown. Denmark pulled out of a friendly against the Netherlands and Nigeria held a sit-in protest over unpaid allowances and bonuses.

In a 2016 lawsuit, the USWNT called out US Soccer for ingrained discrimination at every level, with the men even inexplicably being paid US$75 per diems to the women's US$60 ones. (USWNT champion player Carli Lloyd drily suggested it was perhaps because women are smaller so presumably eat less.) Ultimately, Rapinoe summed up female footballers' and fans' sentiments moments after the USWNT won its record fourth Women's World Cup title when she said everyone – players, fans, even sponsors – is done with asking whether women are worth it; everyone's ready for the conversation to take the next step.

While the USWNT is the highest-profile team to be advancing the cause, there is undoubtedly a more collective, worldwide movement gathering momentum. Australian female footballers' wage improvements, incremental though they have been, occurred once the players got together and negotiated their agreements as a group. The Matildas and Socceroos have customarily negotiated their CBAs separately and, due to confidentiality requirements, have not had insight into each other's terms and have therefore not been able to leverage them. But the teams have begun to work more collaboratively

under the PFA's guidance, with a view to greater transparency and equality for both.

Like all aspects of women's football, the disparities are greater than just the wages. Improvements such as the FFA providing uniforms, flights, and accommodation, covering laundry costs and medical insurance, and ensuring the internet is available in the players' hotel rooms, have been just as important as obtaining higher-paying contracts. Recent improvements – which have meant the Matildas are no longer actively paying for the privilege of representing their country by having to fundraise and fork out for uniforms, internet, and laundry – have come about through the players negotiating collectively.

In her Optus Sport article, Heather Garriock wrote that the difference between the 2007 and 2019 Women's World Cup squads was purely investment – the talent's always been there. With investment, players have had time to concentrate on football. Like the USWNT, Australia's elite female footballers are walking a difficult line: they are on the one hand fighting for improved conditions and on the other having to prove such improvements are justified through consistently high on-pitch results.

As Melbourne City showed locally and Lyon is showing internationally (the best paid women's club in the world, it reportedly pays its players an average of £145 000 – approximately A$260 000), improved wages means it can attract

the best players, which raises the quality of the football and the league, which translates to results, which in turn attracts fans and sponsors. That's something temporary national team coach Ante Milicic, a newcomer to women's football, recognised, with the benefit of fresh eyes and perspective. Prior to the Matildas' do-or-die 2019 Women's World Cup group-stage match against Brazil, Milicic acknowledged the investment European federations are making in women's football and the giant strides they are making or soon will make. Italy was an obvious example, with Milicic and the Matildas facing the sting of their shock loss to the team days earlier. But Milicic also pointed to other federations such as the Dutch KNVB. Its women's team, which soundly beat the Matildas 3–0 in a pre-Women's World Cup friendly, made it all the way to the 2019 Women's World Cup final.

Crucially, Milicic flagged the need for long-term investment equivalent to that shown by federations that invest in the men's game. It takes time and money to develop juniors and facilities, he said, but it eventually pays off. His words could not be more relevant to Australian women's football – for decades, the FFA has expected that the W-League and the Matildas demonstrate overnight success without recognising that success requires significant time and investment. (Frighteningly, Kate Gill outlined, under their CBA the Matildas take home 30 per cent of the prize money they earn. The remaining 70 per cent goes to the FFA, which is under no obligation to reinvest that money in women's football.) Megan Rapinoe and Abby Wambach made similar arguments as the USWNT came under fire for over-the-top celebrations of its 13–0 opening 2019

Women's World Cup game. Don't criticise us for being too strong for Thailand, Rapinoe said. Pressure FIFA to invest in women's football properly to raise all teams up, including Thailand. 'This is a call to @FIFAcom to do more and give more resources for some of these countries', Wambach tweeted.

In the absence of domestic investment and pathways, international leagues such as those Rapinoe and her fellow USWNT teammates play in have long offered Australian footballers at least a semi-professional pathway. Players such as Kate Gill, Heather Garriock, and Sarah Walsh plied their trade in the US and European leagues in relative obscurity as their games were not televised internationally. More recently, a swathe of Australian players, including Steph Catley, Ellie Carpenter, Amy Harrison, Caitlin Foord, Clare Polkinghorne, Katrina Gorry, Sam Kerr, Alanna Kennedy, Emily van Egmond, and Hayley Raso, have embarked on year-round training and playing through balancing NWSL contracts with W-League ones, earning a living wage and cementing fanbases and national-team berths in the process.

The pay increase for the W-League and the Matildas has also meant players are able to concentrate more on football, even if they're not quite at the stage where they can do so full time. Gorry, for instance, no longer has to work at the café and rely on her boss' grace to take interview breaks. Yallop and Kellond-Knight are completing internships with Matildas sponsor Seven Consulting to help them prepare for post-football work. Players such as Heather Garriock, Kyah Simon, and Chloe Logarzo have also been inventive in developing sideline incomes, including by starting their own branded

football training programs to earn some cash and encourage the next generation of footballers. Current Matilda and Sydney FC player Harrison was in Garriock's first cohort. Garriock's academy-coaching experience also marked the first steps toward her current, post-playing career as a coach. More recently, players such as Kerr and Carpenter have been able to earn money from Nike and other sponsorships.

Commentating too now offers players supplementary and post-playing money-earning opportunities. It also provides a connection to the game for injured players. Harrison, for example, forged a strong commentary presence in the year she was rehabbing her second knee reconstruction. Alicia Ferguson-Cook transitioned from football to commentating and now works full time in sport in the UK. Kate Gill moonlights as a commentator in addition to her role working as a player advocate for the PFA. Sarah Walsh too commentates as part of a complementary side gig to her football administration work.

Optus Sport raised the bar for commentating opportunities with its women-led 2019 Women's World Cup coverage, boasting female football greats whose careers played out before or just at the start of any kind of remuneration. Through it, former players such as Garriock and Gill have been able to continue to give to the game, even though their careers were cut short. And Cheryl Salisbury and Joey Peters have finally been able to earn some income for their football work. It's a long way from cleaning toilets and collecting the dole, and while it far from makes up for what they could and should have been paid, it's a giant step forward for women's football both in terms of wages and respect.

Chapter 6

OVERCOMING INJURIES

When Hayley Raso copped a goalkeeper's knee to the back during a challenge in a Portland Thorns NWSL game, breaking three vertebrae, it was a shocking, potentially career-ending injury. She was first confined to bed, then a wheelchair, and had to learn to walk again after having been at peak fitness; the damage was almost incomprehensible. As was her remarkable comeback six months later. She first scored just 19 minutes after her 2019 W-League return with Brisbane Roar, and later scored a stunning goal just three minutes after she made her national-team return to the pitch in a Cup of Nations match against New Zealand.

Rewatching the challenge that broke her back, it looks painful but no different from many other striker–goalkeeper contests. The footage gives no hint of how badly injuring it was and makes you wonder about the fragility of vertebrae. But put in perspective, Raso's injury was something of an anomaly. In addition to hamstring complaints and ankle sprains, far more common in women's football are the dreaded, if predictable, knee injuries.

After decades of women either being or feeling excluded from sports such as football, women's sport participation rates are ascending. As are, unfortunately, their sports injury rates. In a 2016 article for the SBS website, PFA deputy CEO Kate Gill pointed out that wage inequality is what often makes headlines, but it's far from the only disparity that exists between male and female footballers: injury rates are often overlooked but no less pervasive. And in contrast to pay parity, they're a physical embodiment of the issues female footballers face.

The PFA, other organisations, players, coaching, and medical staff had long campaigned for the W-League to introduce common-sense minimum medical standards: having sports-specific medical staff; conducting pre-season medical testing (including anterior cruciate ligament (ACL) injury risk profiling); providing regular access to physiotherapists; keeping detailed medical records; and giving players the option to seek second medical opinions. In other words, the kind of standards you'd be surprised football didn't already have in place. The A-League introduced such minimum medical standards as far back as 2011 and immediately recorded a 68 per cent decrease in injury rates. It took the W-League until the 2017/18 season – almost 10 years since the league's inception – to implement such standards, which yielded immediate results: almost a 25 per cent reduction in injuries compared with the 2016/17 season, based on figures gathered from injuries reported in the media.

For the important role it plays, the ACL is a remarkably small and not at all robust-looking ligament. Buried deep in

the middle of the knee, the ACL connects the femur (thigh-bone) to the tibia (shinbone). Its primary purpose – its one job, if you like – is to prevent the tibia from moving forward on the femur, and to control tibial rotation. For many female footballers, it feels like their ACLs are failing at that job. There's also an air of resignation around female footballers suffering ACL injuries. Even if they haven't torn their own ACL, every female footballer knows at least one other footballer who has.

Questions were asked when 19-year-old Ashley Brown, widely considered to be one of the next generation's top Matildas, re-tore her ACL on her 2013 return from reconstruction. Had she not been ready? Could we have predicted or prevented this? And what did this mean for her football career? Subbed on in the 62nd minute, Brown had started strongly, her form belying the fact she'd had 12 months out with a frustrating rehab that included an unexpected bout of glandular fever. Just minutes from full time, Brown landed awkwardly and her knee collapsed. It took 24 hours, but Brown confirmed the diagnosis via social media and, with not even a full game back under her belt, embarked on another knee reconstruction and another year of rehab. Brown would go on to suffer a third ACL injury – her third in four matches, to be precise – which undoubtedly accelerated her premature retirement from the sport in her early 20s.

Former Matildas physiotherapist Kate Beerworth (now working for Cricket Australia) uses Brown's story to illustrate the importance of injury prevention and the tragedy of losing such a talented player from the sport under these

circumstances. 'I get really sad when I talk about her story', Beerworth says. 'She was like Steph Catley, you know. She was a gun. She only ended up playing six games for the Matildas.'

Weeks before Brown's second ACL tear, fellow Matilda Kyah Simon had torn her ACL in the classic non-contact fashion: when changing direction, her leg gave out as though she'd been snipered. Like Brown, she joined a succession of female footballers, from the grassroots to the elite, to experience the life-changing ACL injury. More recently, MelindaJ Barbieri not only sustained the injury but had to launch a crowdfunding campaign to pay for the surgery. After much social media contention about why an elite female footballer who plays for the Future Matildas wasn't adequately supported with medical insurance, the PFA and FFA, no doubt prompted by the outrage, stepped in to offer some support.

Beerworth says the reasons for the high numbers of ACL injuries in women is multifactorial. While there are factors that may suggest someone may be more prone to them – namely family history and a past history of previous ACL injury – we cannot identify who may or may not go on to sustain an ACL injury.

Various researchers have suggested differences in women's anatomy – such as knee shape and pelvis and ACL sizes – as well as hormonal and neuromuscular function as potential contributing factors. But there is little evidence to link all these potential intrinsic risk factors to non-contact ACL

injuries, and there is contention around the relative importance of each. Throw in other elements such as poor running and landing techniques and varied and often sub-par pitch surfaces, and there are too many variables to be able to identify a clear cause.

'The reality is all female athletes that play multi-directional sport are high risk. Screenings cannot predict who will go on to sustain such an injury', Beerworth says. 'What we do know is that ACL prevention programs exist and can reduce injuries by up to 50 per cent. The issue we have globally is the implementation of these programs. The programs work, but won't work if people don't know about them, start doing them, and keep doing them. Football has led the way in this space globally with the well-proven FIFA 11+, an effective neuromuscular warm-up being validated and scientifically tested in many different football populations in both men and women, boys and girls.'

Women have been fighting so long and so hard to achieve equality in football, they've been wary of drawing too much attention to anything that would give men an excuse to push them off it again. Women are (depending on which research you read) approximately four to six times more likely to tear their ACLs than men, as well as 25 per cent more likely to sustain a second knee injury when they return. To put it in perspective, ACL injuries are the bane of not just women's football but other sports that also involve sudden changes of direction, pivoting, accelerations, and decelerations, such as rival sporting codes AFLW and netball. The numbers play out in equivalent leagues around the world. USWNT star

Megan Rapinoe, for instance, has undergone three knee reconstructions.

Most ACL injuries occur in women 18–20 years of age. That age bracket traditionally includes some of Australia's top female footballers. Jenna Drummond, Amy Chapman, Di Alagich, and Emma Checker tore their ACLs at around this age, just after receiving call-ups to the Matildas. For Alagich, the tear would come just as she made her first national-team Starting XI appearance. She would be out for two years and have to undergo a second surgery to correct issues related to the first. Drummond's experience was similarly tough. 'I was 20. It was devastating because it happened the day after my Matildas debut', Drummond says. 'I happened to be in my hometown [Coffs Harbour] when it happened, so my mum and dad were there. I was very much aware of what an ACL injury was because so many of the girls had had them.' As with many of the Matildas, she travelled to Adelaide to have the surgery under team doctor James Ilic's tutelage. 'I was fortunate my parents came down to support me', Drummond says. 'Everything was covered for me, so that was good, but they obviously had to pay their own flights and accommodation.'

Sam Kerr was a teenager when she first injured her knee in training in China, just days before the 2012 Olympic Qualifiers kicked off. She was initially positive, but the gravity of the situation hit home when she was away from her teammates and about to undergo surgery. For Kerr's birthday, which was a few days later and which would normally have been celebrated with the touring team gathering together to share some cake, physiotherapist Lauren Hanna (née Cramer)

wrote and performed a rap (she would occasionally write the team poems to entertain them during long tours). The team filmed the rap and sent it to Kerr to wish her well.

The first time Matildas first-choice goalkeeper Lydia Williams tore her ACL she was playing in Sweden and was one of almost 20 Swedish league players to sustain an ACL injury. (She later suffered a second ACL injury that would leave her racing the rehab clock to be fit for the 2016 Olympic Games.) Scandinavian countries keep a national register that records every ACL injury at both professional and grassroots level. There isn't yet an equivalent injury register for female footballers in Australia. The FFA has been monitoring injuries for the past five seasons in the W-League and for the past 12 in the A-League, although it does not currently publicly release its findings. The PFA includes what it can about W-League injuries in its annual W-League report, but by its own admission the figures are compiled only from what has been made public.

While it may not publish its research, the FFA is working on knee injury prevention behind the scenes. It has has partnered with researchers at the Australian Catholic University and Griffith University to research biomechanical and strength profiles of Australian female footballers. Following Beerworth's resignation from her head physio role for the Matildas at the end of 2016, she began a new national injury-prevention consulting role. She advises W-League and A-League clubs on implementing ACL prevention protocols, with a view to integrating such prevention into FFA coaching curriculum and reaching players at all levels.

The AFLW releases an annual injury report, and has partnered with La Trobe University to create the ACL injury reduction program Prep to Play. This came after the AFLW had a horror run in its first two seasons, during which research revealed that AFLW players are almost 10 times more likely to rupture their ACLs than male AFL players. Although the league was recruiting players from other codes who had at least some base strength and conditioning, players were dropping on an almost weekly basis in those early days. High-profile examples include Matildas and W-League goal-keeper turned AFLW player Brianna Davey, and Adelaide Crows co-captain Erin Phillips, a former Opals basketballer who'd already undergone one knee reconstruction. The latter tore the ACL in her 'good' knee during the 2018/19 AFLW grand final; teammates and opposition alike went up to shake the two-time AFLW best and fairest winner's hand and wish her well as she was stretchered from the field.

If you cast your eye over a photo of the 2010 Women's Asian Cup-winning Matildas team, you can gain a sense of two things: Australia's euphoric first serious taste of success in Asia; and a point-in-time look at the number of Matildas who were or would soon be affected by knee injuries. There's Sarah Walsh, who's had three knee reconstructions and so many arthroscopies (keyhole surgery to examine and treat damage) she is trying to track down her medical records so she can determine the exact number. She had repeatedly proved

medical professionals wrong who'd told her she shouldn't be playing football by coming back from injuries that might have ended others' careers.

For others, knee injuries were on the horizon. Kate Gill would tear her ACL just two months shy of the 2011 Women's World Cup and just months after she was named the 2010 AFC Women's Player of the Year. Having been at the peak of her career success and on the eve of heading to a Women's World Cup, 'the timing', Gill says, 'was the worst part'. Thea Slatyer had narrowly missed out on the squad because her knee had not quite recovered in time from an arthroscopy. Leena Khamis, Kyah Simon, Lydia Williams, Casey Dumont, Kim Carroll, Melissa Barbieri, and Elise Kellond-Knight would all tear their ACLs in subsequent years. Lauren Colthorpe, who played through the 2011 Women's World Cup with pain-killing injections and who warded off pain by continuing to move during the half-time break, would retire from football early due to knee injury complications. Sally Shipard and Collette McCallum would follow soon after. Shipard, who's also perhaps the highest profile example of an elite female footballer to publicly acknowledge grappling with an eating disorder, was just 26 years old.

The Matildas' approach to knee reconstruction rehabilitation is necessarily conservative to prevent the likelihood of a secondary knee injury, so players are required to rehab for a full 12 months before they're allowed to recommence playing. This approach has been in line with the world's best practice. Players follow a criteria-based rehabilitation, and research suggests that achieving these goals and taking time,

particularly for those rupturing their ACL under the age of 20 years of age, leads to a lesser re-injury rate. With all players who've undergone ACL reconstructions prone to potentially career-shortening early osteo-arthritis, Kate Beerworth points out that managing players' health long term is integral. 'A successful outcome is not how quickly they get back', Beerworth says, 'but if they're still playing in five years' time'. So, it's a year on the bench, but the long-term implications are bigger than just missing one year of football.

Scientific developments including the LARS – the Ligament Augmentation and Reconstruction System, or artificial ligament, touted as helping athletes get back in as little as four months – temporarily offered hope. But as former Matilda Jo Burgess found, the artificial ligament can, like the biological ACL, stretch and tear. There was a nerve-wracking W-League period where she and the Brisbane Roar medical staff knew that each time she took to the pitch the stretched ligament might fail. 'I had the LARS in 2010, and I came back and had a high partial tear in it', Burgess says. 'I played out the season with [my right knee] heavily strapped and ended up tearing it completely in the grand final that year.' Burgess was pragmatic about it, but she ultimately had to undergo another knee reconstruction and a full rehab program with a hamstring graft. She would later tear her ACL in her left knee and have to go through the hamstring graft and rehabilitation program for that knee. That time she skipped the LARS and went straight for the biological hamstring graft.

'When I first took over the [national-team] program in 1994, we had a spate of ACLs', Tom Sermanni says. While

Sermanni emphasises he's no expert on ACL injury causes, he has given the issue a lot of thought. 'I think the two reasons for it was there was no education about causes or prevention, but we also went from a situation where international players went from playing club football where they were playing twice a week and then at a national-team level and the training load was massive. But now you have the likes of Sam Kerr who's been a pro for four years.' Also, the pre-match prevention programs are much improved. 'I think the fancy word for it is pre-activation. We used to call it a warm-up', Sermanni quips.

With the standard of women's football accelerating, and with more footballers playing year-round in differently timed leagues, players are increasingly being exposed to ever-faster play and ever-greater workloads. That's something the ABC picked up in a report using data compiled from more than 850 games in which Matildas Starting XI players such as Alanna Kennedy, Steph Catley, Ellie Carpenter, Emily van Egmond, Elise Kellond-Knight, Chloe Logarzo, and Sam Kerr featured over three years. We can conclude from the data that the number of games these footballers are playing is higher than average – perhaps dangerously so. With players juggling commitments to domestic W-League and international clubs as well as national-team duty, not getting enough rest between games is a problem. The amount of travel these players are doing, which is greater for Australian footballers than for most players from most other countries, also hampers recovery time.

If you were to ask the players, they would likely say they just want to play. The memory of not being able to get regular

game time is still fresh for many of them, and being able to play football year-round is still something of a luxury. The pay issue factors in here too. Di Alagich remembers a time around 2001, for example, when the team didn't play a single game and so, because their pay was contingent on game time, didn't get paid. The fear of not being selected if you're not seen to be available probably also plays a role. As does the need to play enough to earn a decent salary. As we saw in the last chapter, like elite female footballers everywhere, Australia's female footballers are having to play more – work harder – for less money than their male peers.

Amy Chapman had thought knee injuries were behind her when she suffered a third ACL injury. Her two previous ACL tears happened when she was a teenager, and she'd had more than 10 years and countless tackles in between. But, as does anyone who's already had an ACL injury, she immediately knew she'd reinjured it. After two knee reconstructions, Jenna Drummond no longer plays football. Nor does Ashley Brown. They are two of countless promising female footballers lost to the game due to ACL injuries and a lack of medical and rehabilitative support. 'It's hard to put a number on it, and it's so multifactorial, it's hard to say if they had had ideal rehab conditions that they wouldn't have gone on and done a second one', Beerworth says. 'But I think the number lost [to the sport in the past] would have been a lot. They had to do it tough.'

'Most probably the hardest part for me working in the women's game is the amount of players who have done their ACL', Melbourne Victory W-League coach Jeff Hopkins says.

'Especially when you realise how much work they put in and how much sacrifice they make; to know the prevalence of the ACL is 4–5 times more in the women's game than in the men's … Despite all the work they put in, that still happens. You go through the rehab with them for a year and then you're always a little bit on edge then when they're out playing.'

Drummond, who was playing in Hopkins' Brisbane Roar at the time, knew she was injured when she tore her second ACL. But in the moment she didn't know how badly. 'I knew I had done something to my knee, but I was probably in a bit of denial so I kept playing. Well, I did it and the physios brought me off and tested it and they thought it was ok so I went back on', she says. 'Then I did something like dislocated my knee. It wasn't good. So then I knew.'

Her decision to leave the game was cumulative. 'Everything added up. I did my knee, then I did my next knee, and I came back and played something like three games and I did my meniscus, and then I needed surgery on both my feet and it was too hard. I thought, we're not getting paid enough and I need to finish uni.' That's not to say she doesn't miss it. 'I miss the fun aspect, the team sport', she says, 'but I lost my confidence. [The ACL injury] takes its toll'.

Decades before Beerworth joined the team, player Sue Monteath's parents provided the national team with medical support: her mother as team physiotherapist; her father as team doctor. Both past and present examples shine a light on medical teams' Herculean undertakings, and the challenges and triumphs they experience in trying, with limited resources, to get, and keep, players fit.

Beerworth, for example, frequently provided post-operative care for players in her own home. 'Hotel Beersy still exists, even after my tenure', Beerworth says. 'Hotel Beersy' involves transport to the hospital, accommodation, and airport runs. 'Sometimes it's just having a friendly face around. When you go to a different city for surgery, sometimes it's a bit of a daunting task so it's nice to have a friendly face around who's got your back', Beerworth says. 'My dad's on the "payroll" because he sometimes takes them to the airport if I can't.' (By payroll, she means that, like any good football dad, he's volunteered.)

Beerworth's care wasn't just for players, either. 'I was one of them', former Matildas manager Jo Fernandes laughs. The Sydney-based Fernandes also went to Adelaide for a knee reconstruction and stayed with Beerworth until the anaesthetic left her system and she was mobile enough to be able to fly home.

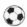

After scoring a goal in the 2012 Olympics for the USWNT, co-captain Megan Rapinoe retrieved a message she'd stored in her sock. The message, which she held up for broadcast cameras to capture, wished Ali Krieger, who was missing the tournament due to a knee injury, a happy birthday and telling her she was loved and missed. It was a gesture that Rapinoe, who had herself gone through two knee reconstructions and would later undergo a third, understood. Being unable to play or adequately train for 12 months, as well as losing

the social connection playing brings, makes for a remarkably lonely road back.

The informal creation of the virtual support group Knee Club is testament to the large number of players stricken by ACL injuries. People regularly contact players such as Walsh via their social media accounts to ask for advice. Their accessibility, reassurance, and advice has helped many an injured female athlete, from the grassroots to the elite. Canberra United's Caitlin Munoz, who has had multiple knee reconstructions and countless cartilage-tidying arthroscopies is, like Walsh and Colthorpe, a lifetime member.

'Knee Club was a bit of a joke I had with a few other players, trying to make light of injury disappointments, I guess', Colthorpe says. 'It helped us deal with setbacks, and while you're isolated from your teammates, training alone in the gym, it kind of gave us our own little sense of belonging.'

Members of the club take comfort in knowing others understand what it's like to not quite know where to sit or what to do when you're temporarily out of the team. Sometimes they seek out advice; 17-year-old Taylor Ray literally called out to teammate Amy Harrison, a fellow two-time ACL-injury sufferer, moments after Ray sustained a second ACL injury. Sometimes – often after surgery but long before they are able to re-take the pitch, a waiting period that can feel interminable – they don't want to talk about how their knee is at all. Either way, Knee Club has proven a good support mechanism. 'When there was more than one of us in Knee Club at a time, living in the same city and training together, it was a great motivator to push each other through

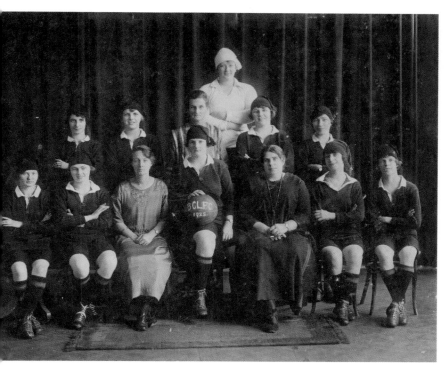

1922 Brisbane City Ladies Football Club team. *Courtesy of Football Queensland*

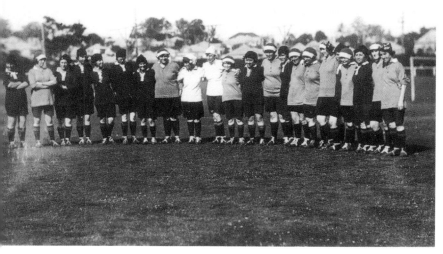

Team members of the Brisbane North (Reds) and Brisbane South (Blues).
Courtesy of Football Queensland

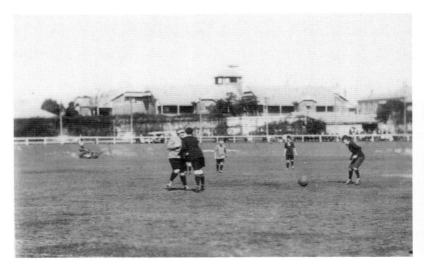

The first public game of football played by women at the Gabba on 24 September 1921. *Courtesy of Football Queensland*

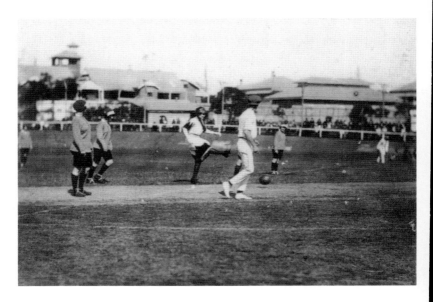

Amy Rochelle kicking off the match. CW Searle in his cricket whites refereeing the game. *Courtesy of Football Queensland*

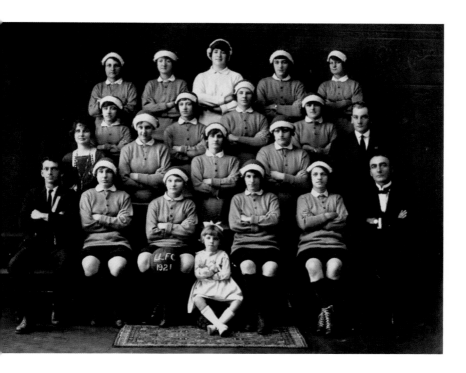

The 1921 Latrobe Ladies Football Club. *Courtesy of Football Queensland*

RULERS OF LADIES' FOOTBALL IN BRISBANE.

EXECUTIVE OF THE QUEENSLAND LADIES' FOOTBALL ASSOCIATION.

LADY PLAYERS.

AN ENTHUSIASTIC BODY.

Keen enthusiasm is the characteristic feature of the members of the Queensland Ladies' Football Association, and they appear to be determined to make all possible headway with their venture. That "Soccer" as a sport finds favour with many members of the fair sex is amply evidenced by the fact that the association, although it has only been in existence for some two months, has now 60 members and three affiliated clubs—the Brisbane Ladies, the Brisbane City Ladies, and the Latrobe Ladies. The ladies are happy in the possession of a strong executive, portrayed in the photograph which is reproduced on this page, the members being: President, Mrs. C. W. Searle; hon. treasurer, Miss I. C. M'Gregor; secretary, Miss N. Borwick; committee, Mrs. L. Yates and Misses Campbell, Free, and J. Robinson. This afternoon the ladies were to make their first appearance at the Cricket Ground. Next season it is hoped to run a competition, and in the meantime efforts are being made to induce the formation of country teams, with inter-town matches as an object to be attained. Several country centres have been communicated with, and the secretary of the association is determined to do all that can be done to organise matters thoroughly. The ladies train twice in each week, and show an interest in their work that augurs well for the ultimate success of football for ladies in Queensland.

QLFA executives (1921). *Courtesy of Football Queensland*

Wynnum Ladies set off for the 1975 New Zealand tour.
Courtesy of Football Queensland

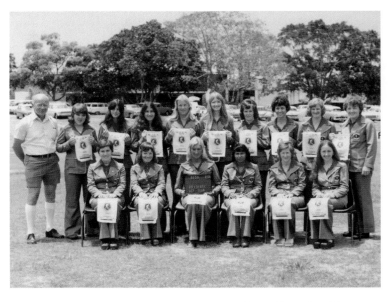

Queensland's first team to attend the National Championships
in Sydney in 1974. *Courtesy of Football Queensland*

Tiwiwarrin players Leonie Young and her baby sister, Rhonda Yow-Yeh. *Courtesy of Leonie Young*

Kerry Millman (1984). *Courtesy of Football Queensland*

Elaine Watson at Atlanta Field, Geebung, Brisbane, the first purpose-built headquarters for women's football in Queensland. *Courtesy of Football Queensland*

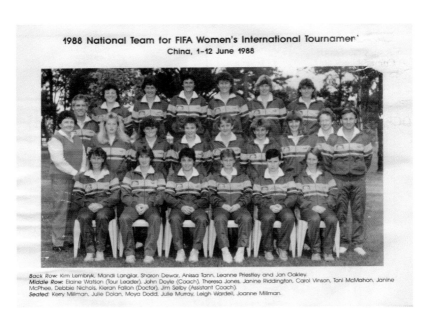

The national women's football team that participated in the 1988 pilot Women's World Cup. *Courtesy of Football Queensland*

Team photo for the national women's
football team. *Courtesy of Julie Dolan*

The Australian national women's football
team during the 1988 pilot Women's
World Cup in China. *Courtesy of Julie Dolan*

Above Sally Shipard steps up to take her penalty during the 2010 AFC Women's Asian Cup final. *Courtesy of Paul Lau*

Top right The Matildas experience the agony and the ecstasy of the penalty shootout. *Courtesy of Paul Lau*

Below right Matildas Kylie Ledbrook, Clare Polkinghorne, Sally Shipard, Kate Gill, Kim Carroll, and Servet Uzunlar rush forward to celebrate the Matildas' 2010 AFC Women's Asian Cup win after Kyah Simon puts away the deciding penalty shot. *Courtesy of Paul Lau*

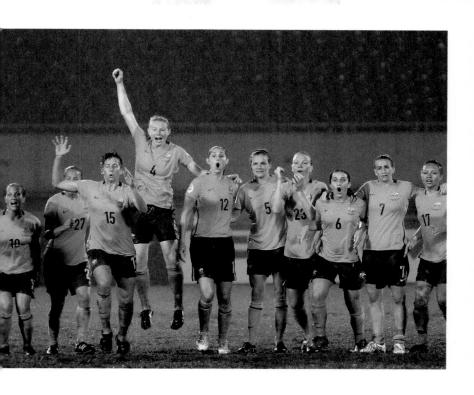

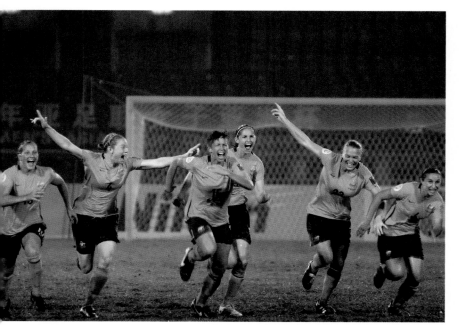

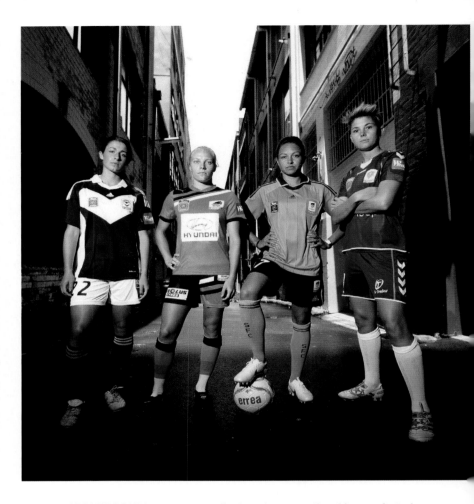

2011/2012 W-League season finals series promotional image, featuring Ashley Brown, Tameka Yallop, Kyah Simon, and Michelle Heyman (L–R).
Courtesy of Bryan Crawford

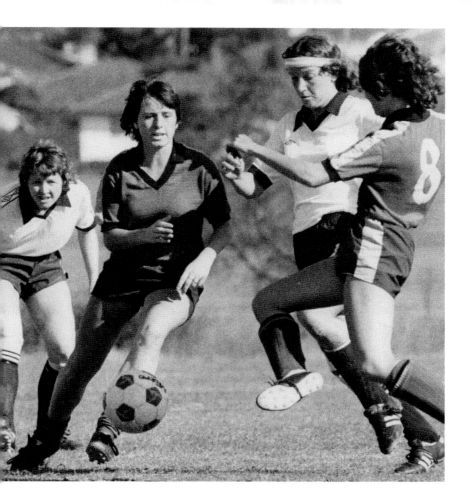

Some of Australia's best in action: Sue Monteath, Kerry Millman,
Connie Byrnes. *Courtesy of Football Queensland*

The Matildas at a pitch familiarisation session in Jinan, China, during the 2012 Olympic qualifying tournament. *Courtesy of Bryan Crawford*

Matildas Emily van Egmond, Laura Alleway, Michelle Heyman, Aivi Luik, Tameka Yallop, and Melissa Barbieri (L–R) warm up beside the pitch in Jinan, China, during the 2012 Olympic qualifying tournament. *Courtesy of Bryan Crawford*

Matildas Lisa De Vanna (foreground), Aivi Luik, and
Kyah Simon (background) during training. *Courtesy of Bryan Crawford*

Brisbane Roar's Brooke Spence and Canberra United's Michelle Heyman contest the ball during a W-League match. *Courtesy of Bryan Crawford*

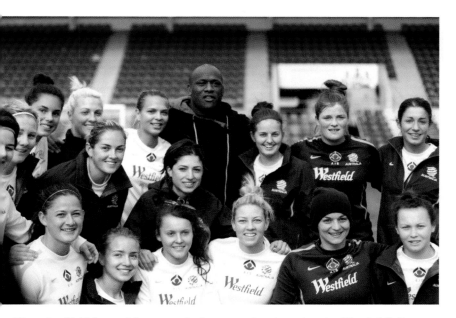

When the Matildas met former rugby league and rugby union star Wendell Sailor during a Matildas training camp in Wollongong, New South Wales, in 2012.
Courtesy of Fiona Crawford

The Matildas on the team bus during the 2012 Olympic qualifying tournament.
Courtesy of Bryan Crawford

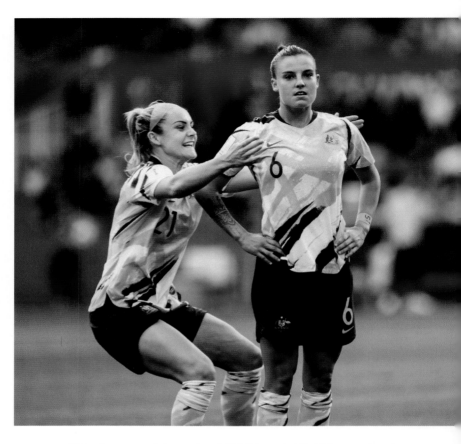

Chloe Logarzo celebrates her 2019 Women's World Cup goal against Brazil by striking a 'super woman' pose. The pose was a tribute to injured teammate Laura Alleway, who would sing her Alicia Keys' 'Super Woman' song before every game. *Courtesy of Rachel Bach*

rehab and celebrate each other's small achievements along the way', Colthorpe says. 'But mostly it was created for a good laugh and making humour from an otherwise disappointing situation, to be honest. It served us well.'

It's not the only support mechanism players have initiated. Injuries have led to a number of other incredible moments of support. Laura Alleway narrowly missed the 2019 Women's World Cup after sustaining a foot stress fracture just before the tournament started. But she continued to contribute to the team, mentoring her replacement, Karly Roestbakken, as well as doing her traditional pre-match performance of Alicia Keys' song 'Super Woman' for Chloe Logarzo. Only instead of singing it in the changeroom, this time she recorded it on a phone. Logarzo's Super Woman-pose goal celebration in Australia's 'Miracle in Montpellier' comeback against Brazil was a tribute to Alleway and her contribution. As was the fact that team coach Ante Milicic reportedly instructed the kit manager to hang Alleway's jersey in the changeroom in a tribute to the absent defender.

The issue with women's football is, of course, that without investment in the game as a whole, important issues such as knee injury prevention slip through the cracks or are unevenly implemented. With women's sports participation rates already lower than men's, and with those participation rates dropping off a cliff around puberty, it's a chicken-and-egg scenario; there's less investment and training, so players are more likely to incur injuries. They're more likely to incur injuries, so are less likely to play, rehab well, or return to play post-injury.

The problem with a sporting career, too, is that a player is, unfortunately, only ever one bad injury or non-selection away from the end of said career. Michelle Heyman can attest to that, with the striker officially retiring from the Matildas in 2019, citing a mix of physical and mental health struggles. With ACLs, in particular, there's no guarantee a footballer will ever be able to play as well again, whether because of physical or mental barriers or a combination of both. At a grassroots level it's remarkably difficult to return from an ACL injury: lack of knowledge, money, support, and time to concentrate on rehab all hinder recovery. 'In community sport, only half go back because the rehab is hard', Beerworth says. 'In elite sport, the stats are better, so it's about 85 per cent.' No one would argue that they didn't want those stats to be at 100 per cent for both.

It's been well documented that Kerr struggled with serious injuries in the years before her 2017 breakout and that she had considered giving up football altogether. During the 2019 Women's World Cup, she credited AIS coach Aaron Holt with salvaging her career. When Holt worked with her, Kerr was 21, with a knee so injured she was unable to walk. Holt was tasked with not only getting her to walk, but returning her to peak fitness in time to be selected for the 2015 Women's World Cup. So, no biggie.

Holt undertook the work during a concentrated residential rehab stint at the AIS for which AIS-affiliated sports are eligible. 'Effectively, it was so they could access facilities and staff so they could get an intensive rehab period for a specific event', Beerworth says. 'For Sam [Kerr] it was the

2015 Women's World Cup.' With the hard deadline of the 2015 Women's World Cup approaching, Holt had a limited time within which to get Kerr back to peak form. The sessions he put her through were intense and necessarily brutal, and Kerr completed her final fitness test just hours before travelling to the Women's World Cup.

That intensive AIS residential rehab has only been available in recent years and wasn't there when players such as Walsh, Drummond, and Brown could have benefitted from it. Ultimately, it made all the difference to Kerr; instead of missing out on realising her potential, she's become one of the best-known strikers in the world, captaining the Matildas, being sponsored by Nike, and being headhunted by clubs around the world. Like the benchmark Melbourne City set for how clubs should treat their players, such a rehab program shows what's possible, and sets an example for how injuries could and should be supported.

Chapter 7

COACHES: THE FUTURE IS FEMALE

Five months out from the 2019 Women's World Cup, the FFA sacked Alen Stajcic, the Matildas' most successful coach to date. Ranked sixth in the world, headed to the tournament with the advantage of their first ever seeded spot (easing qualification to the knock-out stages as they could not be drawn against the world's top five teams in the initial group stage), the Matildas were entering the tournament as possible contenders. The decision to remove Stajcic was unexpected, ill-timed, and clumsily handled.

Speaking on behalf of the board, FFA CEO David Gallop, who would resign shortly after the Women's World Cup, offered little to no explanation. Instead, he pointed to two confidential team surveys that illuminated concerns around players' wellbeing in a reportedly toxic and dysfunctional team culture. The survey results dovetailed with several recent poor on-pitch performances, and the FFA decided it wanted a different coach to lead the team to the 2019 Women's World Cup. It was within its rights to do so as Stajcic's contract contained a no-cause termination clause. But the handling of the

decision – an awkward press conference on a Saturday to get ahead of rumours – and the very public fall-out that followed was, whichever way you look at it, astonishingly poor.

Social media was quickly alight with diatribes, charges, and statements, all sorts of 'what ifs' and whataboutery, with people decrying everything from the irreparable damage of the Matildas brand to the reputational damage to Stajcic's 20-year career. Former players noted issues with injuries and results; journalists directed their concerns at the FFA; everyone related to the Matildas either spoke to the media or was hounded for comment, then hounded again for either what they did or didn't say. Worse, the confusion and outrage around Stajcic's dismissal continued to haunt the national team's fortunes at and after the 2019 Women's World Cup – headlines such as 'Matildas' World Cup exit reignites toxic coach debate' on SBS's *The World Game* began to appear in the immediate aftermath, and media, fans, and former players alike wondered what effect Stajcic's dismissal and the handling of it had had on the Matildas' Women's World Cup campaign.

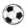

Players who earn a place on the national team take on custodianship of our national identity, willingly or otherwise. It's a privilege for them to represent our sense of our individual and collective sporting selves, but also a burden. Fans often feel we own, share, and celebrate their victories as if we played a key role. Simultaneously, we feel we have the right to com-

plain about their individual and collective failures, to offer our often inexpert opinions about what went wrong and who is to blame. We take to social media to express the pain of loss, but we will never feel it as keenly as the players and staff who are directly involved.

A few weeks after being removed from his post, Stajcic, who'd been quiet, staged a one-day media blitz to state his case and speak about the injustice he felt. Among other appearances, this included an interview with journalist Leigh Sales on the ABC current affairs program *7.30*. Hours later, the spotlights on Stajcic, the FFA board, and Gallop shifted to an even bigger story: Australian refugee footballer Hakeem al-Araibi, who had been detained under dubious pretences while travelling on his honeymoon, was released from a purgatorial Thai prison. The conversation about Stajcic's sacking got lost. The issues would resurface, of course, but few recall that Stajcic spoke about the double-edged sword of elite professional sport – he noted that the happiness of a player was determined by whether they were selected. He suggested that the pressure, which had been described as the root cause of the problems within the squad, had also been the key to its success. He pushed the team hard and got results.

Tom Sermanni has been credited with bringing the Matildas into public consciousness. When approached to start the national women's football program, he was immersed in coaching top-level men's football teams in Canberra. 'People

looked at me like I was from another planet', Sermanni says of the decision to move across to women's football. Usually people move the other way: women's football tends to be thought of and provide a stepping stone for male coaches on their way to greater pay and glory working with men's teams.

Sermanni's first stint as national team coach, between 1994 and 1997, would see the team set up a development framework and nurture talent, but toil in relative obscurity. During his second stint, 2004 to 2012, the team would record a heroic quarter-final effort against Brazil in the 2007 Women's World Cup, a heart-stopping 2010 Women's Asian Cup win on penalties, and also progress to the 2011 Women's World Cup quarter finals. These results gained the team media attention and a little more funding and, most importantly, gave them confidence that they could hold their own on the world stage. Sermanni was voted 2007 AFC Coach of the Year and the Matildas were named 2010 AFC Team of the Year.

Two things stand out about Sermanni's style: his gentlemanliness and his laidback approach, which includes an inherent trust in his players and staff – Sermanni expects professionalism, but doesn't micromanage. Sermanni often uses an adage attributed to an old English player, Jimmy Greaves, that football is 'a funny old game'. It's perhaps how he's managed to forge such a long career in women's football, spanning the Matildas, the USWNT, and domestic US teams such as the Orlando Pride. Sermanni is famous for doing crosswords on the tour bus, an activity he says keeps him 'sane and sensible'. And as former colleagues of his have noted, the Scots-

man turned Aussie can find a cup of tea no matter where the team is. 'The secret is to keep a stash of teabags in your backpack', Sermanni laughs.

It's testament to his popularity that players from traditional rivals New Zealand, the Football Ferns, recently encouraged Sermanni to apply for their national team coach role when it came up in 2018. At 64, Sermanni, who'd just finished up at Orlando Pride, says he wasn't looking for work at the time: 'I was actually ready for a rest'. But the New Zealand gig, which featured a team he knew well, admired, and respected, and was just across the ditch from his home in Sydney, was too good an opportunity to pass up.

The FFA has long favoured Dutch football technicians such as coaches Guus Hiddink and Pim Verbeek as well as technical directors Rob Baan and Han Berger, but Hesterine de Reus was the first Dutch woman they appointed and only the second female Matildas coach. De Reus, who succeeded Sermanni, was a former Netherlands national-team player. During her time coaching the Jordanian national women's team she had, alongside Moya Dodd, been instrumental in gaining approval for a sports-safe hijab to enable women of Islamic faith to participate safely in football.

In contemporary terms, De Reus' tenure was short-lived, though not as short as that of the first female Matildas coach Trixie Tagg (née Barry), who only coached four fixtures in 1981. In the case of De Reus, the players – or at

least a number of key members of the team – pushed back against her attempts to impose a more stringent team environment, a stark contrast to Sermanni's relaxed approach. Players remain tight-lipped about what happened internally, but the PFA released a statement that it had concerns about De Reus' 'intimation of non-selection if players take overseas contracts', something they did and continue to do to eke out a liveable income, and her wider 'disregard for player well-being and development and commitments outside of the game'. After De Reus' contract was terminated, some Matildas players allegedly formally requested the successor be appointed on skill rather than gender.

While their position is understandable under such strained circumstances, it is also incredibly disheartening. While we can only speculate, one issue might be that many young female footballers have spent their careers learning to consent to particular discourses around coaching – discourses that promote the idea of coaching as a male profession, one with embodied masculine values. In 2000, Kari Fasting, a researcher from the Norwegian University of Sport and Physical Education in Oslo, and Gertrude Pfister, a researcher at the Free University, Berlin, interviewed 38 elite female footballers from the US, Sweden, Norway, and Germany. They found that male coaches are most likely to adopt a 'masculine' style of interaction. This often led to female players feeling as if they were not being taken seriously by a male coach.

In contrast, the footballers identified feeling more content being coached by female coaches, who are generally more communicative and regarded as better 'psychologists', but

participants were uncertain about whether that amounted to what could be described as a 'coaching philosophy' or 'style'. Some players felt women should not be coached in the same way as men. Overall, however, the research found that players prefer to be coached in the ways they are most used to. Where women's football continues to be dominated by men, the majority of female footballers are unlikely to experience a different style of leadership. (Tameka Yallop, for example, did not play under a female head coach until she played in the US in 2012.) The result is likely to be the perpetuation of unequal opportunities and outcomes for women in sport.

In early 2019 Donna de Haan, a researcher at Utrecht University, and Leanne J Norman, at Leeds Beckett University, similarly found that the work of female coaches is often considered to still be 'in development'. Irrespective of how experienced or successful they are, they tend to be regarded as simply 'holding the fort until the real coach gets here'. The very act of their taking on a coaching role is still seen as transgressive, outside of football norms, or worse, a 'risk'. Male coaches, regardless of their level of expertise and experience, are viewed with significantly more trust. This is not to say that there are not good male coaches of women's teams, simply that men have dominated coaching in Australian women's football for so long they have become associated with the role.

Encouragingly, however, Fasting and Pfister also found that female players who have an ingrained 'think coach, think male' philosophy may initially resist a female coach, but invariably change their view after having had one. Female coaches have successfully coached female players to win, something that is

now evident in North America and Europe. Five of the eight qualifying teams in 2019 Women's World Cup quarter finals were coached by women. The eventual runners-up, European champions the Netherlands, are coached by Sarina Weigman. The tournament champions, the undefeated USWNT, won a record fourth Women's World Cup and became the first team and, in Jill Ellis, the first coach to win back to back Women's World Cup trophies. After coaching the American women through a five-match, five-city victory tour in the US, Ellis stepped back from the coaching role in late 2019.

Breaking down entrenched beliefs about coaches is a tremendous challenge, but both Weigman and Ellis have proved that female coaches can compete at the highest levels. They are only two such examples. Organisations such as Equal Playing Fields and some of football's top clubs and federations are now working hard to institute holistic change to ensure there are many more examples to follow.

The FFA initially temporarily appointed Alen Stajcic as the Matildas coach to steady the ship after Hesterine de Reus' departure. The Matildas were at that time reigning Women's Asian Cup champions and their title defence, the 2014 Asian Cup, was fast approaching. De Reus might have been an unknown quantity, but Stajcic was very much a known one. Unusually for a male coach and for the coaches tasked with steering Australia's women's football teams, he had only ever coached women up to that point.

After coaching elite New South Wales female football-
ers for decades, including overseeing players such as Caitlin
Foord and Chloe Logarzo for almost the entirety of their foot-
balling careers, and after leading Sydney FC to consistently
high W-League finishes, Stajcic had proven his ability to get
results. His additional prior national-team experience from his
time spent coaching the Young Matildas made him a logical
appointment to settle the team. Stajcic would go on to guide
the Matildas through two Women's Asian Cups, an Olym-
pic Games campaign, and a Women's World Cup, equalling
Australia's best Women's World Cup placing with a berth in
the quarter finals. He is credited with overseeing the national
team's best and most consistent run of performances so far.

Almost as stunning as Stajcic's dismissal is the dearth of
detail around it. The newly installed FFA board had promised
greater transparency, and yet have never seemed so opaque.
Concurrently reeling from Stajcic's sacking and the over-
whelming media attention it brought with it, players either
said nothing or paid tribute to Stajcic, speaking of his high
expectations, which ultimately improved them as players.
Logarzo's first-person piece in *The Players Voice* online maga-
zine, written months before Stajcic was dismissed, expressed
how beneficial she'd found his direct style. After a few years
lost to football, she vowed to work harder than everyone else
and never put a foot out of line. She'd had the opportunity
at Sydney FC under Stajcic and squandered it. Second time
round she put everything she'd learnt from his coaching into
getting back into the national team. Stajcic had become the
Matildas coach during the same period. Logarzo's new-found

form and enthusiasm secured her the second chance. In the *Players Voice* article, she says, 'He was always on my arse about wearing the wrong socks or the wrong shorts to training and I couldn't see what the big deal was. But it wasn't about the socks and shorts. It was about attitude and professionalism.' Having been a standout at the 2019 tournament she can say she hasn't looked back.

Questions remain about whether FFA senior management knew about the issues the surveys highlighted and failed to act in a timely fashion, or whether they had no idea when they should have. Immediately after the Matildas exited the tournament, SBS sports analyst Craig Foster asserted that any review on 'how Australia entered another World Cup with an interim coach' should be independent, in-depth, and retrospective. He also noted that 'the point is not about Alen Stajcic per se, but to ensure no national team has to enter another critically important tournament in a state of instability'. At the time of writing, that independent formal review has been set in motion.

After Stajcic was dismissed, Ante Milicic was presented with the task of restoring calm to the now-unnerved Matildas squad and preparing them for a major international competition 100 days away. As teenagers Milicic and Stajcic played together in New South Wales state teams. They aren't close and take very different approaches to the game, but they have a high regard for each other. Prior to the job, Milicic held an assistant coaching role at the 2018 [Men's] World Cup in Russia under experienced Dutch coach Bert van Marwijk. Milicic's previous experience includes membership of the

Socceroos coaching staff at the 2014 Brazil [Men's] World Cup under Ange Postecoglou, the man responsible for an A-League football transformation when he coached Brisbane Roar. These roles, and others, have led many football fans to see Milicic as something of a perennial offsider, a good right-hand man, but maybe not quite ready for the top job. His low profile in the media does not, however, reflect how well known and well respected he is by industry insiders. While the furore around Stajcic's dismissal continued, Milicic took on the responsibility of guiding Australia's current, and arguably best, generation of talent through a pressure-cooker Women's World Cup campaign. In his first press conference he reinforced his approach and assured those watching and listening that he hoped the prospect of competing against the best teams in the world would quickly galvanise the team. He said, 'I've got the support of the players because there's a World Cup at stake and they're proud Australians and professional athletes'. He didn't see his inexperience in coaching women's football as a drawback, instead saying, 'It's an advantage because I'm coming in with fresh eyes and no pre-conceived ideas'.

Milicic signalled his long-term intent to move into men's football by signing a contract with new Sydney A-League team Macarthur South-West a little over three weeks before the Matildas embarked on their Women's World Cup campaign. In the lead-up to the 2020 Olympic Games, he will juggle A-League duties with concurrent national-team Olympic Games duties. It might be a challenge, but former Brisbane Roar coach and current assistant coach for the Matildas,

Mel Andreatta, doesn't see it as an insurmountable problem. Recruited by Stajcic two weeks before his departure, Andreatta barely had a chance to work with her old boss before she found herself wondering if she'd still have the job. Milicic elected to keep her on. When we asked Andreatta about Milicic's dual roles and priorities, she was upbeat and optimistic. 'He's not the first coach to manage two sets of responsibilities at this level. And Ante is really organised, and calm and professional, and he has a clear view of what he wants to do.'

To some, the short Milicic tenure – he's signed only until the 2020 Olympic Games are complete – represents a lack of foresight or planning. What the FFA plans to do with the Matildas head coach role once Milicic's tenure ends remains unclear. Optimists believe his departure presents an opportunity for a long-term female coach, committed to building women's football, to step into the role. It would certainly align with the approach the world's top teams are taking – including the quickly developing European teams Milicic spoke of during the Women's World Cup. In an interview with *The Women's Game* after early rounds of the Women's World Cup, Milicic underlined the importance of the FFA's contribution to the W-League if they want the national team to be competitive. Of the Europeans, he said, 'You can see the investment they're getting, with the coaching, with the facilities they are getting. We also had a visit to the Dutch KNVB (national federation) and we look[ed] at what their team had to train in every day and have a camp, have a base. The investment is there, and in the end sooner or later it's got to bear results.'

Disappointingly, the FFA's response has been to abdicate responsibility to the clubs who support a W-League team; only a few of those have employed a female coach, and even fewer have actively worked to develop and mentor female coaches. But Australia's state associations are now working hard to build the platform. With 28 participants in 2018, Football Queensland's first all-female advanced coaching course has been the largest in the country so far. Both domestically and overseas, the clamorous noise around the need to have more female coaches leading women's football teams is becoming difficult to ignore.

In the 2016/17 season, the Central Coast stadium, home of A-League team Central Coast Mariners, played host to Canberra United, one of the W-League's most consistent and successful teams. The venue was arranged so Canberra United could participate in the double-header initiative driven by the FFA. (The pairing seemed suitable because the Central Coast Mariners no longer have a W-League team, enabling Canberra United, which doesn't have a counterpart A-League team, to make use of the venue.) With double headers, fans can enjoy a women's match and a men's match for the price of one ticket, provided they have the time to sit through two games. Central Coast Stadium is a multi-purpose venue with capacity for over 20 000 fans. With six bars, 21 corporate suites, and 58 corporate enclosures, it's a solid enough venue to host music concerts, National Rugby League matches,

Super Rugby (Union) matches, and a season of A-League fixtures. Yet when Canberra United took on Brisbane Roar on 18 December 2016, the W-League rivals found themselves getting changed and prepared for their match in small marquee tents. The stadium's entire set of changing room facilities had been turned over to the two A-League teams, which would be competing within an hour of the women's fixture. To deepen the humiliation, the match organisers had pitched the tents immediately adjacent to each other, which meant neither team could discuss match tactics or positional play.

It should have been a moment to celebrate: the Brisbane Roar team, coached by Mel Andreatta, and Canberra United, coached by Raeanne 'Rae' Dower, were at that time the only two teams in the W-League led by female coaches. Andreatta and Dower are close friends. Both Queenslanders, the former teammates are integral to the national women's teams' set-up and key drivers in developing girls' and women's football in Australia. They are also two of Australia's most experienced and qualified female coaches.

Female coaches have been essential to the Australian women's game since the 1970s; for some, such as Lyn Ketter, Elaine Watson, and Betty Hoar, for example, it's their chosen career; others saw the necessity of forging a road themselves to facilitate opportunities for young players, the way Pat O'Connor and Leonie Parker did. Their numbers are also increasing exponentially, at grassroots and state levels, in cities and in regional areas, but for the most part their efforts remain invisible and unheralded. Very few female coaches break through to the national level. To date, fewer than 10 women have

coached in the W-League. One is an immigrant, two have been imported specifically for the task, and the rest have been raised on a hard diet of Australian sports culture.

All of the female coaches the W-League has seen, including Perth Glory's Nicola Williams and Melbourne Victory's Vicki Linton, are talented and hardworking and have achieved results exceeding the resources they had to work with. But Canberra United, until recently steered by the innovative Heather Reid, has led the way in providing opportunities and mentoring for female coaches, and worked to normalise having women in coaching roles. The club recruited Jitka Klimková from coaching in the Czech First Division. Klimková improved Canberra's already excellent standard, leading the team to its first premiership and championship in the 2011/12 season. When Klimková announced she was leaving Canberra United to coach New Zealand's Young Ferns (U17s), Reid involved her in recruiting her successor and developing a succession plan. The club subsequently appointed former Dutch inter-national player Liesbeth Migchelsen, and Klimková spent time with her to mentor her and ensure a smooth transition for the players. Migchelsen, a former Dutch national-team defender, guided Canberra to a premiership in the 2013/14 season and the season that ran in 2014 (it started and finished earlier to accommodate hosting the 2015 [Men's] Asian Cup). Before Migchelsen left, she handed over to her assistant coach, Dower, as had been done for her.

The daughter of one of Queensland's leading and long-est serving football administrators, Dower traded stable employment as a detective in the Queensland Police for an

assistant coaching job and long, long hours. Dower's work with Queensland U13, U17, and U18 state teams had gained her an FFA Coach of the Year award in 2009 and a great deal of notice. Reid wanted her at Canberra alongside Migchelsen, both because she was a great coach and because she'd demonstrated the highly sought-after ability to bring young talent through the ranks and ensure they are ready for, and settle into, senior squads.

From the age of 12, Dower was playing and 'watching four or five games, including men's football, a day most weekends'. Her family was so heavily involved in the North Star club in Brisbane, and football in Queensland, that family holidays were scheduled around football tournaments such as the National Championships. This level of immersion highlights what Dower sees as 'one of the key changes in the game since I started playing in 1977. Watching all those games. We had no choice, but I learnt so much.'

Still, the lack of choice enabled Dower to develop an inspiring depth and breadth of football knowledge. A secondary role in the commentary box for Fox Sports – one of the many roles she juggles – has grown out of her innate capacity to read the game and her animated ability to translate it for the watching fan. More importantly, her childhood engagement with the game means that she brings a keen sense of community to her coaching. Despite four very successful seasons at Canberra – two as assistant and two as head coach, including two premiership wins, one grand final win, and a semi-final place in each of the years – Dower believes one of her most important achievements, so far, is initiating

and developing the football academy at NTC United/ACT Academy of Sport women's program: 'We had girls' teams running across every age range, from U11 to the U20 National Premier Leagues (NPL) team. It was really exciting. And because the set-up was so good, we had at least 10 players in the U17 and U20 national set-up.'

Key to that success is care for the players. 'For women football is much more about relationships. More about a sense of community. Communication is so important,' Dower says. 'Players need to know you care about them. It's as simple as talking and listening. When I touch base with the [Junior Matildas], I always ask them how school is going, and what else is going on. It's not ever just about the football.' Also that players need to have a Plan B. 'We know as few as 2 per cent of players will go on to make a living out of football', Dower says. 'That figure is improving, but we want to make sure the girls are able to have a life. Fatigue is a big factor too. Female players burn out faster. These players are training four nights a week and playing a match on the weekends. So, we prioritise life skills, make sure the girls are trying to maintain a balance.' She underlines that this approach ensures the players are grounded and that, if they do hit the newspapers, it's for the right reasons. For the most part, with the exceptions of the calendar, the strike, and the Stajcic sacking, press coverage related to the Matildas is positive. To prove her point, Dower recalls the story of the three young male players who cheekily knocked on Sam Kerr's front door in Perth to ask her to play football, only to be told, 'yes' and to 'wait a minute' while she grabbed her boots.

It's been a long road for Heather Garriock from appearances for Queensland Sting to coaching Canberra United, not least because the road involved stints playing overseas. Garriock made the third-most appearances for the Matildas before her national team playing career was cut short because there was no maternity leave or support for returning to the sport after having kids. While Garriock wasn't yet ready to finish playing, not being selected forced her hand. So she turned her focus to her post-playing career, reinventing herself as a coach. She spent three seasons coaching the Sydney University Women's football team, achieving enormous success in the New South Wales Women's National Premier League 1, before being given a chance to take over Canberra United following Dower's promotion.

Coaching Brisbane Roar from 2012 until 2016, Belinda Wilson is the longest-serving female coach in the W-League so far. Wilson replaced former coach, the highly respected Jeff Hopkins, after a three-year stint as a director of coaching in Norwegian football. Expectations were very high for her going into the Brisbane Roar role, as the side had reached all four previous W-League grand finals. Her first season resulted in a premiership.

Andreatta's was one of the names mentioned in the speculation around a replacement for Stajcic. Although she didn't start playing until she was 18, with Brisbane-based Taringa Rovers, Andreatta quickly reached a high level of skill. Taking leave without pay, in 2003 she travelled to northern NSW for a trial with Mike Mulvey's Northern New South Wales Pride (the team that would become the Newcastle Jets). She had to

pay her own way, including buying her own club tracksuit, but she played two seasons in the WNSL. While she'll tell you she 'wasn't a great player', playing a lot of team sport helped Andreatta develop an acute ability 'to read the space available. I can see or at least sense how to hurt or contain a team.'

Andreatta's role as Brisbane Roar's head coach began with Wilson's departure in 2016. In the three years after she took over, Brisbane Roar regained its status as one of the most formidable teams in the W-League, winning the premiership in the 2017/18 season. Having sustained and overcome a season-ending ACL injury in her first ever season as a player, Andreatta understands the challenges facing female footballers while also embodying what it means to persevere and overcome challenges to stay involved in the game.

The former Young Matildas coach, selected in January 2015 as one of six female coaches for a 12-month FFA mentorship program, has a reputation for producing future stars. She currently coaches Queensland's NTC players in the WNPL, is involved heavily in state team programs, and teaches football at Cavendish Road High School. Occupying several positions gives Andreatta an understanding of players at multiple levels of the game. 'It gives me a good view and a good perspective of what's out there and the talent coming through', she says. 'At Cav[endish] Road, the next level we see us developing players for is the [W]NPL. A lot of kids we get are local players, or haven't even played before and are just kids coming because their friends are. With the girls, we pretty much just take them all in and try to develop that

passion for the game and encourage that football develop-
ment for the [W]NPL level,' she says. 'The more young girls
we get playing the game, the bigger the talent pool is, and the
more chance we've got of finding the next Katrina Gorry, the
next Lisa De Vanna, and that's exciting.'

The AFL, the ASC, and the Richmond Football Club have
reportedly jointly funded research to 'investigate the real and
perceived blocks to women reaching the highest positions
in sport'. This may be a response to the need to rethink the
economic rationalism that affects the game, and address the
irrational prejudice around gender that infects boardrooms
dominated by men with limited understanding of the wom-
en's game. The question of who will be entrusted with the
oversight of Australia's most beloved sports team after Milicic
returns to men's football, then, is less who the coach will
be and more whether the 'think coach, think male' cultural
biases have been acknowledged and addressed. If the best
person for the job ends up being male, that's one thing. But if
the only candidates considered are male because of biases and
a lack of emerging, established, or even normalised pathways
for women to become high-level experienced coaches, that's
another.

Andreatta credits Jeff Hopkins as an example of a man
who understands the barriers and actively tries to break them
down: 'He took me on as a coach. Irrespective of my gender,
he saw me as a football coach above anything else.' And, in

the time she coached Brisbane Roar, Andreatta witnessed a shift in the environment, noting that 'more balanced and calmer discussions about how to affect change are far more frequent now'. The changes are a result of there being 'greater exposure of gender-based discrimination and the number of organisations who've been brave enough to put women at the forefront'. Tennis and cricket have led the way in Australia, Andreatta says. And the USWNT is a stunningly successful example of taking the 'risk' of appointing a female coach. 'Things are building, shifting', Andreatta says. 'The more people we see challenge that thinking, the more frequent the challenges will become, and the faster change will come.'

Chapter 8

WOMEN'S WORLD CUPS AND INTERNATIONAL TOURNAMENTS

The Matildas' 2007 Women's World Cup heroics – a thrilling, last-ditch, team-effort goal scored to draw them level with Canada and put them through to the quarter finals for the first time ever – formed a defining moment in Australian women's football. With that draw, and through the stories surrounding it, captured by the *Never Say Die* documentary crew that followed the team through the tournament, the Matildas recorded their equal best Women's World Cup result. In the process, they inspired the next generation of female footballers. That next generation included Steph Catley who was, like many Australians, watching at home in her pyjamas in the middle of the night. Catley was so impressed by what she saw, she decided then and there that she wanted to grow up to be a Matilda. By the 2015 and 2019 Women's World Cups, she had cemented a Matildas Starting XI berth.

What's little remembered is that the breakout 2007 game against Canada had actually been delayed. 'We were about 100 minutes out from our match with Canada and the match

was postponed for 24 hours', former Matildas manager Jo Fernandes says. Both teams were on the way to the stadium in Chengdu in their respective buses when they received a call saying the game had been delayed. Typhoons on the other side of China meant the equivalent games were postponed. 'The principle with that third round is that the games are played at the same time', Fernandes explains. So although the weather was fine in Chengdu, the match had to wait.

Fernandes had actually been assured the game was going ahead regardless. 'They had said, "No, no, we're not moving it, we're not changing it". So we were actually on the bus, about to go to the ground, and it was about 100 minutes before the game, and I got a phone call from the [general co-ordinator] who said, "Oh Jo, the match is cancelled. I've got to go and call someone else, but the match is cancelled today. It'll be tomorrow." So I got off the bus, we got off the bus, and the Canada team manager was getting off the bus at the same time, and we looked at each other and kind of said, "What the eff is going on?", you know. So it was postponed at the very last minute, and then the match was played the very next day and that was where we made it through to the quarter finals for the very first time.'

Every 23rd minute of every 2019 Women's World Cup match featuring the Australian team, the significantly large contingent of vibrant, vocal Australian fans bellowed a reworked version of 'Waltzing Matilda(s)':

We stand and we sing
for our women in the green and gold.
Who'll come a Waltzing Matildas with me?

Thanks to the fans' dedicated efforts, almost every player had their own song:

She's tough and she's a winner,
She eats forwards for dinner,
Ya know she's gonna skin her
Alanna Kennedy! [words by Mandy Jamieson]

Humorous and catchy, it was (mostly) positive, supportive, and crucial. The singing could be divisive. Those focusing on the football didn't necessarily want an enthusiastic supporter waving a giant flag in front of them the whole game, or a gang drumming and chanting in their ears. But the engagement, the colour, and the life it brought to the tournament were immeasurable, and for the most part, everyone enjoyed it. As the song soared, the fans' love for their team and all the other emotion they'd invested shone through.

Record numbers of Matildas fans converged in France, many wearing the new 'Spew 2.0' gold kit splashed with spatters of green and white – named as such for its close resemblance to a horrific 1990s Socceroos jersey. The Matildas strip, designed especially for the team for the 2019 Women's World Cup, was the first women's-specific cut released to devotees who, prior to this tournament, had only ever been able to buy Socceroos replicas designed for male bodies.

Record sales and fan demand have since seen the strip released in a range of larger sizes for male supporters. Some older fans, those who'd followed the Matildas from one Women's World Cup to another long before the team's matches were broadcast and its players were household names, were a little bewildered at the racket and the number of new fans decked out in the splotchy yellow jerseys, but they were clearly happy to see support for women's football was catching on.

In Valenciennes, 9 June 2019, in the first match of the group stage, Australia lost to Italy by two goals to one. A fair contingent of the Australian media and many Australian fans assumed the match against Italy, the Matildas' first 2019 Women's World Cup opponent, would result in three points. The Matildas had beaten other group-stage opponents Brazil several times in previous years and were confident of a good win against the other team in the group, Jamaica, which became better known by its nickname 'the Reggae Girlz'. With a team full of debutants – it was Italy's first Women's World Cup appearance in 20 years – the Italians were something of an unknown, but quickly turned out to be more of a challenge than expected.

The Azzurri had gone a goal up initially before having it ruled offside through a VAR decision. Then Sam Kerr was brought down in the box at the other end. Aussie hearts thumped when the Italian keeper saved her penalty kick, but Kerr quickly scored the rebound. Still, the first Italian goal

seemed inevitable as the Australian defence looked less than impervious. A defensive mistake in open play 10 minutes into the second half led to Italian striker Barbara Bonansea's equaliser. Just as the Matildas looked like they'd manage a draw, five minutes into injury time Bonansea punished them again. And crushed Australian fans' hopes in the process.

Much to most people's surprise, Italy topped the group. Those surprised included Italian fans who assumed their team would at best finish second in the group and pre-emptively bought tickets to the Round of 16 match already scheduled for 22 June in Nice. It was the match and venue that would, through the upset results, instead feature Australia and Norway. The Italian team went on to defeat China in the Round of 16 before narrowly losing the quarter final to the tournament's eventual runners-up, the Netherlands.

The Australian contingent attending matches in France was easily the largest the Matildas have enjoyed in the eight Women's World Cups in which they've participated. Broadcast audience estimates for the Matildas' opening match – close to 600 000 viewers watching SBS coverage and many thousands more watching online with Optus (school children could even watch for free) – were remarkable, considering the match ran alongside coverage of [Men's] World Cup Cricket and an NRL fixture. It should not be surprising: 1.85 million Australians have a registered involvement in football in clubs and schools, as coaches and referees, as volunteers and

participants, and that's not including the mums and dads who spend their weekends watching from the sidelines. Currently, 21 per cent of participants from 150 cultures are female, but the FFA has initiated a Gender Equality Action Plan aimed at reaching a 50 per cent gender participation split by 2027. The #GetOnSide 2023 Women's World Cup bid also focused on the flow-on effects of hosting the tournament. These included the visibility and improvements it would bring to football, particularly women's football, at both the grassroots and elite levels. The 2023 Women's World Cup bid was Australia's third run at hosting the tournament.

Alongside the USA and Chile, the ASF submitted its first formal expression of interest (EOI) in hosting the 1999 Women's World Cup in February 1995. In December the same year, the ASF withdrew the EOI. The withdrawal made economic, if not football, sense in light of the US$30 million operating budget put together by an American delegation for the same tournament (rolling off the back of the highly successful 1994 [Men's] World Cup). Chile withdrew around the same time, and the combined result handed the US hosting rights. During that 1999 Women's World Cup in the US, Soccer Australia presented a well-organised, polished, full-colour bid to host the 2003 tournament. If it had not been for the intrusion of FIFA politics, it would have succeeded too.

The 1999 Women's World Cup tournament arguably provided the template for success. Women's soccer in the US boasted estimates of over one million registered players, a figure that grew further still following the success of the

tournament. It also featured the highest ever attendance at a female sporting event when the final match took place at the Pasadena Rose Bowl in California. Estimates for the crowd range between 91 000 and 93 000. Whichever is the correct figure, it is still the record. In front of the sport's largest ever television audiences – approximately 90 million – the US won a tense final against China (world number two at the time). Brandi Chastain's now famous penalty-kick celebration, where she removed her shirt and swung it around her head, sparked controversy, became a *Sports Illustrated* cover, and has just been captured in bronze outside the stadium to mark the 20th anniversary of the Women's World Cup win. Maria Berry, one of the 2003 bid organisers, was there. She wore her 1999 Women's World Cup t-shirt to the 2019 Women's World Cup final in France. 'It was pretty incredible', Berry says of that 1999 final. 'Bill Clinton flew in on a helicopter. Jennifer Lopez sang ('Let's Get Loud'), and the US Air Force did a flyover. It was all a bit over the top, but a lot of fun.'

Berry's football career began in 1979. She played, became more involved in the administration of the club, then found herself helping out at state-level football, before joining the AWSA as a director in 1995. She stayed in the post until 2003 and is currently chair of the Women's Standing Committee for Football Federation Victoria (known as Football Victoria as of December 2018). Berry has effectively been working for the good of football in Victoria and Australia for 40 years.

Berry bought the 1999 Women's World Cup t-shirt when she travelled as a member of the delegation to Los Angeles with the Australian 2003 bid. Officially submitted by Soccer

Australia, the FIFA member association, the bid's prime movers were actually AWSA president Denis O'Brien and CEO Warren Fisher, both of whom worked closely with Australian Soccer Association chairman Basil Scarsella and CEO David Woolley. Having received strong support from state governments, especially in Victoria, 'the Australian bid was very well organised, with a colourful eight-page brochure; better than anything anyone else had produced for a women's event at FIFA', Berry says. 'There was a great buzz about Australia as the 2000 Sydney Olympics were shaping up to be a huge international win for the country.'

Better still, Australia was the only country bidding. Australian football put its best foot forward and it appeared to pay off. At the women's symposium held during the tournament, Berry remembers, 'the delegation were being congratulated on our success, and people telling us they were looking forward to visiting Australia'.

The bid made an excellent pitch for the tournament, highlighting AWSA estimates that Australia had 65000 registered women's players. Participation rates had doubled since 1997. There were high expectations of the Matildas side competing in the 2000 Olympic Games, and the team was gathering attention for its football as well as its calendar. The bid suggested the tournament would significantly increase the visibility, and attract appropriate sponsorship, sports-friendly media, and strong, positive publicity in a nation that loved its sport. At the time, Australia was punching above its weight across a range of international platforms. The Australian women's teams were in world number one spots in hockey,

netball, and cricket. Foregrounding venue accessibility, the bid stressed the relatively large number of venues, including two each in Brisbane, Sydney, and Melbourne, and one each in Adelaide, Canberra, Newcastle, Wollongong, as well as a proposal for a new stadium in Perth to manage the competition. It highlighted how frequently teams competing in the WNSL and the [Men's] National Soccer League (NSL) travelled between cities.

The 2003 bid also underlined Australia's track record for hosting international events (including the FIFA World Youth Championships in 1981 and 1993), Formula 1 racing, test cricket, and the forthcoming Olympic Games. It went to great lengths to profile a tournament that would both take place in the sun and be cost-effective. It emphasised Australians' ability to put on a show and the burgeoning international status of both the country as a football community and the Australian team. Between 1997 and 1999, the USA, China, Italy, Canada, and New Zealand all visited Australia to play international matches. The national team was playing competitive international football in the youngest and smallest of FIFA's six confederations. At the time, the Oceania Football Confederation consisted of 10 teams eligible to qualify for the World Cup: Australia, New Zealand, the Cook Islands, the Solomon Islands, Tahiti, Tonga, Papua New Guinea, Fiji, American Samoa, and Samoa. At the time, only Australia, New Zealand, Papua New Guinea, Fiji, American Samoa, and Samoa had organised women's competitions, a pre-requisite for any bid.

The brochure included words from Julie Murray, who'd captained the Matildas to the 1995 Women's World Cup,

and from Prime Minister John Howard, who positively gushed about football, Australia's natural wonders, its friendly people, and its clean air and healthy food. Emphasising the multicultural society and parallels with the US, the more than 170 languages spoken, and the diversity of food available – from sophisticated city restaurants to the simplicity of home-cooked barbeques – the Australian bid said 'we can make it as easy or as fancy as you want us to'.

As the only bid, it should have been a certainty. The deal, though, had been stitched up well before that. Australian television networks did not pick up the rights to broadcast any of the 1999 Women's World Cup and this may have tainted the bid. Either way, at the last minute a FIFA deal changed the outcome. China had bid for a [Men's] Youth World Cup but was not successful, and the Asian bloc was unhappy. In a compensatory move, even though China had not bid to host the 2003 Women's World Cup, FIFA gave the country the tournament.

FIFA's decision to dismiss the Australian bid was easy to make. As a member of the far smaller, less powerful, Oceania Football Confederation, Australia had very little clout. While the official announcement noted the closeness between the two bids from Australia and China, it's been alleged that the Chinese delegation demonstrated a great deal of reticence, and worse, had actually supported the Australian bid. In response, it was made clear that if China did not take the tournament, FIFA would make it very difficult for China to successfully bid for the more lucrative [Men's] World Cup. The Chinese delegation apologised to their Australian counterparts and

explained that FIFA had foisted the tournament on them. In a twist of fate, China didn't end up hosting the 2003 tournament. As a result of the SARS epidemic in China, the tournament was moved to the USA at the last minute – a decision no doubt influenced by the fact that the US had hosted the previous Women's World Cup and had the infrastructure in place to take on the 2003 iteration at short notice. As compensation, China hosted the 2007 tournament.

Playing against Brazil in Montpellier, France, on 13 June 2019, the Matildas found themselves two goals down, needing three for the crucial win to keep them in the tournament, when VAR turned friend from foe. The goals by Chloe Logarzo and Caitlin Foord, and the one controversially awarded as an own goal after Sam Kerr wreaked havoc with Brazil's defence, after a replay, were the first Brazil conceded in a group stage match in five Women's World Cup tournaments and led to their first group-stage loss in seven Women's World Cups. More importantly, the win exemplified the grit, tenacity, passion, and courage that marks the Matildas' play and the three iconic words – never say die – that encapsulate their playing approach.

The Australian fans' jubilant reaction to the third goal had photographers and journalists hurrying around the stadium to record them. Those same fans' mix of relief and adulation was almost palpable at the final whistle. It was true for Australia's captain Sam Kerr too. During the post-match interview, she

told her critics to 'Suck on that one', indelibly marking the phrase in people's minds and spawning a range of unofficial Matildas merchandise emblazoned with the words.

At the match held in Grenoble on 18 June 2019, Italy scored five goals against Jamaica without answer. The Brazilians scored three. The competition for second place in the group – the prize, that match against Norway in the Round of 16 – depended on the result between Italy and Brazil and the number of goals Australia scored. Italy had six points. Brazil would have six points if it beat Italy. Australia needed to beat the Reggae Girlz by at least three goals to have six points and finish second in the group. The possibility of facing the talented, home crowd-supported France as the third-place team was almost as terrifying as trying to calculate the various permutations the possible range of scorelines could produce. While no goals were scored, the Matildas faced the prospect of third place and France. The Matildas were 3–1 up at 69 minutes, but if Brazil scored it wouldn't be enough for Australia to finish second. Five minutes later, that's exactly what happened. The pressure was on for a fourth goal. Then Kerr, leading from the front, already on a hat-trick, duly delivered in the 83rd minute. The last seven minutes, with the powerful and athletic Jamaicans coming back into the game, made for a close finish. The Matildas finished second in the group and they and their fans were off to take on Norway in Nice.

The first formal contestation of a FIFA-endorsed Women's World Cup took place in China in 1991. Since then, six countries have hosted eight Women's World Cups: China (twice), the US (twice), Sweden, Germany, Canada, and France. The US and China have the world's highest levels of participation in football and FIFA has always been keen to host the tournament in a country that has the interest, the appetite, and the potential to further grow the game. The US has won four Women's World Cups so far (1991, 1999, 2015, 2019). Norway won the tournament in 1995. Germany won the 2003 and 2007 tournaments; Japan edged out the US in 2011.

The 1991 tournament was FIFA's first, but there were predecessors. Stranger still, perhaps, is that the Matildas performed in two Women's World Cups – the 'unofficial', 'test case' 1988 tournament in China and the 1995 tournament in Sweden – before Australia even had a domestic national league competition or the team was known as the Matildas.

The first iteration of the unofficial Women's World Cup, the Martini & Rossi Cup (so named because beverage company Martini & Rossi sponsored the tournament, paid all six teams' travel, accommodation, and expenses, and also provided kits) was held in Italy in July 1970. Denmark beat Italy in the final. The champions succeeded over five other teams, including England, West Germany, Mexico, Austria, and Switzerland, to claim the prize. Czechoslovakia (as it was known at the time) almost attended the tournament,

but withdrew shortly before. The final is reported to have attracted a crowd of 30 000. The 1971 six-team sequel tournament in Mexico attracted huge crowds, equal to those that had watched the [Men's] World Cup in the same country the year before. Over 110 000 fans attended the Mexico v Denmark final in Azteca Stadium, Mexico City. Around 80 000 watched the home nation play England in Guadalajara in the second stadium used for the event. The other participants were Italy, Argentina, and France.

Sports historian Jean Williams argues the tournament was a success because the organisers assumed it would be: that women's football would be as popular as men's football. They brought in an excellent PR team, gained TV and press coverage, attracted a range of sponsors, and sold large quantities of merchandise. There was never any expectation that it would be anything other than a success. So it was.

The Women's Football Association in England almost managed an international tournament. England striker Geoff Hurst and coach Alf Ramsey met player turned writer Sue Lopez, who highlighted that sponsorship had been promised in 1971 and that several members of the English men's team had provided support and mentorship. The ban had been turned over and the group planned to build and capitalise on the growing interest in women's football. The English FA, the English game's governing body, voted against taking up the offer, effectively killing off the idea.

And five iterations of the international invitational tournament, the Mundialito, or 'the little World Cup' in Spanish, took place in Japan in 1981 and in Italy between 1984 and

1988. In Japan, the host team were joined by Italy, China, England, and Denmark. The later tournaments took place in northern Italy. The hosts dominated West Germany, Belgium, and England in 1984, and lost out in the final to England after both teams beat Denmark and the US in 1985. The 1986 and 1988 editions featured more teams, including France and China, and were split into two groups. Not much is known about the tournaments except that the US team became 'regulars' alongside England and Italy, the tournament's two most successful teams. In a short time, it became known as the most prestigious women's football event. It has also been credited as the forerunner for the more recent tournament, the Algarve Cup.

The Matildas' name is arguably one of Australia's most iconic – it's definitely up there in recognisability with the Wallabies and the Socceroos. It's so entrenched in the Australian psyche few would know that the name is actually fairly recent – it's only been around for the second half of the Matildas' 40 years of existence. For the first 15 years, the Australian national women's football team received what could best be described as second-hand billing and a hand-me-down name. Known to, or at least described by, the media and football authorities alike as the Female Socceroos, Lady Socceroos or, worst of all, the Soccerettes, their name only served to continue the oblique othering of women's sports. Following what was regarded as a poor performance at the 1995 Women's World Cup, and

with a sideways look at the increasing household awareness of the Socceroos name and brand, the AWSA resolved to create a new moniker. Denis O'Brien credits Warren Fisher with the renaming process. 'He proposed we run a competition to get a name ... Warren put the idea to the media.' SBS, the only Australian television channel supporting football at the time, partnered with the AWSA and took up the challenge to determine a new standalone name for the women's national team.

The team's coach at the time, Tom Sermanni, remembers he was driving from Canberra to Sydney in a torrential downpour when SBS called him with the result. He pulled over. On the roadside, he listened to the verdict via his mobile phone – one of those giant bricks. Straining to hear over the raindrops hammering his car roof, he made out the favourite names in the draw, including some like 'Galahs' that Sermanni thought to be a little ridiculous. The general public, he was told, had chosen 'Matildas'. The most popular by far, it was a homage to the iconic Australian song. But Sermanni, like some of the players, wasn't a huge fan of the name. Regardless, it stuck. It took time, but it has grown on people – coaches, players, and fans alike. Looking back on it, O'Brien acknowledges they 'had a great deal of luck' and admits to being 'a bit surprised at how quickly the name became a household name within a few years'.

These days, the team and its name are one of the nation's healthiest, most marketable brands. Rather than succumb to criticism of their campaign in the 2019 Women's World Cup, a new survey has nominated the team Australia's most beloved, up one spot from the previous year. In the eyes of the

general public, the Matildas' collective conduct, hard work, generous spirit, and heart-wrenching effort have further propelled their already burgeoning profile to new heights. Those who've been involved in the game long term know the same collective conduct and spirit have been the mainstays of the Matildas' game for a little over 40 years. The contemporary team's football is faster and technically superior, the venues and crowds are brighter and bigger, the strips have changed dramatically – these are now specially designed for the team by Nike and made of recycled fibre; the team have come a long way from sewing on their own badges – but the attitude and approach that underpins the Matildas' every performance is exactly the same. There just haven't been as many people around to notice before.

Throughout the 1970s and 1980s, women in football were exerting pressure on FIFA to host an international tournament. FIFA, being FIFA, said it would give the matter (the possibility of a Women's World Cup) serious consideration. In doing so, it raised supporters' and players' hopes almost annually. In 1988, FIFA finally, partially, conceded, and oversaw an international competition in China that would become known as the M&Ms Cup. The Australian fixtures all took place in Shiang-Min city. The opening game defeat of Brazil, via Janine Riddington's exquisite chip shot, raised expectations that only made the comprehensive quarter-final loss to China all the harder to take. Angela Iannotta can take

credit for Australia's first official Women's World Cup goal at the 1995 tournament when the Matildas lost 4–2 to China, but Riddington arguably scored the Matildas' first international goal (sorry Angela).

In the still warm and humid Brisbane winter of 1989, Australia, New Zealand, and Papua New Guinea would compete for the third Oceania Cup and a place in the 1991 Women's World Cup. New Zealand beat Papua New Guinea by more goals than Australia and qualified. It left a bitter taste, as the Australian coach, Steve Darby, who was given the choice and elected to let New Zealand play Papua New Guinea first, should have elected to play the less-experienced team before Australia's antipodean rivals. Later that year, the Australians undertook a winter tour in Japan. The small rooms and baths were a cultural contrast to the space people were afforded in Australia. Team meetings, held in hallways because the rooms were too small, were constantly interrupted as hotel guests made their way through.

In 1991, Swedish club team Malmo played a three-match series in Australia. The Swedes won two of the three matches and marked the significant difference in standard between Europe and Australia. The Matildas supported their Oceanic peers by participating in a warm-up series. New Zealand won two of the three fixtures, so it would be fair to say the team was a suitable representative for the region at the Women's World Cup. The Kiwis would be defeated by Denmark, Norway, and China (ranked second in the world at the time and eventual runners-up) in the group stages. If the standard of the Malmo team was anything to go by, it's little

wonder New Zealand's matches finished the way they did.

In 1993, the Australian youth team toured Denmark, with Alison Forman, contracted to Danish Club Fortuna Hjørring FC, acting as liaison between the Australian team and the Danish organisers. The senior Matildas, including Forman, toured Russia the following year and toppled New Zealand to represent Oceania in the 1995 Women's World Cup in Sweden. The three groups of four teams saw Australia in the toughest group. The team would lose to eventual semi-finalist the US, and China. Denmark, the third group team, would be knocked out by Norway, the tournament champions. Australia's placing at the bottom of the tournament ladder would spur the team to greater things.

The 1995 tournament would not be Australia's most successful. The lack of resources leading up to it was definitely a contributing factor. 'The '95 Women's World Cup preparation in Scotland was significantly suboptimal', Murray says, 'because we stayed in a veterinarian university or some university in the outskirts of Glasgow. They had the coldest day in summer in 50 years and it was ridiculously freezing. We didn't play on any grass pitch. We actually played on the school-grounds where people could just walk and have a bit of a kick-around. And the other pitch was dirt [a strange red ash], and we did some scrimmages against some blokes who just turned up and I think that they injured a few players. Those kinds of suboptimal things. So it's chalk and cheese from Turkey,' Murray says of the Matildas' optimal pre-2019 Women's World Cup training base. 'We were eating food from a bain-marie [in Scotland], like prepared university food. It was not remotely

appropriate for a Women's World Cup preparation. And that was probably part of the disappointment. I mean, whether I played well or not is neither here nor there. It was just the whole experience ... ' Especially so, considering the weather and physical preparation conditions would have been conducive to playing matches in a Scandanavian country. Unfortunately, the women's game in Scotland took even longer to enter the public's consciousness there than in Australia.

Still, there were some highlights. 'That's when you had to fax', Murray recalls. 'I remember getting all these faxes: Best wishes, Julie. Then I'd write this handwritten thing on a piece of A4 and say can you please fax this to ... ' It had hallmarks of Julie Dolan's own experiences years before of receiving well wishes via telegrams.

Most significant during this period was the IOC's decision, following lobbying and pressure from thousands of supporters, to include women's football as a full-medal Olympic event. Between the prospect of the Olympic Games and regular qualification for the Women's World Cup, young Australian players could see a way to make their mark on a global stage. It would be some time, however, before they could make a living. Preparing to participate, including aiming for gold in the 2000 Olympic Games, involved intensive training at national camps. Jean Williams suggests the lack of Olympic status prior to the 1996 Olympic Games affected the development of women's football, as the training camps as a means of identifying talent were not rolled out until after Australia failed to qualify.

Australia only conceded one goal in the 1998 Oceania

Cup, the tournament that doubled as the 1999 Women's World Cup qualifier. On the 25th anniversary of the AWSA initiation, the Australian team was on its way to its third Women's World Cup. The 1999 event, the largest to date, featured 16 teams competing across four groups. Average attendances at the games were over 37 000, arguably because all the group matches were played as double headers, so fans got two games for the price of one. Still, cumulative attendance broke the one million barrier. Every match was televised, and extensive sponsorship helped ensure the tournament made a US$4 million profit on its US$30 million operating budget. The Matildas gained Australia's first ever official Women's World Cup point in a draw against first-timers Ghana, but lost their other two matches to finish third in the group. Alicia Ferguson-Cook broke a record, one that still stands, by being sent off within two minutes of kick-off in the match against tournament runners-up China. It would not affect the match outcome.

The seventh iteration of the US Cup (2002), an annual women's football tournament US Soccer hosted and Nike sponsored, was abandoned as a result of the 9/11 attacks. As they did with the other six iterations, the US would win the eighth and final Women's US Cup tournament.

The 2003 Women's World Cup attendance figures did not match those of the 1999 tournament. That was at least partly due to the short-notice move to hold it in the US due to the SARS outbreak in China, but also because US Soccer had effectively let the women's game fall over. The first national professional league that had been initiated after the 1999

Women's World Cup win folded due to a lack of financial support. Australia qualified for the 2003 tournament by winning their final Oceania Cup, but equalled its 1995 points tally with two losses followed by a draw with tournament favourites China. Again, Australian broadcasters neglected to pick up television rights. The only coverage the tournament received were brief packages of highlights and two interviews: one with Adrian Santrac, who began his tenure as Matildas coach in 2001 (a year where there were no Matildas fixtures) and only coached his first match in 2002; and one with team captain Cheryl Salisbury.

The sixth edition of the annual Australia Cup took place in Brisbane in 2004, just before the Oceania Olympic qualifiers. The Matildas played China and New Zealand, and invited North Korea for its first international tour to Australia. The North Koreans reciprocated the invitation and the Matildas visited Pyongyang in 2007. The brochure for the 2004 Australia Cup offered a positive introduction from football supporter, entrepreneur, and newly appointed Soccer Australia chair Frank Lowy, showing that Australian football's new management (or leaders) took the international women's game seriously. The Matildas won the Australia Cup, then comfortably qualified for the Athens Olympics, toured Mexico, and played the US – all before winning their first Olympic game ever against host nation Greece. They lost their quarter final to Sweden, but it was a solid series of performances that established the strength of the team and provided part of the foundation for the FFA to make its case to leave the Oceania Football Confederation and join

the larger, more challenging AFC and enter the 2006 AFC Women's Asian Cup. As if to justify the decision to change confederations, the Matildas reached the final where they lost to one of Asia's two powerhouses, China.

Germany would win the 2007 Women's World Cup in China, but Australia would record its equal best result by making the quarter finals. With that tournament, Salisbury was the first Australian player to feature in the finals tournament of four World Cups (1995, 1999, 2003, and 2007). Australia beat Ghana, drew with Norway and Canada, and for the first time powered its way into the quarter finals. Despite the Matildas' heroics, which gave their competitors a heart-stopping run for their money, eventual runners-up Brazil would beat Australia 3–2 and secure the semi-final place.

For Heather Reid, Lisa De Vanna's 2007 Women's World Cup performance remains a standout. 'The thing we have to understand', she says, 'is for Lisa, it's all about pulling on the green and gold'. De Vanna was still young, but really found her place in the side. Her performances highlighted everything about her game: flair, speed, hunger, tenacity. Fans who attended the 2007 Women's World Cup matches recognised these qualities and chanted her name. 'And Lisa, of course, didn't know what to do with herself', Reid says. 'It was beautiful. She needed a police escort to leave the stadium. Hundreds of people waited on her. She was shaking people's hands and signing shirts and whatever they gave her. At one point, she was leaning on the front of a car, at another she was leaning on a police officer's back. They couldn't get enough of her.'

While current players like Steph Catley were inspired by the Matildas' 2007 Women's World Cup efforts, more than a few players who were in the actual team also consider the tournament a remarkable feat. 'The 2007 World Cup was probably the time of my life', Lauren Colthorpe says. 'The team had some great personalities, and the older players really took us young players under their wing. There was a real maturity in that team and the culture throughout the tournament was excellent. I think Cheryl Salisbury's leadership had a lot to do with it. She always encouraged team success first and whether players were starting, or disappointed not to be, everyone got behind each other.'

And the results were remarkable. 'The preparation for the tournament and the program funding was probably a quarter of what it is today but the team managed to make the quarter finals and push Brazil to the end for a place in the semi final', Colthorpe says. 'I didn't realise at the time the enormity of what the team achieved at that World Cup against so many odds. I heard following that World Cup was the biggest spike to date in female participation rates. I think the country fell in love with the "never say die" mentality of the Matildas during the tournament and the current team has carried that on. We were far from the most tactical or organised teams, and although we had some great technical players, we weren't technically strong in every position. But we made the most of what we did have.'

That spirit carried well off the pitch and even beyond the 23 players selected to embody it. 'Karla Reuter didn't quite make the 2007 Women's World Cup', Di Alagich says. But

while many other players might not want to be around the team and tournament they'd narrowly missed out on being a part of, Reuter travelled with the team to help out. 'She was a shadow player and she slept in Beersy's [Kate Beerworth's] equipment room, and she just helped Beersy the whole time. She was just the biggest supporter. It's such a massive thing for someone to miss out and still contribute to the team ... She helped with everything, like the washing, supporting, water, you know, was an all-round massive part of the Women's World Cup.'

The Matildas continued their form in the 2008 AFC Women's Asian Cup, where they finished a respectable fourth place overall. They would go on to win it in 2010, as we've seen, through heart-stopping penalties: 5–4. Tom Sermanni would become the first Australian coach to win a trophy with the international profile of 2010 AFC Women's Asian Cup, and the Matildas would be the first Australian football team to win in Asia. The win also granted the team automatic qualification to the 2011 Women's World Cup in Germany.

Nike stitched the words 'never say die' onto the inside of the Matildas' 2011 Women's World Cup jerseys so the team played with it sitting over their hearts. The team also prepared for the tournament in Göttingen, Germany, a town that warmly welcomed them but that required the Matildas staff to explain some cultural differences to the players. The pools the team used for recovery allowed people to bathe naked. Physiotherapist Lauren Hanna (née Cramer) remembers: 'We had to explain to some 15- to 26-year-olds like Caitlin [Foord] that there may be naked men who will come and

chat to them'. Still, the Australians brought some traditions of their own. As Tameka Yallop recalls of that and previous tournaments: 'Although Vegemite is still taken on every tour, it used to be eaten for breakfast, lunch, and dinner. When I first started making national teams, tours were mostly in Asian countries and in places that didn't have any western comforts. So Vegemite was always a homesickness remedy for me.'

A loss to Brazil in the opening game could not stop the Matildas reaching the quarter finals. They lost to Sweden, another old foe, in the knockout stage, but Foord was awarded best young player of the tournament, and Kellond-Knight made the tournament's all-star team. Sermanni had put Foord up against Marta, the player FIFA had awarded the best female footballer in the world an incredible five times. 'I knew she was going to be fine, because Caitlin didn't really know who Marta was', Sermanni says, adding that Foord was not intimidated. 'When I was talking to her about Marta, she just kind of shrugged her shoulders: ok.' The Matildas would hold their own against Brazil, with one agonising goal the only difference between them.

Rapper Snoop Dogg would come out in support of the USWNT's calls for pay parity in the wake of the 2019 Women's World Cup. But his first brush with the Women's World Cup, whether he was aware of it or not, might have been in the form of a 2011 encounter with the Matildas. At one stage, Snoop Dogg and the team happened to be staying in the same hotel in Germany. The night Snoop Dogg had a gig, the Matildas staked out the hotel lobby to catch a glimpse and a photo of him – they'd even prepped photographer Joseph

Mayers to take a photo quickly, and he'd done some test shots in the lobby to ensure he could simply point and shoot. The baby of the team, 16-year-old Teigen Allen, a huge Snoop Dogg fan, hovered nervously around the lobby, torn between going to have her scheduled ice bath and terrified she was going to miss Snoop Dogg go past.

The Matildas had been waiting for over an hour by the time Snoop Dogg and his security detail went to make their way through the lobby to the vehicles waiting to whisk them to his gig. When the Matildas stepped forward to request a photo, Snoop Dogg's security were not interested and tried to brush them off. But Heather Garriock was having none of it and all five foot five of her determinedly blocked their path. So the security detail relented and the Matildas immediately, efficiently formed themselves into rows either side of Snoop Dogg, Mayers snapped the pic, and seconds later the rapper was on his way. The players were stoked and Sermanni laughed, commenting that the players had never ever organised themselves with such speed and efficiency for him.

The Matildas would exact some revenge on their 2011 Women's World Cup loss to Brazil and go one better in the 2015 Women's World Cup when they became the first Australian team, female or male, to win through the first round of knockout stages in a World Cup. That tournament – which controversially played out on astroturf in yet another example of how conditions that would not be tolerated or even suggested for men are deemed acceptable for women – would see Kyah Simon net the rebound from a De Vanna cannonball for the Matildas to defeat Brazil 1–0. Japan, defending

champions and the team that defeated the Matildas in the final of the 2014 Women's Asian Cup, would end the Australians' glorious run in the tournament, but it felt as if the Matildas were beginning to hit their stride. The following year, they made it through the group stages of the 2016 Rio Olympic Games to lose to host nation Brazil in the quarter finals.

It would be the appropriately named 2017 Tournament of Nations that turned our nation's attention to the team. That focus came when the Matildas recorded a win against perennial world number one the USWNT on home soil for the first time in the 27 contests between the two teams. The Matildas also beat Japan 4–2 and crushed Brazil 6–1 to finish as the inaugural, and surprise, tournament champions. Following the tournament, the Matildas were awarded the Public Choice Team of the Year at the AIS Awards. They finished runners-up in the 2018 AFC Women's Asian Cup after defeating plucky minnows Thailand in the semi final on penalty kicks. They lost to Japan in the final, but their second-place finish was enough to qualify for the 2019 Women's World Cup. They lost the 2018 Tournament of Nations to the US on goal difference. But this time, a run of poor results in friendlies would see the team's form come into question.

The Matildas were ranked number 11 in the world when Alen Stajcic took over. In 2018, he managed to get them to number four, the team's highest ever rank. But the Matildas lost to Chile at home in a friendly and were struggling with form that had seemed easy in 2017. Extraordinarily high expectations going into the 2019 Women's World Cup were dented, and should have been more realistic, after the team

lost 3–0 to eventual tournament runners-up, the Netherlands, in a pre-tournament friendly.

When the Matildas did play Norway in Nice, on the French Riveria on 22 June 2019, unlike the other matches, fans needed to get a bus to the stadium from town. Fans left the sunshine optimism of the pre-match party wearing Matildas jerseys of varying sizes and vintages. They held their breaths through a hard-fought 90 minutes that ended in a draw. Norway took the lead 30 minutes in. Australia only equalised through a Kellond-Knight corner kick in the 83rd minute. The prize, a quarter final against an in-form England, made both teams jittery. But the combination of their collective frailties and strengths balanced a robust and energetic match. Very little separated the teams, and the 30 minutes of extra time did not change the result. Sam Kerr missed her penalty and Emily Gielnik's was saved. Norway progressed to the semi final where it would be defeated by a very strong English team, which then pushed the USWNT all the way in the semi final.

The Matildas have now qualified for eight Women's World Cups and made the quarter finals four times. The hope for every Women's World Cup in recent years is that this might be the one in which the Matildas make it one step further to a semi final. The highest World Cup finish the Socceroos have

ever managed – and they've qualified for five [Men's] World Cups – is the Round of 16. In the last two [Men's] World Cups, the team gained a solitary point and has yet to finish the tournament with a positive goal average. Which makes much of the criticism the Matildas received after their loss to Norway difficult to see as being credible – one illustrative example is the Fox Sports online headline 'Robbie Slater takes aim at "selfish individuals and groups" over Matildas' Women's World Cup "failure"' (24 June 2019). The article describes a Fox Sports news segment where former Socceroo and football commentator Robbie Slater, despite limited engagement with women's football, described the Matildas' defeat and exit from the tournament as 'an absolute fail'. Few commentators provided the measured commentary or balance football analyst and advocate Craig Foster did in 'Why Matildas woes run far deeper than World Cup exit', which was published on SBS's *The World Game* site the same day. While progression on the international stage follows the same steps as men's football, there are great disparities in the promotion of women's sport and female role models, in geographic inequalities, in resourcing, and in what we expect our national women's football team to achieve.

Irrespective of gender, the 2019 tournament was the most exciting Women's World Cup in recent memory. The VAR (Video Assistant Referee) predictably frustrated those it condemned, particularly a Cameroonian team caught up in the heat of the moment, but it detrimentally affected a substantial number of teams. So many teams, in fact, that mid-tournament FIFA took steps to change its own new rules around goalkeeping offences.

Referee Kate Jacewicz is pragmatic about VAR and recognises its potential to improve the game. 'I'm going to preface it with I love VAR and I love working with it because essentially it's just a process', she says. 'You understand the protocol, you understand laws, you understand the interpretation. It's just a second chance of looking at your decision or making a different decision. So I love it in that sense.'

Jacewicz and the other officials had worked hard to familiarise themselves with the technology before the tournament. 'But in terms of adding another challenge, there were certain situations that came up during matches, and in my match as well, the Round of 16, where we hadn't actually experienced that in our simulations or training before. So it, was like, wow, we're in new territory … We made a few clerical errors, logistical errors, which we could have done differently. The outcome was still ok, but just from an optics perspective or a management perspective we could have done things differently and had a better outcome,' she says.

'For example, my VAR review at the World Cup, I had a handball. So I went to the screen and everything was fine. We had the decision within 20 seconds … Got to the field and I was about to throw down the penalty, give the penalty. And then as I was about to do it, Caroline Seger, the Swedish captain, goes: "Hey ref, there was a hold before the handball. Did they see that?"' Jacewicz asked the VAR to confirm. 'So I went back to the screen to have another look, which they don't really want you to do because it makes me look like I have doubts over the decision I'm getting. But that wasn't the case. We actually had a whole new decision to give. Or just

the check. Because if there was a hold before the penalty, the penalty would have been null and void and we would have given a free kick to Sweden, a defensive free kick ...

'FIFA didn't want me to go back to the screen. They just said: "It would have been better if you'd just stayed with Seger, the captain, pulled on your shirt, and shown to the world that we're checking a hold, and just waited. And then once it came through that it was all clear, again, pull my shirt again and wave it away and just say "no, no, no, nothing happened", and then give the penalty. So that sort of thing we'd never experienced, as an optics it would have looked better rather than me going back to the screen.'

Still, if that was the biggest issue then Jacewicz was doing ok. She'd prepared for six months with her refereeing team, but the week before the Women's World Cup, Jacewicz was tapped on the shoulder. Experienced Canadian referee Carol Anne Chenard had been diagnosed with breast cancer. Her two assistants – one from the US and the other from Canada – needed a referee. Jacewicz was the solution. 'So everything we'd prepared for was completely flipped around, on its head', Jacewicz says. 'I just had such a unique, different experience for my first World Cup, having to prepare so quickly and so differently with two new girls in our team. We just clicked. I can't begin to explain how ... We worked hard for it, that genuine connection, which is something I highly value as a referee, working with a team that we trust unconditionally. And we got there in a week – less than a week, actually.'

The team had 90 minutes of training match practice together before launching into the Women's World Cup.

They officiated the second match of the tournament, 'which was unexpected, as well', Jacewicz says. Surprisingly, she felt the most relaxed she'd ever felt going into a match: 'Even in the warm-up, the crowd were clapping and cheering for us.'

Regardless of what was happening out of sight of players and fans, the standard of football, reflecting the highest standards of the game being played in Europe, the US, and Australia, outweighed the negatives of the tournament and brought in new audiences. The 2019 Women's World Cup broke new ground in the mainstream media and public consciousness.

Fans can usually pinpoint their exact whereabouts and emotions at any given iconic football moment. For example, scrambling to a television late on a school night, breathless with stress and anticipation at the Matildas' 2010 Women's Asian Cup win 5–4 on penalties. Up in the middle of the night with tea and in pyjamas, euphoric when the Matildas nearly, so very nearly, pulled off an upset by coming back from two goals down against Brazil in the 2007 Women's World Cup. In pyjamas again, but this time wretched with disappointment following the poor decision-making and unforced errors that gave Sweden, a team the Matildas could and should have beaten, a semi-finals berth in the 2011 Women's World Cup.

There have been other versions of 'the Waltzing Matildas' with variant football-related lyrics. Heather Reid is not alone

in recalling that players and fans repurposed the song used in previous tournaments. But this new generation of fans is a little different. These fans are not former players, or the family members of current players. These are not people who have grown up feeling excluded from the sport, conducting secretive transgressive workouts. Instead, these fans watch football, attend football matches, and kick a round ball around in a park.

This new fan base's exponential growth is the result of many things: the Matildas' demonstrated never-say-die ethos; the draw of goalscoring, backflipping Sam Kerr; and the stunning skill with which the players play the game. Whether or not Australia hosts the 2023 Women's World Cup, these fans – some wearing 'Suck on that one' shirts, some wearing Spew 2.0 kit that finally comes in a women's cut, and others wearing khaki uniforms and brandishing a giant, inflatable croc-Kerr-dile – will be out in force. For, like their name, the Matildas are a team that are easy to admire and hard not to love. And they'll be demonstrating their spirit in 2023 and beyond as they work to perform up to their own and others' expectations in subsequent Women's World Cups.

Chapter 9

WHERE TO FROM HERE?

When Melissa Barbieri arrived back in Australia after the Matildas narrowly missed out on qualifying for the 2012 Olympic Games, she was dealt a second blow: Melbourne Victory coach Vicki Linton had elevated up-and-coming goalkeeper Brianna Davey to the first-choice keeper spot and let Barbieri go. But the decision proved a blessing in disguise. Avid Newcastle Jets fans the Gentle family – parents Sarah and Phil, who'd met playing football, and children Zeke and Brinley – started a Twitter campaign to get her to Newcastle. It succeeded; Barbieri temporarily relocated to play for the Newcastle Jets and now counts the Gentles as family.

Brinley Gentle, who dreamed of nothing but being a Matilda, and who wore a 'supergirl' cape pitchside over her Kyah Simon replica Matildas kit while brandishing a 'Super-bubs' banner in support for Barbieri, is now excelling in multiple sports. Her dream of playing for the Matildas remains as strong and clear as ever. Among the merchandise Barbieri gave her during her Newcastle stint, there's a Matildas jersey. Barbieri has told Brinley that she can, once she's made the

national team, give her a Matildas jersey with 'Gentle' on it. She also wants to be the one to present Brinley with her Matildas cap.

Melissa Barbieri, Ellen Beaumont, Rebecca Price, Sarah Walsh, Di Alagich, Cheryl Salisbury, and Sam Kerr are not alone in relating tales of their early football days as the only girl on a boys' team – very often as the more skilful player. Theirs is a familiar, almost universal, story for female footballers of their generations. Irrespective of age group, these players joined the boys' team because it was the only one available. They were invariably challenged. All were subjected to a greater level of scrutiny than their teammates. All of them had to work harder than everyone else to remain in the side, even if they were recruited to give the boys' team its best chance of success.

When Barbieri was young, people often assumed that because she was good, she must be male. She encountered plenty of mothers who were unhappy their sons were being upstaged by a girl. Similarly, before her football career, Kerr spent her early years excelling as a member of a boys' AFL team. She played for three years before she told them she was female. At least one of the boys was brought to tears when he learnt the truth about his teammate's gender. And Beaumont, as her team's only girl and lead goalscorer, had to threaten not to play the final because the boys, unhappy at being outclassed by a girl, relentlessly bullied her. The fear of

losing the final proved an appropriate incentive to improve their behaviour.

As one of many young female footballers who cut her hair similarly to the boys, Amy Chapman expresses some nostalgic glee when she shows us a photo of her old haircut, but notes that she didn't then have any female footballers' hairstyles to emulate. The haircut also disguised and shielded her from the inevitable attitudes and less than positive informal commentary from parents of the opposition players she was running rings around. The first time Di Alagich saw other girls playing was when she attended her first ever state trials: 'There were six other girls and I was, like, "Oh wow, girls actually play"', Alagich says. 'I had no idea. My first ever nationals, we had 12 in our team because that was all there were in South Australia in U16s. So everyone got a game.'

Barbieri is one of a number of players who have played for men's teams to develop skills that would give her a competitive edge. In the run-up to the 2007 FIFA Women's World Cup in China, Barbieri played in an adult male league competition to hone her shot-stopping capacity and test her abilities. The short SBS documentary of that 2007 World Cup, *Never Say Die*, includes footage of Barbieri taking a couple of palm-warmers – cannonball shots she saves with her goalie gloves on – and a difficult high ball amid the rough and tumble of a muddy men's match. The documentary also highlights her husband's view from the sideline, listening to fans focus their grumbles on the woman on the pitch.

Goalkeeper Carolyn Jones knows the Barbieri story inside and out. In 1987, at age 17, she was initially selected

and then banned from goalkeeping in the Tasmanian men's league – more than a decade before Barbieri took to the field. The official reason given was 'safety concerns', but the taunts of local AFL players about football being 'a game for sissies' were most likely a contributing factor. Like Barbieri, Jones was simply trying to improve her skills in the absence of a strong women's league.

This situation is beginning to change. At the beginning of the 2019 season, the U12 boys' Division 1 side at Brighton District Football Club in Queensland recruited Miri Lowe from the U12 girls' team, where her friends are. Her skills were so significant, she was poached to help strengthen the boys' team. Lowe now trains and plays once a week with the boys, and trains and plays across the rest of the week with her friends in the girls' team. She often finds herself torn between the warmth, humour, and camaraderie of playing with her friends and the need to challenge and develop her game in a suitably competitive environment.

There are considerable differences between the experiences and football development of Gentle and Lowe, and those of current and former elite female footballers. With the introduction of women-specific programs, and with enough girls and women now playing the sport to field their own teams outright, for players like Gentle and Lowe, playing on or against boys' teams is now becoming a choice they make to challenge their physicality and speed rather than a necessity.

Right now, we're witnessing some significant lasts and firsts of Australian women's football. The current generation of players in the prime of their careers or approaching retirement is, in addition to being the last generation that can remember a world before ubiquitous social media and internet, hopefully also the last to remember what it's like to carve out a football career without pay above the poverty line, clearly defined pathways, or identifiable role models. But that generation is playing alongside and mentoring a generation of firsts: the first women to not only be able to look up to female heroes they wish to emulate, but also to see an at least partially paid football career pathway.

When she first started playing football, Matilda Hayley Raso didn't know the World Cup was also for women. Ellen Beaumont didn't know who the Matildas were, let alone that she might be selected to play for the team or its junior versions one day. Jenna Drummond knew there was a national women's football team, but says she wouldn't have known its name. Now, not only do female footballers know there's a national team and a pinnacle international women's football tournament, they know their names and can imagine being part of both.

Professional players have never been more visible, both through media coverage and their own social media leverage. Some – still relatively few – even manage a full-time wage through football contracts and sponsorship. With every W-League and Matildas match now being broadcast, with W-League players earning a minimum wage and receiving improved medical care, with football the sport of choice for

women in Australia, and with the players, accessible via social media, reaching household-name status, future generations of female Australian footballers will likely never know a time when opportunity, pay, and pathways were not available.

This is testament to the generations of women who made invaluable incremental inroads before them. Those women, the Millmans, Monteaths, Taggs, Dolans, Dodds, Vinsons, and Boyds were, as former Canberra United player Grace Gill notes, there 'on their own time', without the promise of fame or fortune. 'It was purely the time commitment from individuals who, as a collective, were beyond proud to play for their country', she says. 'The passion that existed in that generation fills my heart – they paved the way for what we know to be football in Australia today.' Coach Jeff Hopkins concurs: 'That's probably the thing that really drives me on in my role now', he says. 'To try and reward these players that have really made these sacrifices and to make the game as professional as we possibly can now.'

Historical records are not well maintained for Australian women's football. The high turnover of people, frequent office moves, and the fragmented nature of the game's organisation have all led to a lack of continuity in the story, particularly outside of the large population centres. There is a high turnover of people supporting the sector, as it primarily runs on volunteer labour, mostly from players' families. This burns people out quickly, and people's investment in the work is often, understandably, limited to their children's involvement.

The low levels of resources and funding, and the fact that any available resources have been ploughed back into

developing the game, have also made it difficult for individual organisations, particularly governing bodies, to establish a home. Relatively frequent changes of organisational management in the male-led governing bodies that oversee the game have also affected the development of the women's game and have, until recently, led to an unstable infrastructure built on disparate points of strength. To make matters worse, whenever belts had to be tightened, women's teams attached to male clubs – historically considered no more seriously than any of the junior sides – have been the disposable, 'luxury' item.

But things are changing for women's sport in Australia. They really are. In addition to experiencing generations of lasts and firsts, we are seeing a rising tide of enthusiasm. Demonstrating growing interest in women's sport, global photography service Getty Images reported an 86 per cent increase in demand for images featuring women and football. In 2018, eight of its 10 top-selling sports images featured women. Google also published women's football-themed doodles (including one by Brisbane artist Sophie Beer) on its homepages throughout the 2019 Women's World Cup. Other codes, including AFLW, netball, women's cricket, and women's tennis (thanks to the recent ascendance of Ash Barty) are also driving interest in, and the professionalism of, women's sport. David Beckham even turned up to the 2019 Women's World Cup, both to show his daughter what she could be part of and to show the English women's team his admiration and support.

So women's participation in football is starting to be normalised and the stories of women's football are starting to be

documented and shared. Still, the pace of progress toward parity is not nearly fast enough, or even acceptable. And it could easily be undone if its development is not carefully considered. The notion that you're good enough to play, to help, to stand in where it supports the boys, but not necessarily to be supported yourself marks the limited level of thought that most organisers put into the women's game. The same ignorance that saw women banned from playing in the 1920s continues to see their sport sidelined and treated as a second-class pursuit.

The women who play, manage, and support the women's game continue to prove themselves beyond any reasonable expectation applied to their male counterparts in the same position. Yet they're often overlooked for senior positions – for women, being incredibly knowledgeable and competent is still nowhere near enough. As Melissa Barbieri points out, women's football has only seen the changes it has 'because those [who] play and enjoy women's football have banded together and played a part in ensuring the brand is seen'. Women are being allowed to play football now, she says, because they represent additional revenue. But real attitudinal change has yet to occur: 'I will know there is real change when a football club is treating their teams exactly the same. Same changerooms, same pitch allocations. Same resources and same equipment. When you go to a grassroots club and you see the smallest of girls out on the furthest pitch away from adequate toilets and lighting, then you know the equation is not equal.'

Still, the possibility of a career in football has become tangible. Nike's 2019 Women's World Cup campaign, which

foregrounded superstars Sam Kerr, Brazil's Andressa Alves, and the Netherlands' Lieke Martens, featured a young girl participating in matches alongside her heroes. The official 2019 Women's World Cup theme was 'Dare to shine', but that tagline seemed a little outdated – women have been daring to shine for a while, they've just had cultural and economic barriers stacked against them. The Nike ad tagline, 'Don't change your dream, change the world', more aptly embodied where women's football currently is and where it's going.

Of course, there are some significant issues that must be addressed to allow the women's game to keep growing. Tom Sermanni, Julie Murray, Mel Andreatta, Rae Dower, Jeff Hopkins, the players, the PFA – frankly, just about everyone – agree that a full home-and-away fixture list is a must-have. Not only would it extend the season and offer players more game time, it would also extend the sport's lifespan in the media cycle, attracting more interest, increasing revenues and crowds. The trick, of course, will be to balance it with the start of other seasons, but there is room in the calendar. And, with the NWSL already a symbiotic league and with talks of establishing a W-League–NWSL partnership, it should be achievable and in all parties' best interests.

Visibility through broadcast coverage is also essential. On a shoestring budget, and with what often felt like a single, albeit well-placed, rooftop camera, the national broadcaster aired a single game per week from the opening seasons of the W-League. In doing so, the ABC kept the coverage of women's football alive when no other channel was interested in showing games – something for which it should be

recognised and applauded. The 2018/19 Foxtel–SBS partnership, which for the first time showed every W-League game, signalled that perhaps women's football was being taken notice of and was worthy of appropriate significant investment. But Foxtel's 2019 announcement that it would be shedding 'niche' sports (with the subtext that women's football falls into that category) after recording significant losses, again threatened the visibility of women's football in ways that would be considered unacceptable were it the men's game. It took more than a decade for every W-League match to be shown; we cannot allow that gain to be lost.

The Matildas are currently one of the nation's best sports brands; they're certainly the most beloved. Most Matildas ply their trade in the domestic competition, bringing the friends they've made playing in overseas leagues with them in an organic, dual-hemisphere cross-promotion and skills exchange. With some innovative scheduling, such as having the men play their match as the curtainraiser to the women's, as well as actively catering to international fans through international broadcast deals and live streams, Australian football organisers may be able to provide women's football with coverage and attention comparable to the men's.

As an indicator of how women's football could and should be covered, the 2019 Women's World Cup coverage truly felt like an event. With global interest in the tournament, attendances and live television audiences broke all records, then broke them again. More than a billion people in total watched the 2019 Women's World Cup; 11.7 million people tuned in to the USWNT v England semi final alone, making

it Britain's most-watched television broadcast of the year. Meanwhile the commentators covering the tournament were an elite team of Australian women's football's former stars – the last generation to have plied their trade in relative obscurity without sponsorship or salary but whose on-pitch and post-football efforts have benefitted the next generation. In a beautiful turn of events that saw these former players finally earning some money for their football expertise, the commentators included former captain Cheryl Salisbury, who had had to collect the dole, and Joey Peters, who had had to clean toilets while playing for Australia.

It's also a hearteningly long way from Sue Monteath's experience in the early 1980s. Monteath turned out for the Matildas while working full time as a teacher at Ipswich Girls' Grammar in Queensland, requesting leave without pay because she had already used up her paid leave to play in other matches. During the same period, a male teacher at Ipswich Boys' Grammar was regularly selected as a member of the Australian Rugby Union team, the Wallabies. By contrast, he was regarded as an asset to the school, and was able to take leave to train and go on a tour with the national side on full pay.

Meanwhile, the injection of money as sponsors recognised both the surging interest in women's football and the potential for positive brand alignment, as well as its rarity as a largely untapped market, meant that players such as Kerr stood to earn additional (much-needed and much-warranted) income during the tournament. As fans showed in booing Infantino and chanting 'equal pay' (the latter was an idea

reportedly sparked by former AWSA treasurer Kerry Harris), and with even Snoop Dogg calling for US Soccer to pay women equally, just about everyone's done with FIFA's and local federations' unwillingness to enact pay parity.

Under pressure, Infantino announced a proposal to expand the Women's World Cup competition to 32 teams for the 2023 Women's World Cup, double the prize money from US$30 million to US$60 million (still far short of the men's, it should be noted), and double FIFA's investment in women's football to £1bn over four years. He announced the proposals with the massive caveat that member associations would need to vote on them – that is, the governing bodies who are not already implementing pay parity. And as footballer-turned-lawyer Moya Dodd noted when speaking at the Equality Summit organised by football and women's rights activist group Equal Playing Fields during the 2019 Women's World Cup, 'Football governance is a giant arm wrestle between governing bodies, clubs, leagues, and players. Women simply don't have an arm in that wrestle.'

Citing the 2019 Women's World Cup's 'astounding success', in July 2019 the FIFA Council unanimously agreed to the 32-team expansion. The tournament's success was arguably astounding only to them – players, administrators, and fans of women's football have understood its potential for decades. The question is whether fans and players will allow FIFA and friends to weasel out of doing the right thing again in terms of pay parity and investment when it comes to the 2023 Women's World Cup. Based on current sentiment, it seems highly unlikely.

Regardless, Australia needs to consider what lessons it can take from the 2019 Women's World Cup and which aspects it can implement locally. With the rise of European nations and the absence of a single Asian team in the final eight, Australia needs to lift its game to remain competitive. As Kate Gill wrote in the *2018/19 PFA W-League Report*: 'What feel like revolutionary leaps forward are quickly superseded by new benchmarks'. Implementing pay parity is a given, something the FFA has done for the 2019 season, with W-League and A-League players earning the same hourly rate, if not the same annual salary.

The next hurdles to address include venue selection and scheduling. Currently, scheduling of W-League matches often takes place subject to A-League clubs' priorities and the availability of venues. Two teams that could attest to a lack of resourcing around match venues are Brisbane Roar and Melbourne City. Brisbane Roar has played a substantial number of matches at AJ Kelly Park (1500 capacity, including approximately 200 seats) on the Redcliffe Peninsula, more than 30 minutes' drive from the Brisbane CBD. Their final fixture of the 2018/2019 season at the larger Dolphin Stadium, also in Redcliffe, recorded a crowd of 4300. Melbourne City, whose training ground facilities are the envy of most professional sports franchises in the country, play at the recently developed CB Smith Stadium in Fawkner, 12 kilometres from the Melbourne CBD (2000 capacity, including 500 seats). Both teams' venues are excellent for state-level league football development. (CB Smith Reserve is the home ground of Pascoe Vale, the renowned semi-professional NPL

team for which Hakeem al-Araibi plays.) But they are no longer appropriate for or capable of accommodating the expanding interest in national-level women's football. With increasingly larger crowds being drawn to Matildas matches, it's clear there's potential for moving women's football to, and selling out, larger, better-quality stadiums.

To date, double headers in larger stadiums have often been scheduled poorly. A 4 pm kick-off on a Friday evening makes it especially difficult for most of the populace, let alone fans and parents of fans, to get there. And four hours of football with a short break in between is a bum-numbing and time-sapping experience for even the most ardent fan. Likewise, there is the constant tension between whether women's football should be a standalone league not tied to the men's or whether it should leverage the existing men's football audience – there are arguments for and against each approach. Regardless of their success or the debate around them, the double headers at least get women playing on the same high-quality playing field in a central location supported by match-day promotion and public transport. So while the changeroom issues have some way to go, the other elements are, at the very least, a positive step and demonstrate investment in, and increased respect for, the women's game.

In June 2017, the Australian Government agreed to fund a $1 million feasibility study into hosting the 2023 Women's World Cup. It added an additional $4 million funding for the bid in early 2018, and the bid was officially launched on 29 October 2018 with the campaign slogan '#GetOnside'. A few months later in April 2019, FIFA confirmed that Australia's bid would be in the mix with bids from Argentina, Bolivia, Brazil, Colombia, Japan, New Zealand, South Africa, and joint bidders South Korea and North Korea.

The federal government has described the Women's World Cup bid as cautious and conservative in comparison to the unsuccessful Frank Lowy-led bid for the 2022 [Men's] World Cup, which was federally funded to the tune of $45.6 million. In announcing the funding for the Women's World Cup bid, the government noted the potential economic benefits of hosting the tournament, including citing the 2015 tournament Canada hosted, which attracted more than a million spectators and global reach across an estimated TV audience of more than 760 million. If it is successful, which won't be known until long after this book is published, the Australian bid would see matches hosted in Sydney, Melbourne, Brisbane, and Canberra. Those are the cities that successfully staged fixtures in the 2015 AFC [Men's] Asian Cup but, more importantly, boast Australia's strongest participation and representative rates of female footballers.

Women have been playing football in Australia for almost 100 years and semi-professionally for 12. As the world game, it's no surprise that football is the nation's number one team sport for participation. Should Australia

succeed in bidding for the 2023 Women's World Cup, it will catapult Australian women's football into yet another level of professionalism, the stage of more lasts and and fewer firsts that normalcy brings. But even if it doesn't, Australian women's football heroes – most of whom are unknown and unsung – will persevere, never saying die, supporting, professionalising, broadcasting, and celebrating women's football.

FURTHER READING

Australian women's football

Books

John Maynard's *The Aboriginal Soccer Tribe*, Magabala
Books, Broome, 2011

Bill Murray and Roy Hay's *A History of Football in Australia:
A Game of Two Halves* (Chapter 14), Hardie Grant
Books, Melbourne, 2014

Ross Solly's *Shoot Out: Passion and Politics of Soccer's Fight for
Survival in Australia*, Wiley, Brisbane, 2004

Marion Stell's *Half the Race: A History of Australian Women
in Sport*, HarperCollins, Sydney, 1991

Elaine Watson's *Australian Women's Soccer: The First 20 Years*,
Australian Women's Soccer Association, Canberra, 1994

Websites

Beyond 90 <www.beyond90.com.au>

The PFA <www.pfa.net.au>, including its annual
W-League report

The Players Voice <www.playersvoice.com.au>

The Women's Game <www.thewomensgame.com>
Womensoccer.com.au: Women's Soccer in Western
 Australia <www.womensoccer.com.au>

UK women's football

Books

Barbara Jacobs' *The Dick, Kerr's Ladies*, Constable &
 Robinson Ltd, 2004
Gail J Newsham's *In a League of Their Own! The Dick, Kerr
 Ladies 1917–1965*, Paragon Publishing, 2014
Gertrude Pfister and Stacey Pope's *Female Football Players
 and Fans: Intruding into a Man's World*, Palgrave
 Macmillan UK, 2018
Tim Tate's *Women's Football: The Secret History*, John Blake
 Publishing, London, 2016
Jean Williams' *A Beautiful Game: International Perspectives
 on Women's Football*, Bloomsbury, London, 2007;
 *A Game for Rough Girls? The History of Women's
 Football in Britain*, Routledge, London, 2003;
 *Globalising Women's Football: Europe, Migration, and
 Professionalisation*, Peter Lang, 2013

Websites

She Kicks <shekicks.net>
The Guardian Women's Football <www.theguardian.com/
 football/womensfootball>

US women's football

Books

Maya E Bhave's *War and Cleats: Women in Soccer in the US*,
Meyer and Meyer Sport, Maidenhead, 2019

Tim Grainey's *Beyond* Bend It Like Beckham*: The Global
Phenomenon of Women's Soccer*, University of Nebraska
Press, Lincoln, 2012

Caitlin Murray's *National Team: The Inside Story of the
Women Who Changed Soccer*, Harry N Abrams, New
York, 2019

Gwendolyn Oxenham's *Under the Lights and in the Dark*,
Icon Books, London, 2019

Websites

Equalizer Soccer <www.equalizersoccer.com>
NWSL <www.nwslsoccer.com>
The Players' Tribune <www.theplayerstribune.com/en-us>

ACKNOWLEDGMENTS

Writing this book, a social history, was of course a team sport. Yes, we put the words on paper. But we could not do so without the support and help of the football community, our own communities, and our wonderful publisher's guidance.

The story of Australian women's football is a rich, important one that warrants being documented, but there were times this book didn't feel like it was going to happen. Just as football administrators of the past didn't think anyone would want to watch women playing football, it was only through perseverance, some incredible community support, the recent 'overnight success' of Australian women's football, and the willingness of NewSouth Publishing to take a chance on us and this book that made *Never Say Die* happen. For that, we are eternally grateful.

In writing this book we've endeavoured to help tell the largely unknown story of women's football, to share the stories that contribute to the larger narrative. We did not seek to present an authoritative text. We've offered a snapshot, a conversation starter. We've interviewed the people we could. There are some we were not able to speak to and others whose

stories have been published elsewhere that we could draw on. Our hope is that the books that follow this one will be written by the players and administrators who witnessed (and contributed to) women's football's history firsthand.

There are many people to thank and acknowledge for helping us make *Never Say Die* a reality, from those who generously shared their football history knowledge to those who gave feedback on drafts and brought us cups of tea. To be fair, we have included them in alphabetical order. If we have missed you, or you would like to share your story, the research project *With the Ball at Her Feet* <www.withtheballatherfeet.com.au> can help.

People to thank

Di Alagich
Mel Andreatta
Baden Appleyard
Lynda Arkinstall
Rachel Bach
Melissa Barbieri
Danielle Batist
Ellen Beaumont
Kate Beerworth
Maria Berry
Simon Boegheim
Helena Bond
Lyn Boorman
Katrina Boyd
Sam Brady
Tony Buckley
Jo Burgess
Amy Chapman
Lauren Colthorpe
Adam Costin
Alan Crawford
Bryan Crawford
Jill Crawford
Louise Crawford
Natalie Demartini
Moya Dodd
Julie Dolan
Faye Dower

Rae Dower

Greg Downes

Jenna Drummond

James Duffy

Peter Eedy

Alicia Ferguson-Cook

Jo Fernandes

Nigel Fernandes

Fatima Flores

Brinley Gentle

Sarah Gentle

Grace Gill

Kate Gill

Michelle Gillett

Tracy Grierson

Richard Griffiths

Sarah Groube

Natasha Hackett

George Halkias

Jodie Hammond

Andrea Hanke

Lauren Hanna

Gerry Harris

Kerry Harris

Roy Hay

Bess Hepworth

Glenys Higgs

Tim Highfield

Jeff Hopkins

Jocelyn Hungerford

Emma Hutchinson

Isobel Irvine

Kate Jacewicz

Mandy Jamieson

Carolyn Jones

Lyn Ketter

James Lamb

Michele Lastella

Paul Lau

Joseph Mayers

John Maynard

Chris McCallister

Hannah McGowan

Harper McGowan

Leah McGowan

Phillipa McGuinness

John McGuire

Garry McKenzie

Kate McShea

Anita Milas

Hary Milas

Rosie Morley

Clare Murphy

Julie Murray

Paul Nicholls

Denis O'Brien

Kevin O'Donovan

Alexandra Payne

ACKNOWLEDGMENTS

Tom Polkinghorne
Rebecca Price
Carolyn Raaff
Heather Reid
Carly Richardson
The Roar Corp
Fred Robins
Tom Sermanni
Dan Smith
Ian Syson
Klara Szabo

Niza Villanueva
Carol Vinson
Michael Ward
Jean Williams
Geoff Wilson
Naomi Woodley
Candace Wright
Tameka Yallop
Bec Yolland
Leonie Young

Organisations to thank

Australian Academy of the Humanities Publication
 Subsidy Scheme
Football Queensland
NewSouth Publishing
Queensland University of Technology

INDEX

INDEX

INDEX